Marilyn Silverstone
London, March 19, 1929 – Nepal, September 28, 1999

This book is dedicated to the memory of our beloved friend
and colleague Marilyn Silverstone by her fellow members
and staff at Magnum Photos.

# MAGNA BRAVA

# Magnum's
# Women Photographers

Eve Arnold

Martine Franck

Susan Meiselas

Inge Morath

Marilyn Silverstone

Introductions by

Isabella Rossellini,

Christiane Amanpour,

and Sheena McDonald

Essay by

Sara Stevenson

National Galleries of Scotland    Edinburgh

Prestel  Munich · London · New York

This book is published on the occasion
of the exhibition, Magna Brava, at
the Scottish National Portrait Gallery, Edinburgh
(5 November 1999–30 January 2000).

Library of Congress Cataloging-in-Publication: 99-66391

Prestel-Verlag

Mandlstraße 26 · D-80802 Munich · Germany
Tel.: (89) 38-17-09-0 · Fax: (89) 38-17-09-35
4 Bloomsbury Place · London · WC1A 2QA
Tel.: (171) 323 5004 · Fax: (171) 636 8004
16 West 22 Street · New York · NY 10010
Tel.: (212) 627-8199 · Fax: (212) 627 9866

Prestel books are available worldwide. Please contact
your nearest bookseller or any of the above addresses
for information concerning your local distributor.

Editorial direction by Philippa Hurd
Design and typesetting by WIGEL@xtras.de
Color separations by Fotolitho Longo, Bozen
Printed and bound by Fotolitho Longo, Bozen
Paper: Galerie Art Silk 170 g/m² (Schneidersöhne)
Printed in Italy
ISBN: 3-7913-2160-9

Foreword

After the success of Eve Arnold's retrospective exhibition which toured to the Scottish National Portrait Gallery in 1997, Sara Stevenson, the Curator of Photography, approached us to ask if we could generate another project with Eve. This time Eve chose to share the limelight with her female colleagues in Magnum, and this has resulted in an important collaboration with the National Galleries of Scotland, which is launched with the exhibition *Magna Brava* at the Scottish National Portrait Gallery in November 1999. Eve has worked tirelessly guiding this project to fruition, and our thanks for her selfless attitude and eye for the bigger picture go to her in the very first place.

Many others have contributed to this project, which was marked by a true sense of co-operation and positive action. We would like to single out some individuals, without whom we could not have made this exhibition and book. Jimmy Fox, for the dedication and enthusiasm with which he made Marilyn Silverstone's archive accessible, and to Antoine Agoudjian at Picto/Bastille who printed Marilyn's work. We extend our gratitude to Linni Campbell, assistant to Eve Arnold, and Danny Pope of Matchless Prints Limited, who printed Eve's work; to Meryl Levin, assistant to Susan Meiselas, and her printers, Laurent Girard of Lexington Labs for the black-and-white US-Mexico work, Brian Young of Phototechnica for the El Salvador material, and Stuart Ward of Laumont for the color Nicaragua work; to MaryAnn Camilleri, assistant to Inge Morath, and Brian Young, her printer; to Marie Thérèse Dumas, assistant to Martine Franck, and her printer Yam at Pictorial Montparnasse.

With regard to Martine Franck's work we would like to mention in particular the generosity of the French Embassy in London which, through Olivier Poivre d'Arvor, financially supported the printing of Martine's Tory Island photos. We are also grateful to James Holloway, Keeper of the Scottish National Portrait Gallery, Timothy Clifford, Director of the National Galleries of Scotland, and his staff.

To Isabella Rossellini, Christiane Amanpour, and Sheena McDonald we extend our heartfelt thanks for the enthusiasm with which they immediately agreed to be involved in this project, and for the way they have brought their personal experience as leading figures in their field to this book. A very special mention should be given to Philippa Hurd of Prestel who has edited this publication with tact and subtlety; and to Petra Lüer for her graceful design.

A very welcome late addition to this book is the introduction of the work of Lise Sarfati, who was voted an associate member of the agency at Magnum's annual meeting shortly before the writing of this text. This follows a period of nominee membership and is the last step on the long road to full membership of the co-operative. Lise's work points towards the future of Magnum, which at the end of this year will proudly celebrate its fiftieth anniversary, with forty-four members worldwide, and four offices in New York, Paris, London, and Tokyo.

In Magnum many women work behind the scenes (see page 145!), and we would like to single out two especially. Sara Rumens, Editorial Director, should be mentioned for the verve with which she has promoted this project, and a very special thanks goes to Christina Negulesco-Burt who, with her eye for detail and determination, pulled all the elements together in the end.

And last but not least we would like to extend our gratitude to the five women whose photographs constitute the heart of this book. For their co-operation and sense of teamwork, and the way they have blazed a trail for many women coming after them, we are extremely grateful.

It is with the greatest pleasure that we present this book to you.

Elizabeth Grogan
Director, Magnum London

Brigitte Lardinois
Special Projects Manager, Magnum London

# Isabella Rossellini

One evening my mother, Ingrid Bergman, handed me the manuscript of her autobiography *My Story*. She was nervous and teary: "I wrote it for you, my children, so that you will know my version of the controversial events of my life. After my death which I know will be soon," (Mom was sick with cancer) "lots of gossip will start up again." She left me in the living room with the manuscript in my hand and she went to bed depressed with a glass of vodka to help her find sleep. I started reading about my mother's life. Most of it I already knew, with the exception of one event. Mother had been in love with Robert Capa. They had had a passionate affair. Mother was ready to leave her first husband, Peter Lindstrom, to marry Bob, but Bob did not want to marry. He knew he was going to die in one of the terrible wars he photographed (and indeed he did, in Indochina, killed by a mine in 1954). I was stunned. Bob Capa had been one of my heroes. His friend Chim Seymour was often at our house photographing all of us. Chim's photos are for me the memory of my family at one of its happiest moments when Mom and my father, Roberto Rossellini, were still in love. That love and my birth as well as the birth of my brother and sister out of wedlock—worse, when my parents were still married to others—scandalized the world in the 1950s, forcing my mother out of Hollywood, and the American Senate to take a stand against her morality.

At home, our morality was shaped more by the photos of Henri Cartier-Bresson (a friend of Dad), Bob Capa, and Chim Seymour than by senators and priests who often used to refer to my family as an example of evil. My father's films such as *Open City* and *Paisà*, which the critics called Neo-realist, shared the same moral concerns as the work of these photographers. My mother in spite of her tremendous success, was getting tired of Hollywood. She went to see my father's films; she loved them, and wrote to him, "I want to work with you." I believe Mom saw similarities between Bob's and Dad's work—Dad's films were like Bob's stills in motion. Mom and Dad made five films together and three kids (one of whom is me).

This is the epic that preceded my meeting with Eve Arnold thirty-five years later. In 1985 I was making my first film as an actress, *White Nights* with Misha Baryshnikov and Gregory Hines. Eve had agreed to come and photograph our set. I knew all of her photos from *The Misfits* to the horses in Mongolia. She, alongside Inge Morath, was the first woman to have joined the Magnum agency, that glorious association named for the big bottle of champagne, which established

photographers as authors of their work, elevating photography to art. My heart was beating fast when I first shook Eve's hand—but to know her is to love her. In her I recognized the benevolence I had seen in her photos—that open, warm, compassionate look, the same moral look that Bob, Henri, Chim, or Dad have, but Eve added a slightly ironic and humorous touch. Is it her feminine eye? This book by five women photographers, all of them from the illustrious Magnum agency, should give an answer.

Marilyn Silverstone wrote: "You know how to take the picture to please them back home." This is a ruthless sentence about photojournalism. She wrote it to describe the moral conflict a photojournalist feels. On the one hand their work is to report, to denounce, to show the world, to attract attention, on the other it can be a violation, a naked exposure, an invasion of privacy.

I cannot comment on the moral conflicts of photojournalists. I mostly admire them and I ask myself: "How do they do it?" I belong to the group "back home", that looks at their photos. I have a warm, beautiful home in New York where I eat three meals a day and when I open the newspapers, magazines, or books my beautiful life is jolted. Photos help me see what I did not notice, or couldn't see, or did not want to see.

I did not want to see, for example, Susan Meiselas' photos of South America. Her images are so shocking it often takes me two acts to process them. Let me explain: Act One, I look; I see a valley, a lake, and hills in the horizon. In the foreground of the photo something looks like disturbed dirt. Whatever it is does not belong to this peaceful landscape. My eyes are disturbed by the sight and move on to something else. Act Two, what I've seen just stays in my mind. It agitates me. I know what it is. It's the power of the image. Powerful images become my own as if they have been seared into my mind. Slowly my brain decodes for my heart all I have seen in that photo. In the foreground there were bones, human bones. A spinal chord sticking out from a pair of jeans with the fleshy legs still inside. It is unbearable to imagine what happened to this human being. Susan's photos are like bullets straight to my heart.

The five women in this book are like Cupids, darting not only arrows of love, but also of pity, horror, sorrow, and compassion, arrows carrying many different, contrasting emotions. Photos have shaped my heart, my brain, my morality.

If photos such as those by Susan Meiselas are the memory of what I don't want to remember, Martine Franck's photos are the memory of what I don't want to forget. Her photos of Irish villages are not just an anthropological documentation; they are also a means of hanging onto a way of life that may be disappearing in Europe. It's the record of our origins, our evolution, our genes.

And then there are Inge Morath's photos; witty, brainy, humorous, or photos of the witty, the brainy, and the humorous intellectuals of our century. Saul Steinberg's mask series drives me crazy—so simple, so clever! Painted brown paper bags over his or his friends' heads. These are not portraits of their features—I still don't know what Saul or his friends look like—but portraits of their playfulness. Photos that capture the mind in one of its highest functions—humor.

Marilyn Silverstone's photos are just a small showcase of her journey through life. It is as if she took us with her on her first steps to embrace Eastern culture. "The very act of taking a photograph is choosing." And she was choosing to show us back home what she saw, what she understood, what she was experiencing. Her photos of India, Tibet, Sikkim, and Nepal are intimate portraits of cultures. But if she needed us as her companions at the beginning of her journey, at a certain point she needed to leave us. "You cannot take part in anything and photograph it. You cannot participate and photograph." In 1977, after the death of her companion Frank Moraes, she became a Buddhist nun.

When Eve Arnold photographed our film, *White Nights*, she tiptoed around us on the set barefoot, snapping photos. She was a transparent presence. If we noticed her lens pointing at us, she stopped. I never felt she was stealing our images, or that she was exposing us to what we did not want to show. Eve was sort of a guardian angel, invisible and attentive. I liked her around us.

When I've asked Eve (the only one of the photographers in this book I know personally) what was the hardest task in her professional life she said: "We all had families and children—it was hard to be both a mother and photographer." That is my hardest problem, too, the conflict of private and professional life.

When I was an adolescent I dreamed of working. I wanted to be independent and on my own. I wanted to have a life just like Eve Arnold, Inge Morath, or Marilyn Silverstone. I imagined their lives to be full, interesting, and adventurous. Adventure was what I craved. It did not seem adventurous to be a wife. It seemed adventurous to have children, but most of all adventures were beyond the walls of home. Little did I know, but the biggest adventure, the most challenging, complicated, confusing, discombobulating, was the mixing of these two lives, family and profession.

Eve, Inge, Marilyn, and my mother were among the first women to break off from the traditional lives of women and fulfil their own craving for adventure and independence. A generation later we still do not know how to resolve this conflict. We still live two lives: a private one and a professional one, most of the time at war with one another. The quest to find a new harmony is a challenge for modern women. In spite of the quest for this difficult answer, I am grateful to these women for having shown me a path, albeit a rocky path, to a life that is indeed fuller, richer, and more adventurous, more surprising than the traditional road.

# Christiane Amanpour

When Magnum asked me to pen a foreword for a book by their photographers, I leapt at the chance. I have a deep and abiding respect for the power of photography, and for the Magnum tradition. I count many friends and colleagues among Magnum photographers. But when I realized the book showcases the work of Magnum's *female* photographers, I was especially motivated, out of solidarity and a slight sense of puzzlement that there are still so few of them at Magnum, only five full-time members.

I am always grateful to the women who came before me in this profession because they paved the way. My generation of journalists has little to complain about. We are out there, we are doing it, we are more than holding our own. It is of course more difficult for us, because we have so much more to juggle. The balance between professional and personal is still much more complicated for women. Eve Arnold writes that to be a "woman photographer" would have limited her. But to use her insights and perspectives as a woman would distinguish her as it does many women in this field. Women do look at things differently, interpret events differently and above all I find subjects simply react to women differently. They are more open, more generous, more trusting of women, and after all we still live in a macho world where male subjects are much more likely to say yes than no to a woman...at least the first time!

As a television journalist I have had many hilarious and infuriating, combative and supportive discussions with my friends who are stills photographers. Although we all do much the same kind of work, the "stills" consider themselves the real thing, almost the royalty of the world of pictures, reportage, and photojournalism. We TV menaces are deemed too commercial, too tabloid, not serious enough. Above all, we work in teams, have the support of network resources, job-security, and we get paid even if we don't get the picture or the story that particular day. The stills photographers constantly remind us that their travails are much harder, lonelier, and demand more courage, more close-ups. We never let them get away with that kind of talk, we roundly shout them down, we are proud war correspondents! But of course there is much truth to their tales of woe. I respect their courage and commitment, and I sympathize with the difficulty they now have in getting photos published in our age of cost-cutting and electronic picture transmissions from the field. We live in a time that sadly places less value on the serious than on the sensational, less worth on the truth than on the trivial.

The five Magnum women were fortunate to have known and worked in a different environment, when cynicism was less crushing, when the search for truth and communicating that truth seemed to matter more, when photography, reportage, and photojournalism were more noble callings, and when the world was not necessarily a better place, but when people cared more about making it better. I marvel at Eve Arnold's pursuit of China, which took her beyond what the Chinese wanted us to see. I love her photos of the art class and the horse training for the militia. Today the desire for access into certain countries often dictates how far news organizations are willing to push the limits. I am shattered by Marilyn Silverstone's emaciated *pietà* and Susan Meiselas' pictures from Nicaragua—that awful spine in the valley, the innocent children lying in a pool of blood, the woman wheeling her dead and shrouded husband. I find these hard to take, even though they mirror what I see today in Kosovo, Bosnia, and Rwanda. We must never get used to these images.

Inge Morath's witty, wonderful mask series makes us smile, and she gives us a privileged look at the other side of human nature, the creators not the destroyers. Martine Franck whose humanitarian reportage I know best, gives us the gift of timelessness on Tory Island. We stare longingly at the delighted daring of little girls leaping off a wall, and the pure happiness of the windswept bridal couple on the beach. They reaffirm life.

These days it is much more difficult to bear witness, especially to the great tragedies, the famines, and cataclysmic wars. For a start, people seem to care less; our value system has mutated into a strange state of being where all things must be equal. We are in the age of moral equivalence, of desperately seeking balance and where none can be found, an age which creates artificial balance. Victim and aggressor must no longer be distinguished; but we cannot succumb to these falsehoods.

Like Susan Meiselas, we who do this particular kind of work are also record-keepers for history. Our work can be called forensic. Our discoveries of concentration camps and mass graves can lead investigators to pursue the guilty. It happened in Bosnia and Kosovo. I was an eyewitness to the latest war, NATO's conflict with Serbia over Kosovo. Because I understand the language of the world I deal with, I insisted on labelling Belgrade's actions in Kosovo *war crimes*. The hundreds of thousands of ethnic Albanians who were forcibly marched out and threatened at gunpoint were, strictly speaking, *deportees*, their expulsion a crime against humanity, as defined in international conventions. Indeed the architect of this horror, Yugoslav president Slobodan Milosevic, was indicted by the war-crimes tribunal, but until that day many of our editors wanted to call them *refugees*, a more neutral, less offensive, and less honest term. In addition many commentators wanted to equate NATO's surprisingly few mistakes that caused civilian deaths in Belgrade with the Serbian rampage in Kosovo. When we finally got into Kosovo in June along with the NATO peacekeepers, we found the terrible truth of what all those deportees had told us. We went to all the places where they reported executions and mass graves and what we found was exactly what they had told us and more, much more. Now NATO believes the Serbian forces probably killed 10,000 ethnic Albanians in less than three months.

As journalists and photojournalists we cannot allow the public, the pundits, the politicians to take refuge in a misreading of history, or a misrepresentation of the facts.

In Bosnia I believe the efforts by journalists and photographers to tell the objective facts made a difference. NATO finally intervened and ended that war in 1995. Furthermore I believe that our eyewitness accounts of events in Bosnia built up a reservoir of guilt among western leaders, so that they knew they could never get away with such inaction when Kosovo flared.

Marilyn Silverstone writes that sometimes she is repulsed by her own skill, that she feels she is taking pictures of people as if they were pieces of meat. I understand what she means. While I constantly strive to ascribe dignity not degradation, to shine a light not to shock, to tell the story of human beings not statistics, I have had terrible black moments when I am no longer able to endure the horror before my eyes, when I hate my role as vulture, and when I wish I could leave people to suffer in private. But we who have chosen this profession, this *life*, must be there, we cannot avert our eyes, we cannot stay silent, we cannot even permit silence to the sufferers. And we do this because we have to give a voice to those who must be heard, because the world has to know of the crimes and injustices, because there is always a chance that we can make a difference, and because it is our way of protecting our humanity.

# Sheena McDonald

I remember visiting Sarajevo in the summer of 1993, in the thick of the Bosnian-Serb siege, which would continue for another two years. I flew in on an army transport plane, and was driven from the airport into the city center by a UN armored personnel carrier. It was daylight, and I could squint through the narrow window at the devastated and abandoned houses that lined the road. And the houses on the road from the airport were shattered. And I was not surprised. And this shocked me. My familiarity with the television images of the siege was so embedded in my mind that I accepted the frightful, inhuman realities of existing in a war-zone with apparent equanimity.

I considered my reaction later, and worked out that half the world's inhabitants are now made artificially familiar with places they will never physically visit, and sights they will never bear live witness to, by the photograph, or the moving picture. There are few parts of the globe that I do not have some "knowledge" of, by dint of seeing images which are generously and economically made available to me in newspapers, magazines, and books, and on my TV screen.

By and large, this is an example of benevolent and worthwhile human progress. It helps us to go a little way towards understanding our fellows—but only a little way. When we realize how easily we absorb the images presented to us daily, it makes the achievement of Magnum's members all the greater.

These photographers have made and maintained an art form of their business, and here you see both a quintessential demonstration of artistry in action, but also the particular skills operated and honed by the women of Magnum, a skimpy five in number.

Each has her own eye, and has used it differently. What unites them all is their portrayal of life in all its ordinariness, its banality, its beauty, its exceptionalism, its daily round. Do they see with a woman's eye? That you may consider for yourself, although for me, much of the subject matter has been selected with female sensibility. I find it hard to imagine that some of these images—two cats flanking a fireplace, a television poised on a mat-decorated table—would strike a man as worthy of immortalization.

And yet such simple images as these contain such a wealth of narrative. These photographers have chosen to portray images of real life, which do far more than illustrate their interest in their separate subjects. They

each and collectively open a window on ways of life which may or may not have any familiarity with our own, but which are comprehensible, and point to lifestyles particular to their provenance and time.

Eve Arnold's images of China in 1979 are groundbreaking. Here is a society which was not simply unknown to the rest of the world at the time, but effectively demonized. Through her caring portrayals of ordinary life, we enter a secret garden, where the patterns of cooking, farming, childcare, and aging seem perfectly normal, and unsullied by foreign intervention. Her portrait of a retired woman worker is timeless. Snatched as Arnold passed by, it carries such strength, complexity, and simplicity, captured in one swift image.

Martine Franck's commemoration of Tory Island, off the coast of Ireland, similarly freezes a timeless way of life, where stone and sea are the eternal elements, and their human inhabitants—including an uncharacteristically relaxed Gerry Adams—seem temporary adornments to the landscape. Franck has lovingly photographed an idealistic way of life, whose participants believe in what they are doing and how they are doing it, as faithfully as Eve Arnold's Chinese.

Susan Meiselas has served the "hard news" market. Yet her choice of subjects, and the way she has portrayed the desperate ways of life in Central America and on the US borders, smacks of a far deeper motivation than simply snapping a sensational shot to illustrate a news story of the day. These are images which insist that you think about these people as individuals, struggling—and sometimes failing—to survive in a hostile situation.

Then we reach wheels within wheels. Inge Morath and Marilyn Silverstone both offer us portraits—the former shot in the West, the latter in the East. There is a superficial similarity between the posed, reflexive images Morath lays down and the more aware of Silverstone's subjects, but the similarity disappears when Silverstone directs her camera on the unknown, the poverty-stricken, the needy. Then she establishes lives lived with as much dignity as individuals can muster.

Morath's subjects, although less obviously in need, define their humanity in their decoration and self-consciousness. She has caught her subjects with as much humanity as Silverstone, and framed them judiciously, so that her consciousness of their context overrides her—often famous—subject's self-awareness

and willing submission to the lens. She does not glorify her portraits, but nor does she gratuitously mock them. Rather she places them, so that we can understand the sense of self-promotion that some are broadcasting, and assess it in the context of all humanity.

Silverstone, too, despite her eventual self-deprecation, her renunciation of photography in favor of the duties of a Buddhist nun, could be defined by her compassion. Her photographic insights are profound, and her portrayal of the East goes far beyond the news-snappers' ready aim of recognition.

Bosnia in 1993 was neither the time nor the place for independent photographers. The erosion and violence of war, and the desperate, dangerous attempts to report it for often disinterested outsiders made inevitable my knee-jerk acceptance of the images I saw. But each of these photographers might have found herself there. It takes courage to take photographs which reach for the greater truth beyond the immediate image, the courage to invade the lives of the subjects, to share their situation however briefly. Here you can see a sublime, quiet demonstration of courage combined with insight, intelligence technical skill, humanity.

The photographs in this book are eclectic but linked. Each of the very different participants has, in her own way, focused on life and reality, in ways that may not always make easy viewing, but always make for challenging images. Each photograph begins a dialogue with the viewer, in the traditional manner of all great art. Take your time, observe, and allow yourself to begin the conversations that you have been invited to join.

# MAGNA BRAVA

Eve Arnold's photographs of China were all taken in 1979.

Martine Franck's photographs of Tory Island were taken between 1993 and 1997.

Susan Meiselas' photographs of Central America were taken between 1978 and 1983, and her photographs of the US-Mexican border in 1989.

Inge Morath's photographs of New York were taken between 1953 and 1998.

Marilyn Silverstone's photographs of India, Tibet, Nepal, and Pakistan were taken between 1959 and 1977.

Lise Sarfati's photographs of St. Petersburg and Moscow were taken between 1992 and 1999.

My first lunch with Eve in 1976 was particularly memorable in that she quietly warned me that few amorous relationships survived alongside Magnum. I was struck by her candor and somewhat surprised that in such a matter-of-fact way we had suddenly become quite intimate. It is perhaps this disarming directness that brings her to know her subjects and render them so well.

Eve was born in America of Russian immigrants. She discovered photography accidentally when a friend gave her a camera. But soon after giving birth to her son, Francis, she studied for six weeks with Alexey Brodovitch, the master art director of *Harper's Bazaar*, and then embarked on the adventure which would become her way of life.

Eve's first published work was from the fashion shows in Harlem and it is with that work that she became the first woman with Magnum Photos in New York (Inge Morath joined Magnum Paris at about the same time). In her book, *In Retrospect*, Eve writes: "I didn't want to be a 'woman photographer'. That would limit me. I wanted to be a photographer who was a woman, with all the world open to my camera. What I wanted was to use my female insights and personality to interpret what I photographed."

The role Eve chose for herself was initially to engage her curiosity focusing on such personalities as Marilyn Monroe and the Queen of England, Malcolm X, and later the infamous Joseph McCarthy among others. Eve's work has always been a mixture of the famous with the unknown, portraits against working lives, such as those she portrayed so poignantly: the migratory potato pickers of Long Island, black women protesting in Virginia, and women mourning their dead in Hoboken, New Jersey. She writes: "What I learned was not technique, but that if the photographer cares about the people before the lens and is compassionate, much is given. It is the photographer, not the camera, that is the instrument."

As a younger photographer, I think what most impressed me about Eve was her intense focus, organization, and determination to pursue her own ideas. Often she had had the support of major magazines such as the London *Sunday Times*, but she remained independent in spirit, proposing projects that took her into foreign lands such as the USSR and South Africa, as well as her legendary work documenting the lives of veiled women from Afghanistan to Dubai, Egypt, and Oman.

I watched as Eve went off to China with a three-month visa (quite rare at the time) and then returned again within months, insistent on finishing the book she envisioned. She had covered 40,000 miles to go beyond what the Chinese had wanted her to see, "to try to penetrate to their humanity, to try to get a sense of the sustaining character beneath the surface." With that accomplished, and within months of mounting the exhibition on China, Eve launched herself into another massive task, this time to photograph America. As she stood in the corner of the photographers' room in Magnum New York, I remember the stacks of paper with systematic research growing as she mapped her future journeys, criss-crossing the familiar with communities she hoped to discover.

What continues to amaze me beyond the feats of her ambitious projects, is Eve's remarkable generosity, first to her subjects and then to her "family" in Magnum. It is her gentle yet unflinching criticism at critical moments, quietly given, often at a mere whisper, that assures she is not only heard, but respectfully listened to. But it is her persistent patience to withstand the unpredictability of photography that I most admire. Grace is her being, and fortunately she has shared it with all of us through her work.

Susan Meiselas

## Eve Arnold

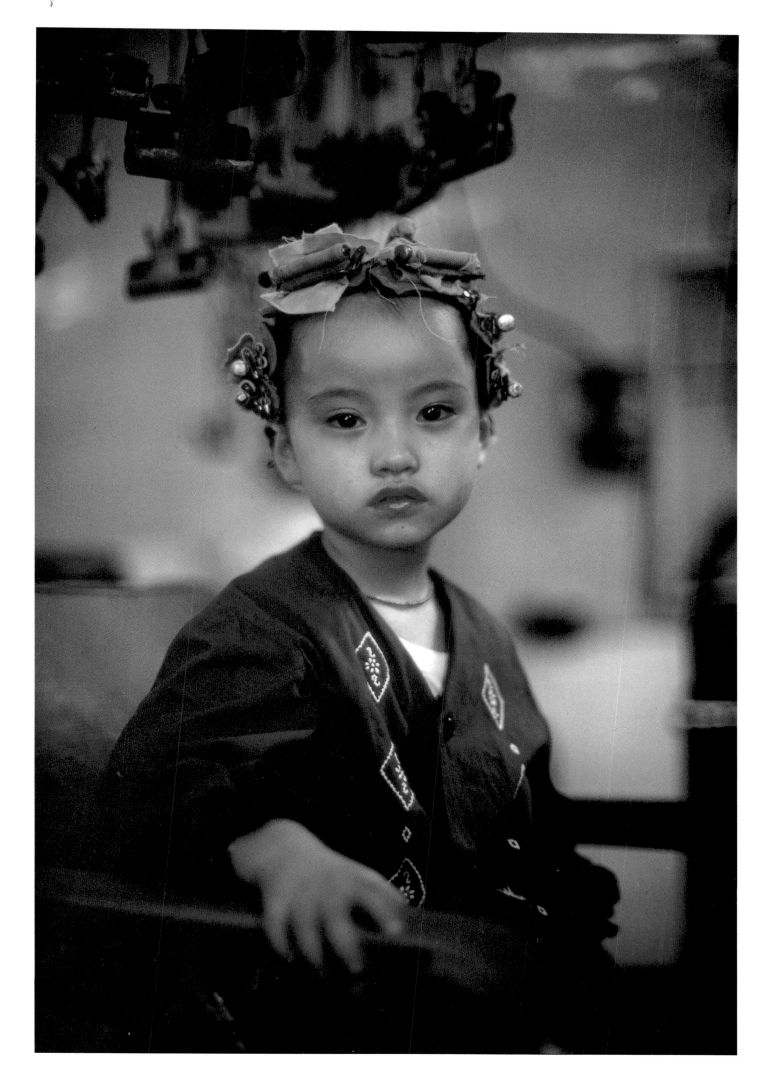

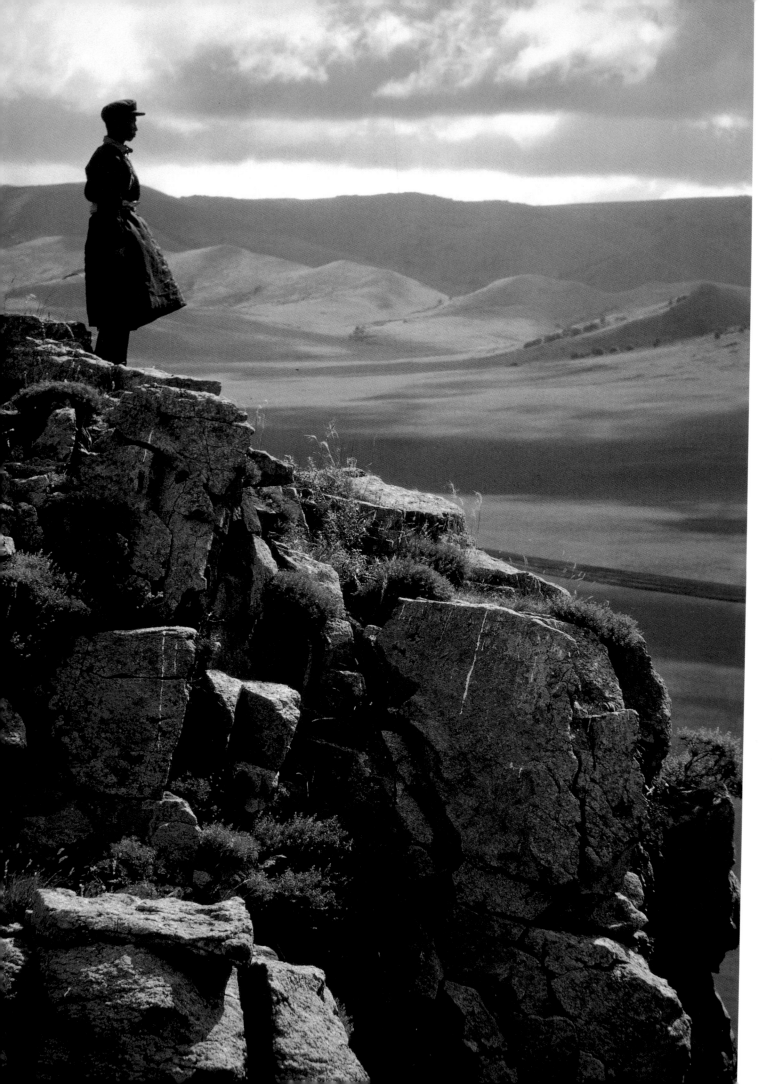

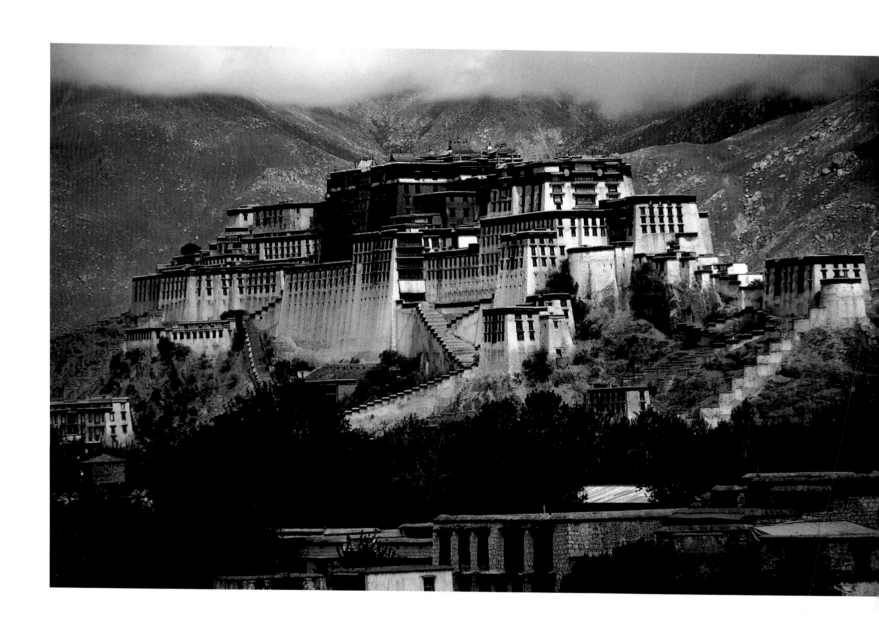

Inner Mongolian steppes, cowboy

Lhasa, Tibet, Potala Palace

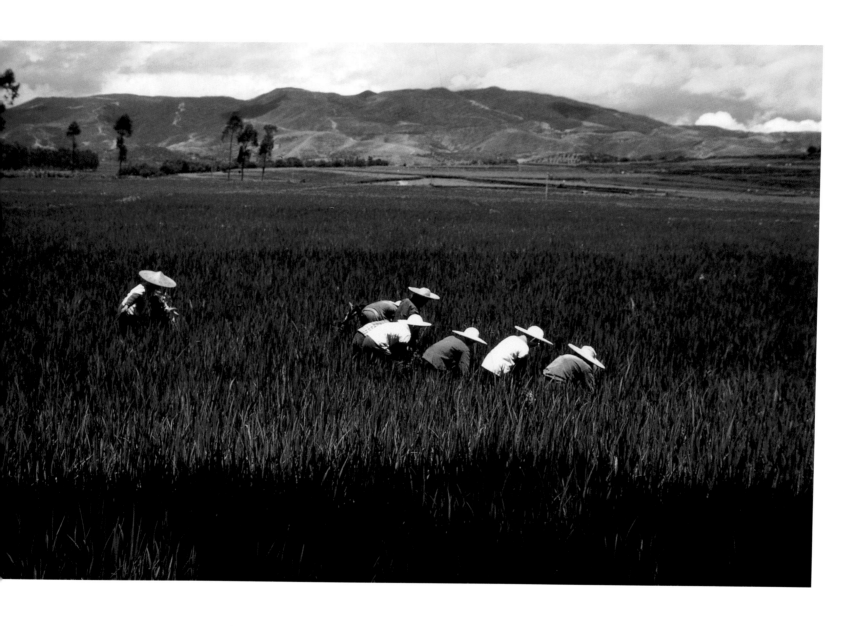

Hsishuang Panna, weeding

Sinkiang, family in an Alpine forest

Chungking, art class

Bottler, beer factory

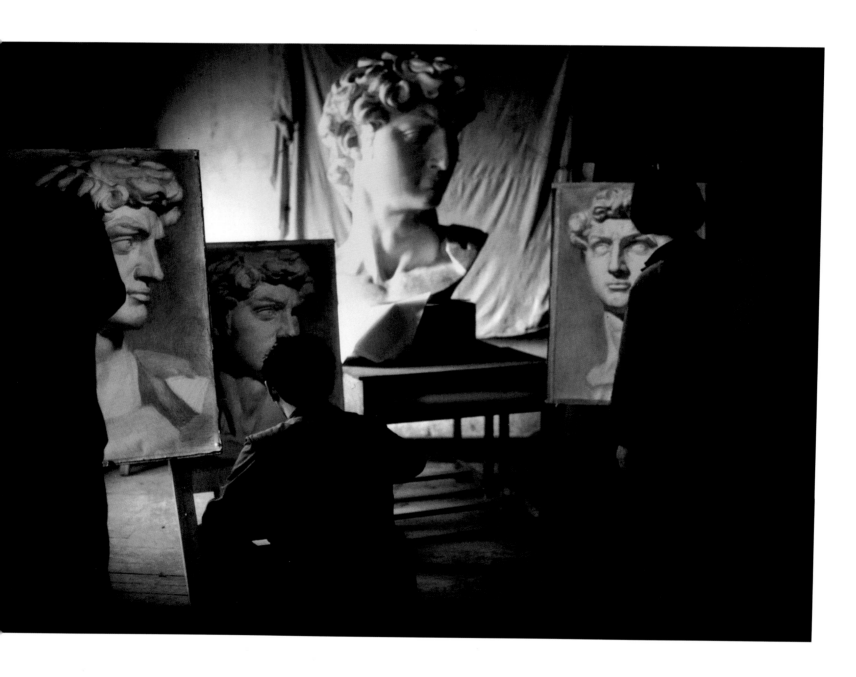

Machine operator, tractor plant  ▷

Welder, locomotive plant  ▷▷

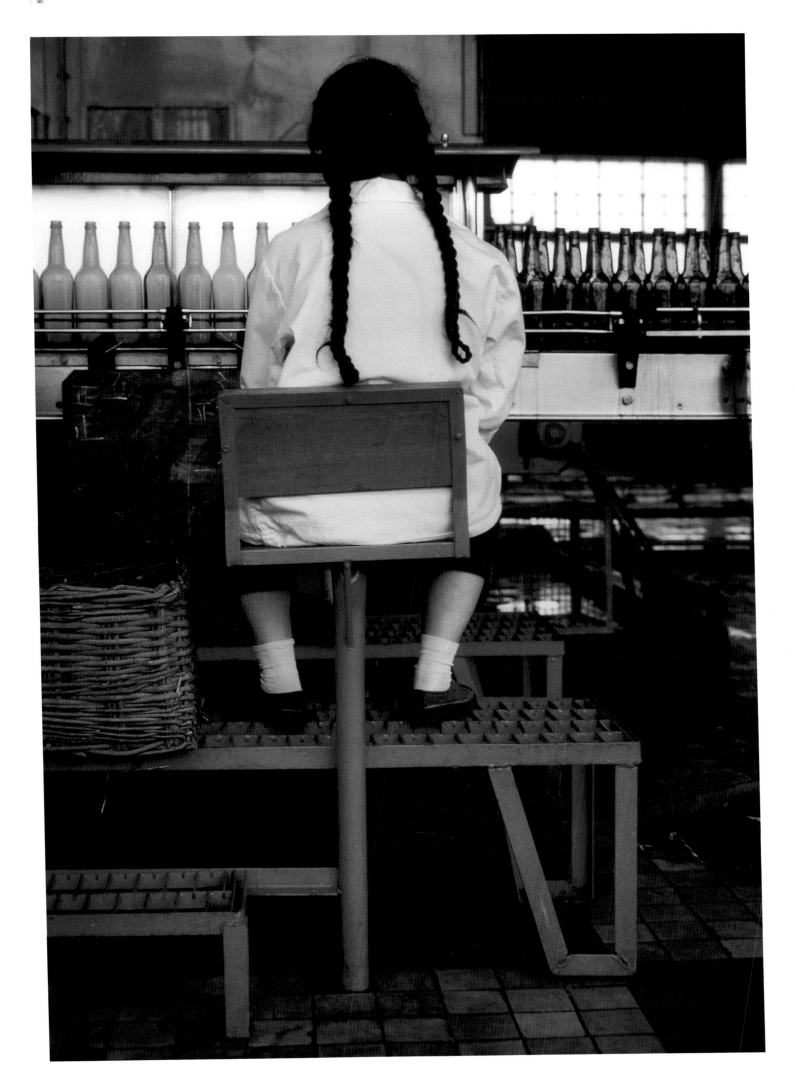

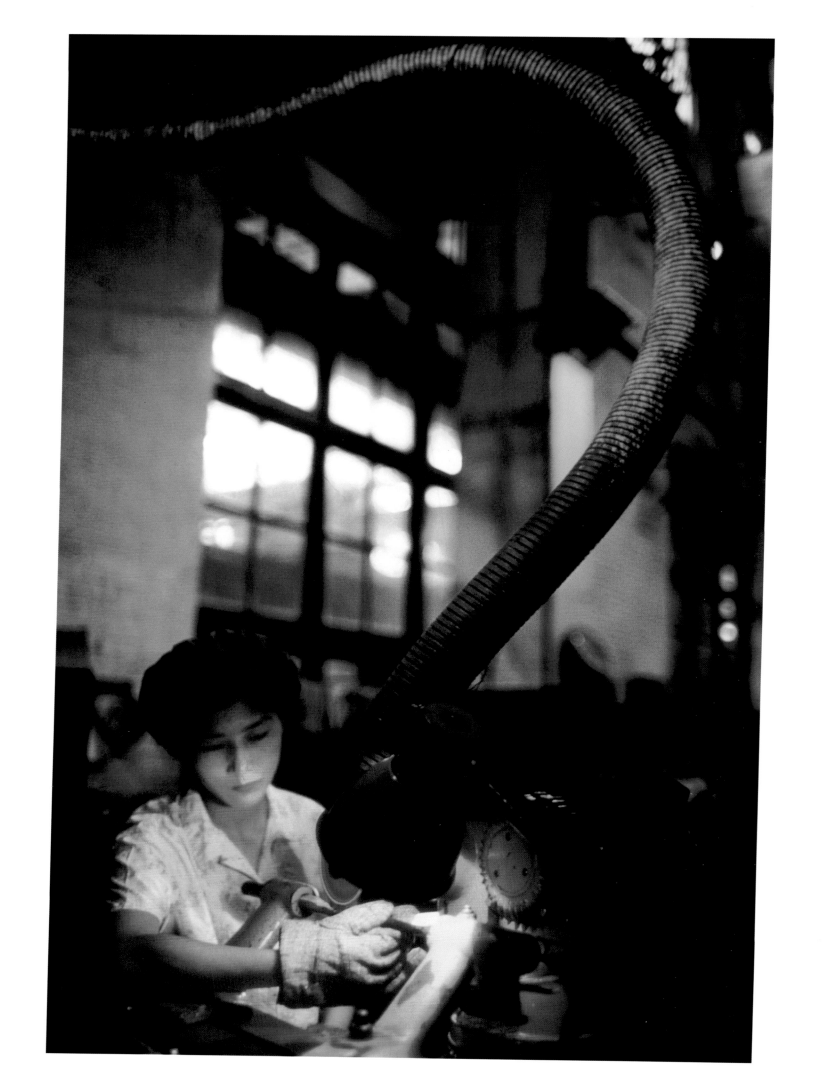

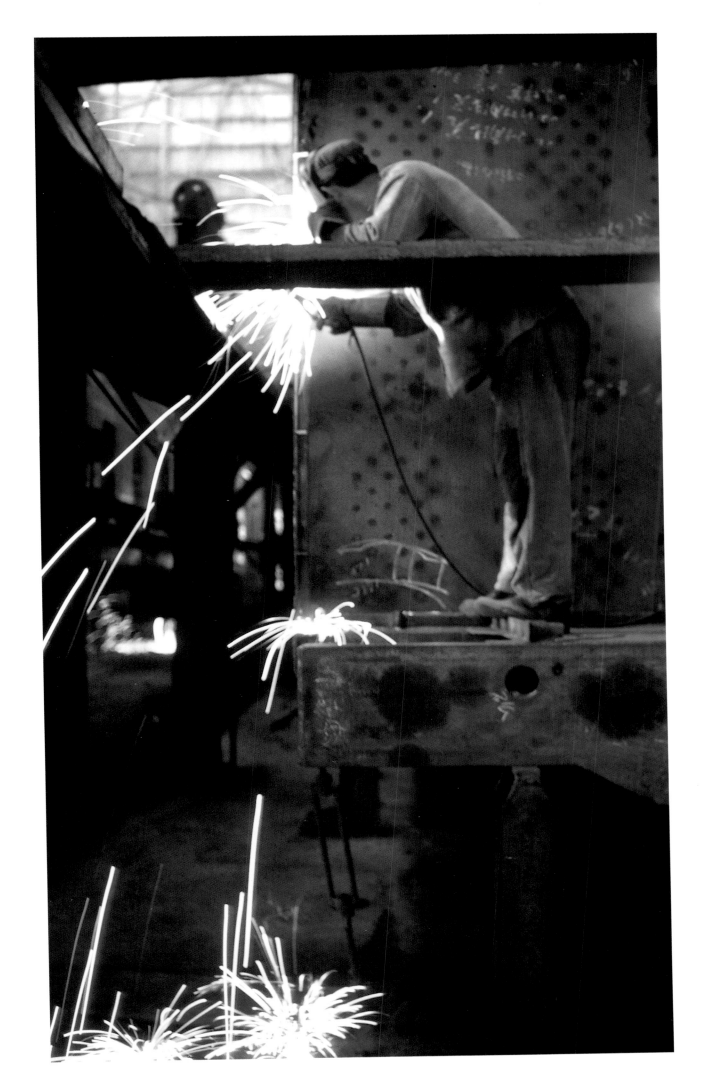

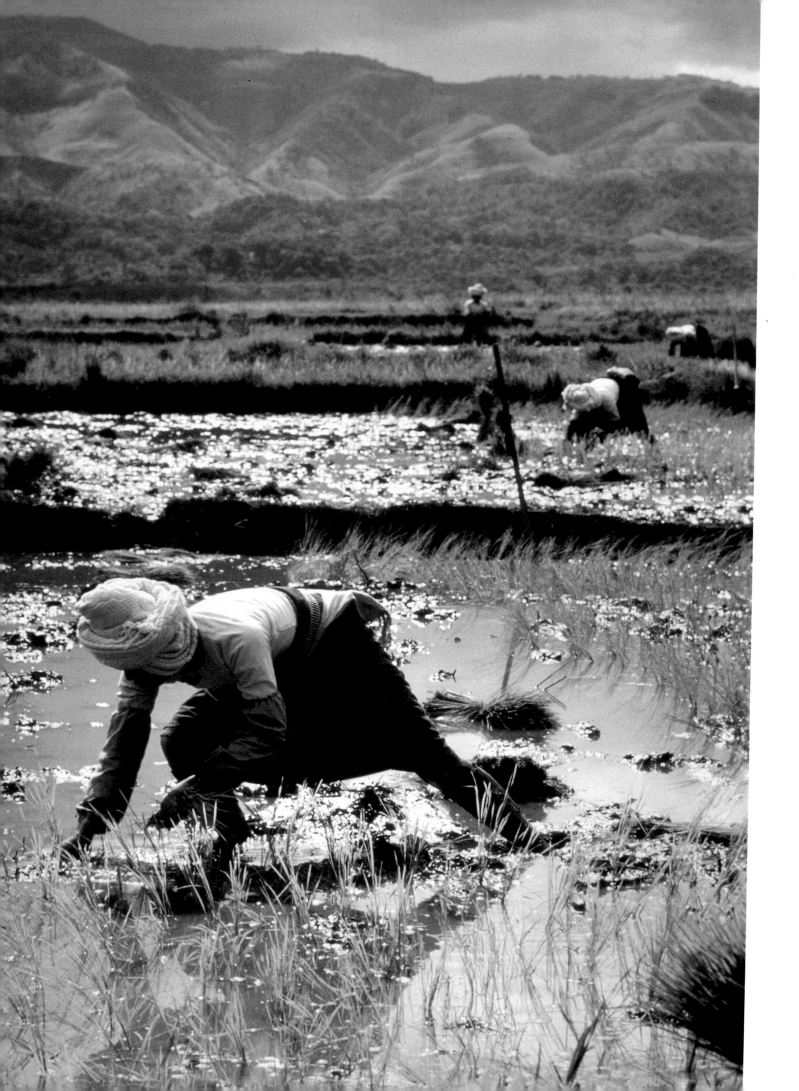

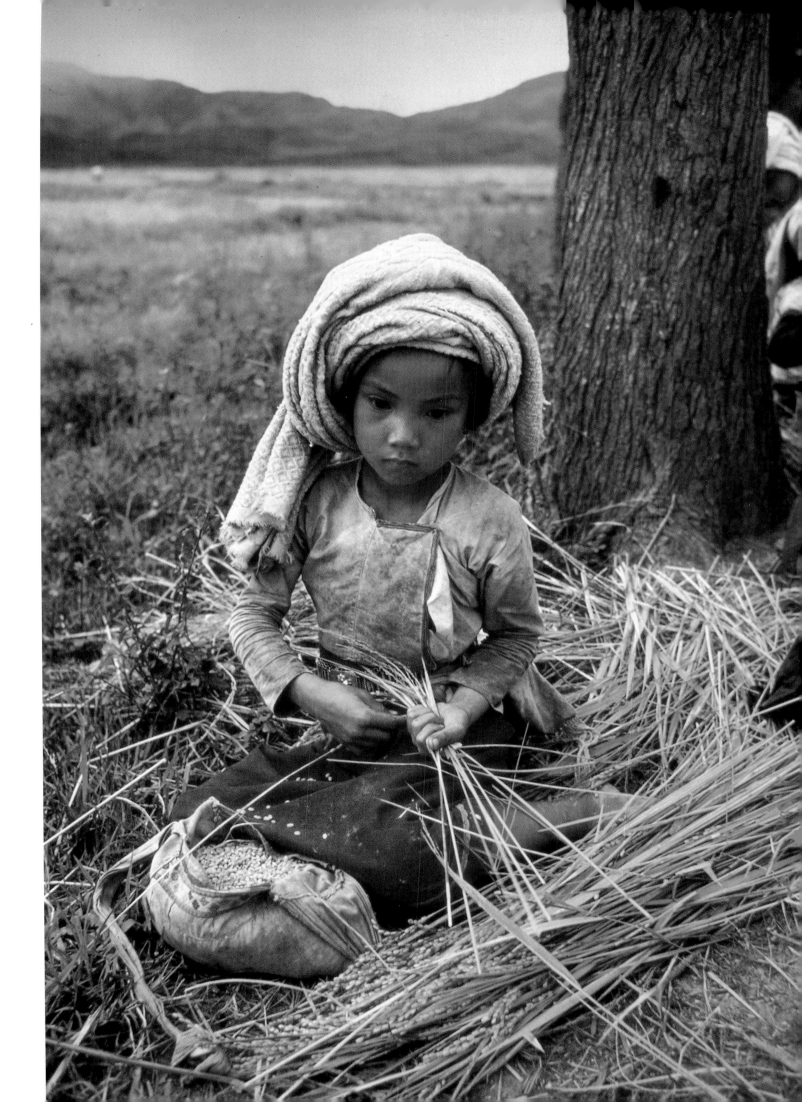

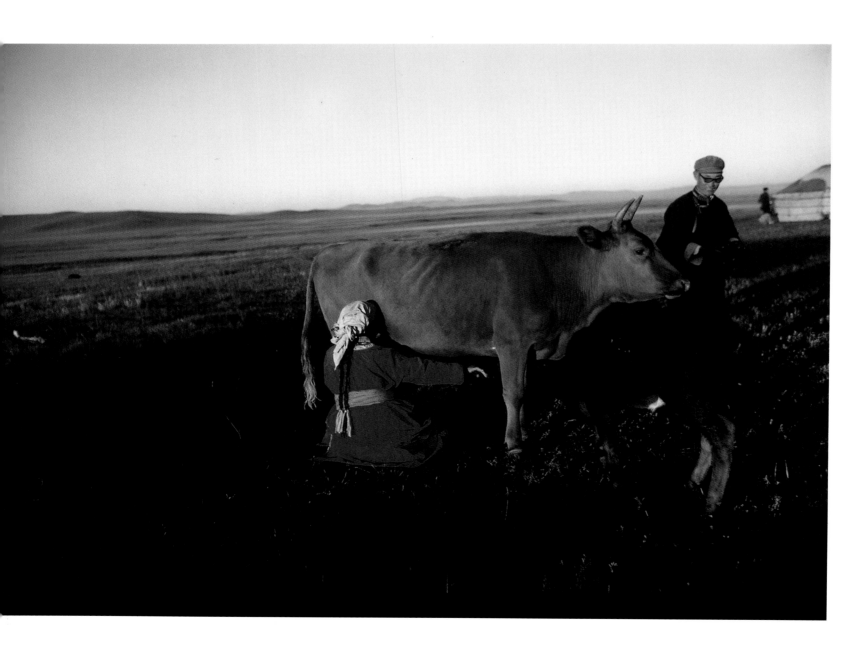

28

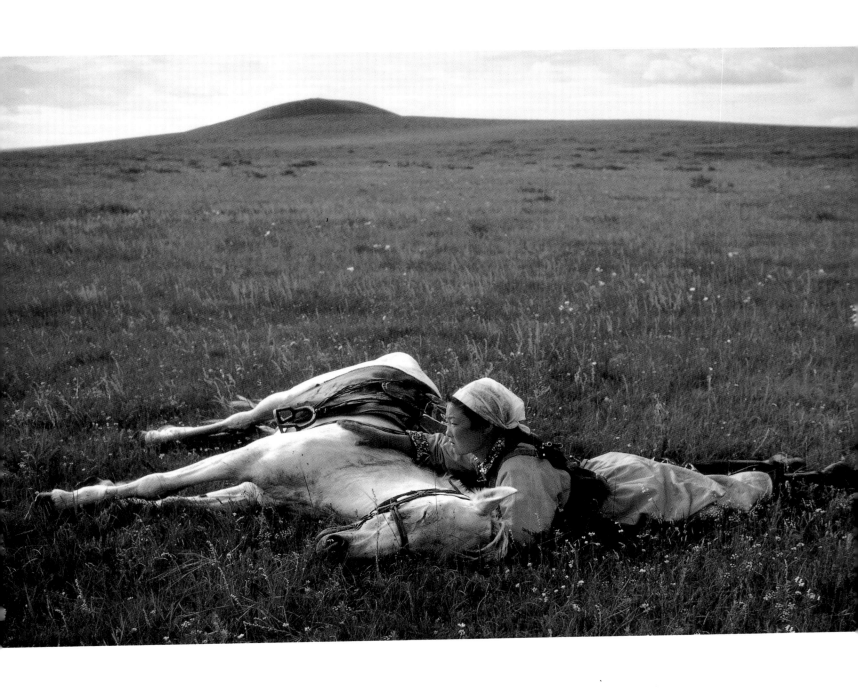

Inner Mongolia, dawn milking

Inner Mongolia, horse training for the militia

Grand Canal, bringing rice to the state granary

Fishing on the Grand Canal

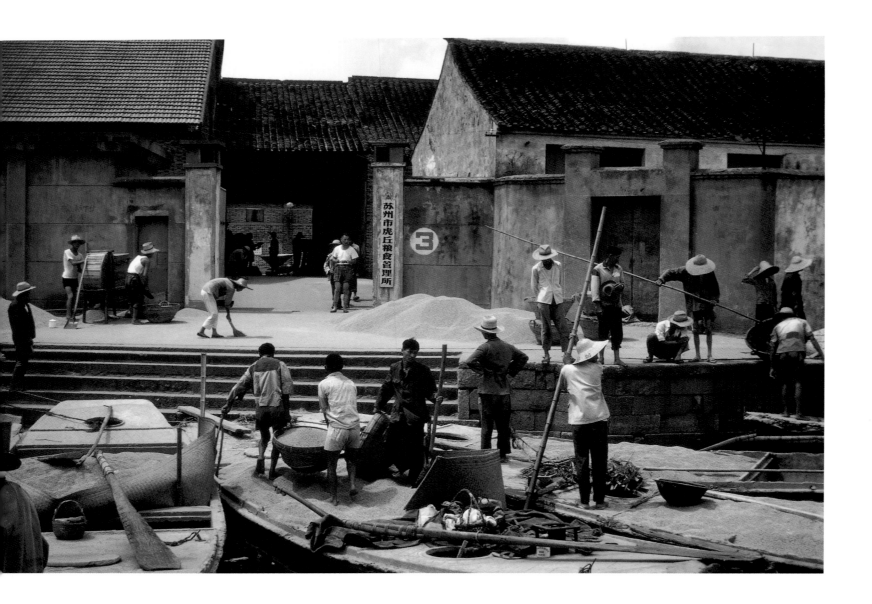

Inner Mongolia, cowboy and his children  ▷

Tibet, barefoot doctor  ▷▷

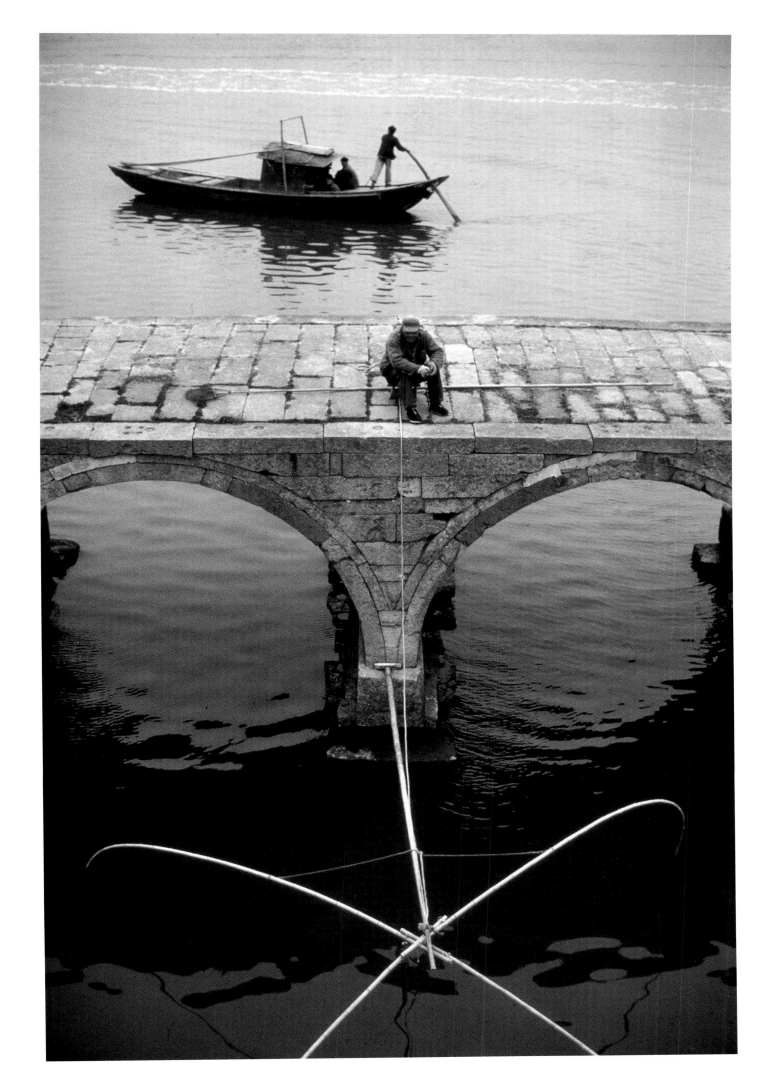

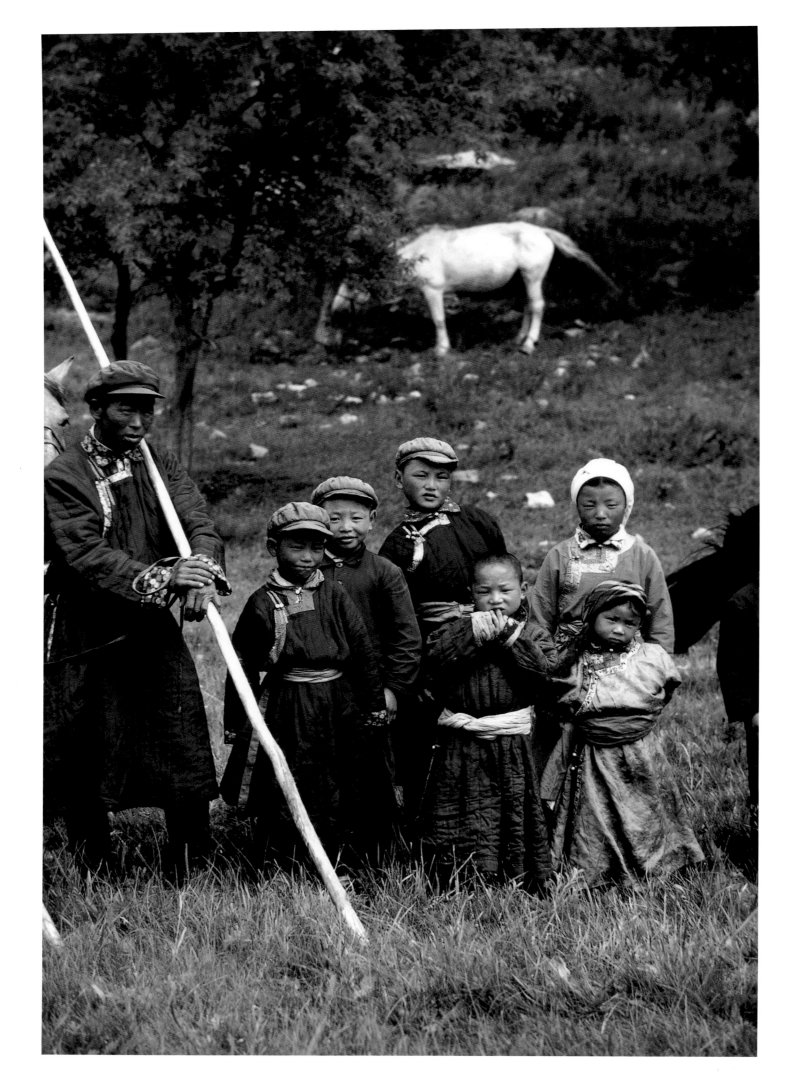

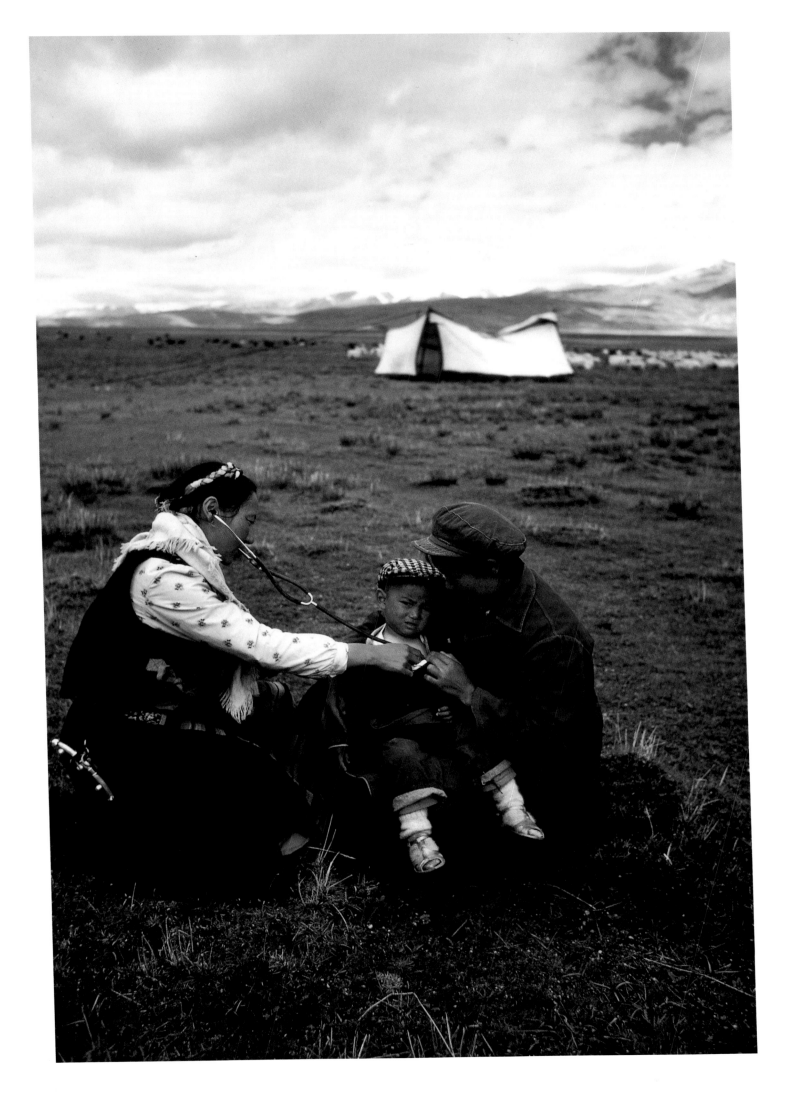

Hsishuang Panna, road-building

Herb seller, free market

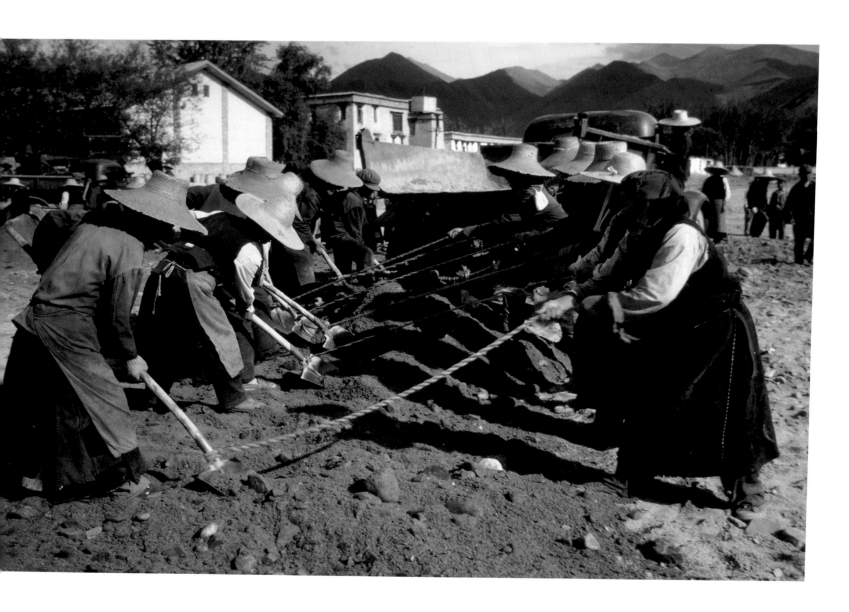

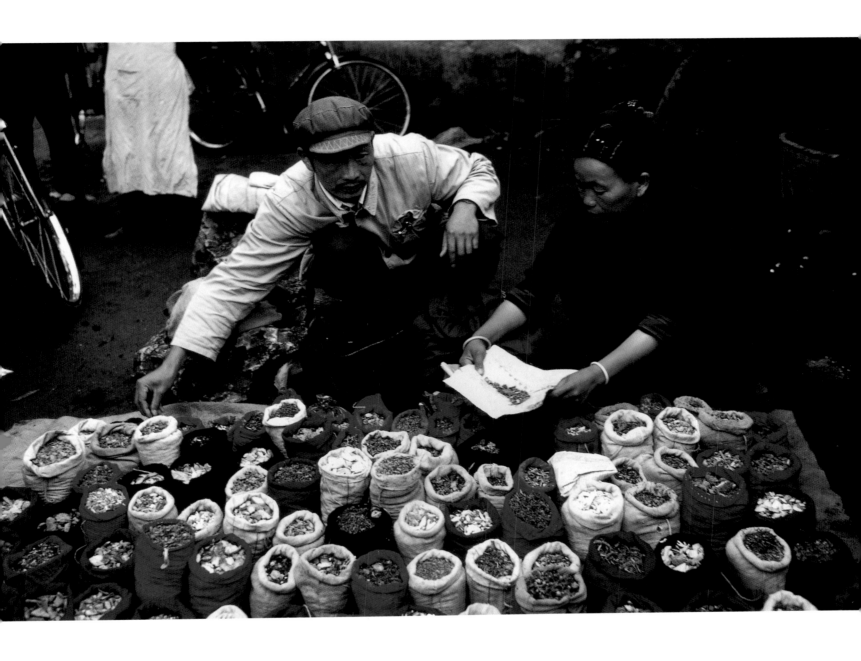

Accountant  ▷

Preparing herbal medicine for impotency  ▷▷

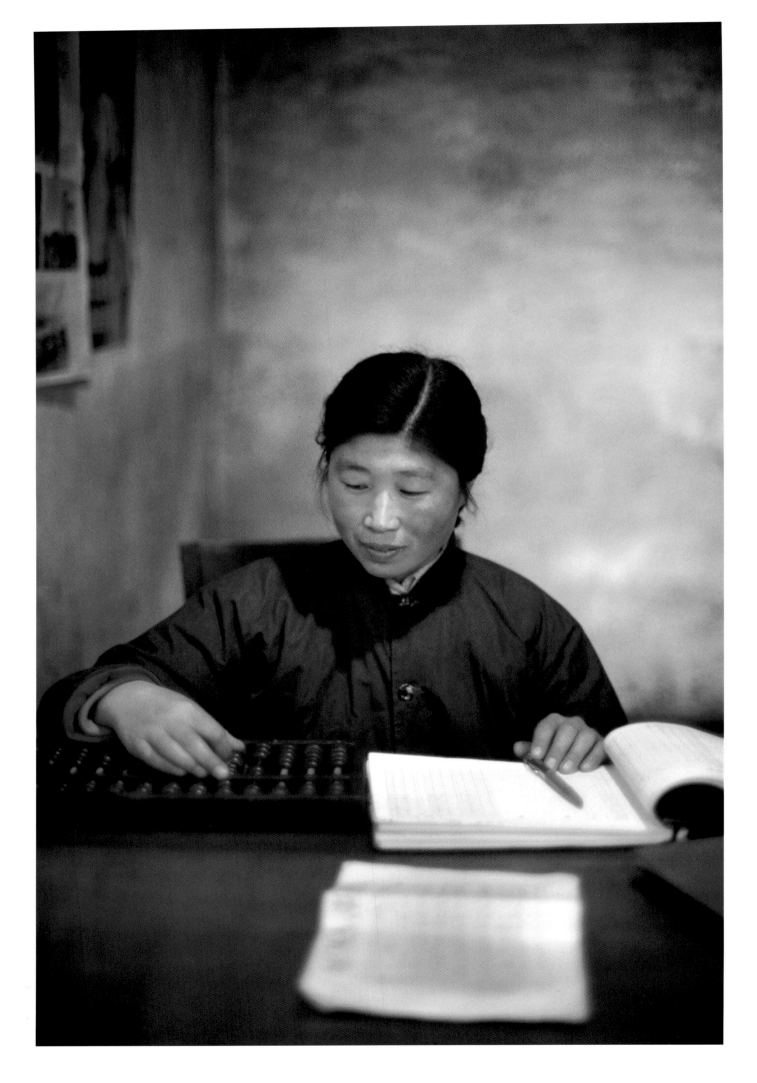

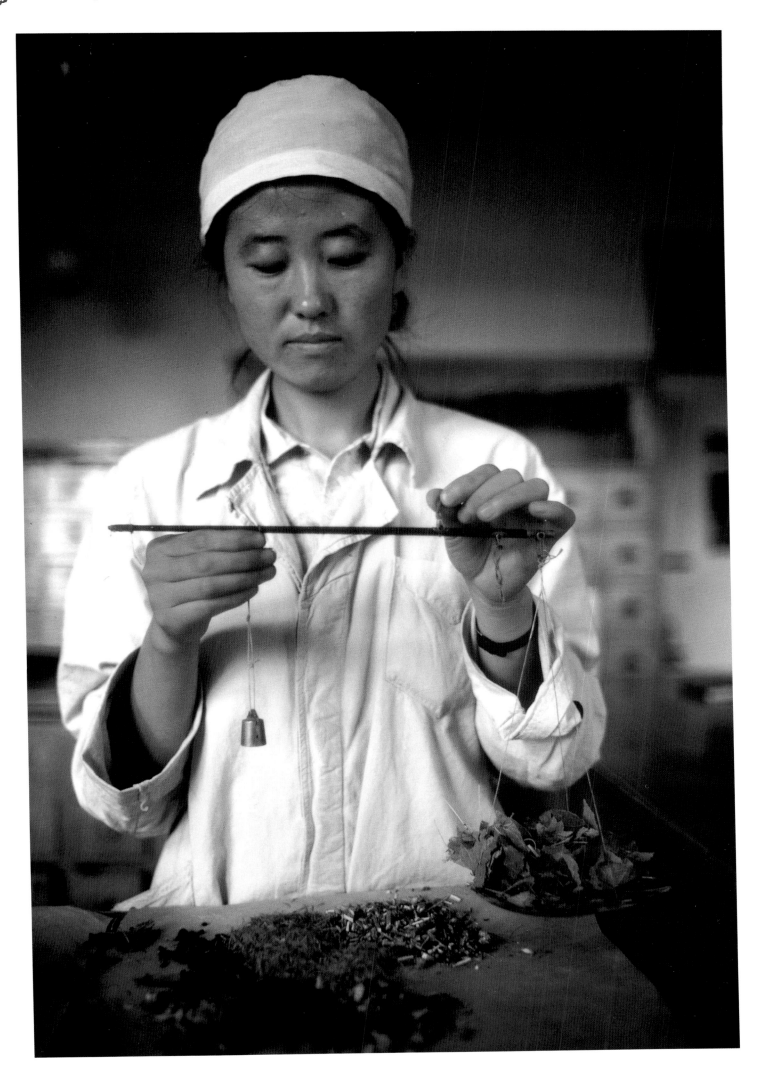

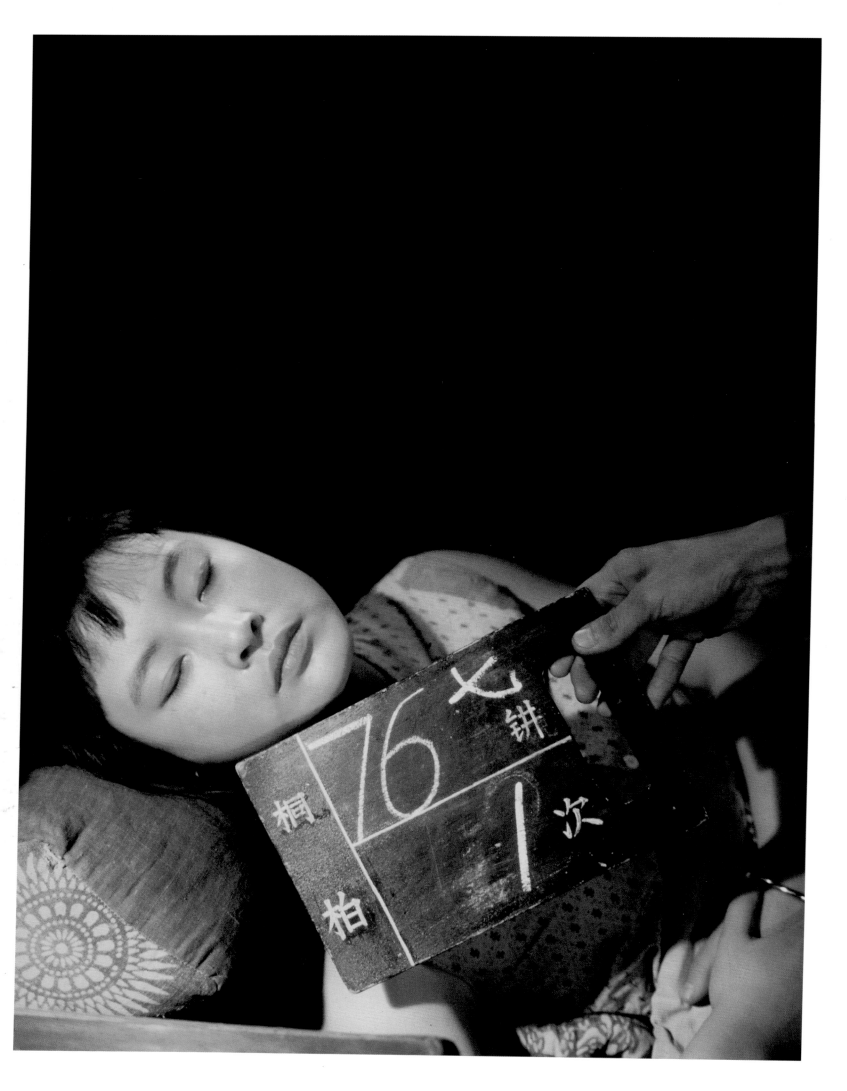

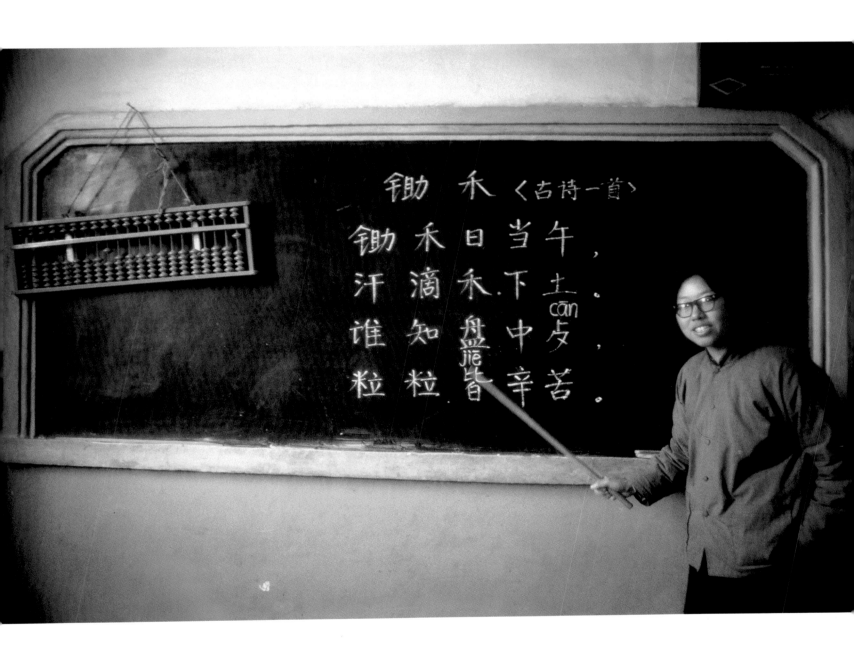

鋤 禾 〈古诗一首〉

鋤 禾 日 当 午 ，
汗 滴 禾 下 土 。
谁 知 盘 中 cān ，
粒 粒 皆 辛 苦 。

Chen Chong, film actress – first take

Teaching poetry

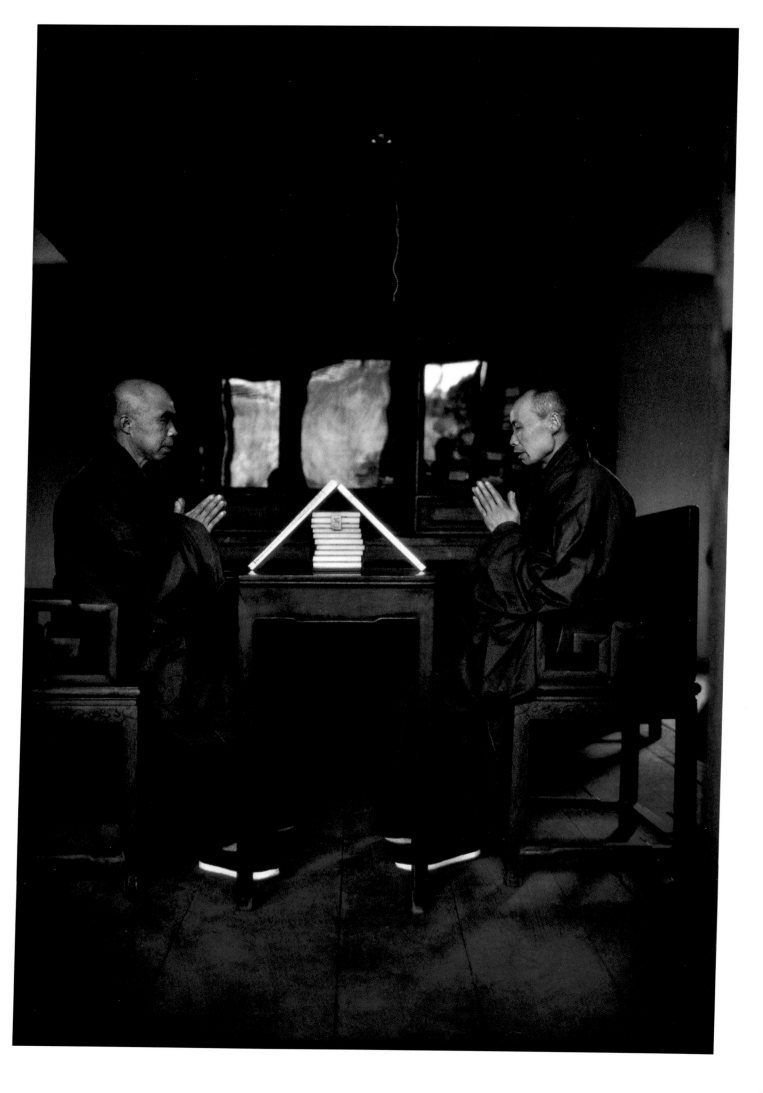

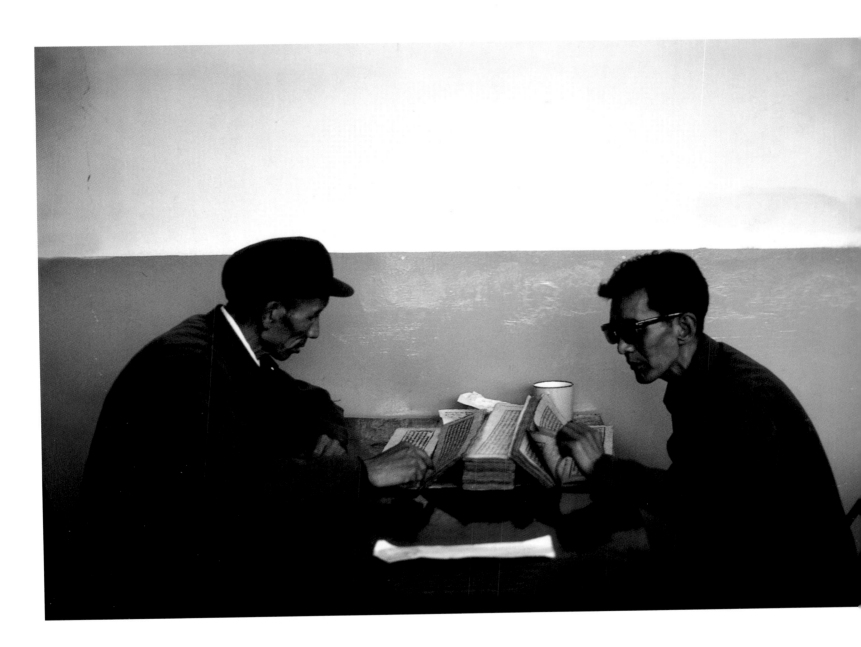

Soochow, Buddhist monks studying sutras/cold mountain monastery

Western trained doctors studying Tibetan medical texts

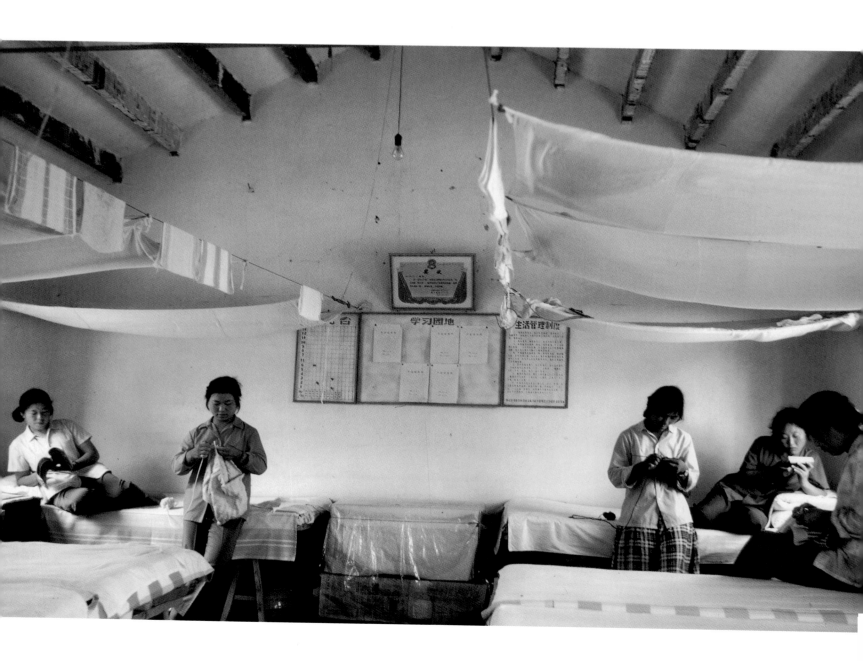

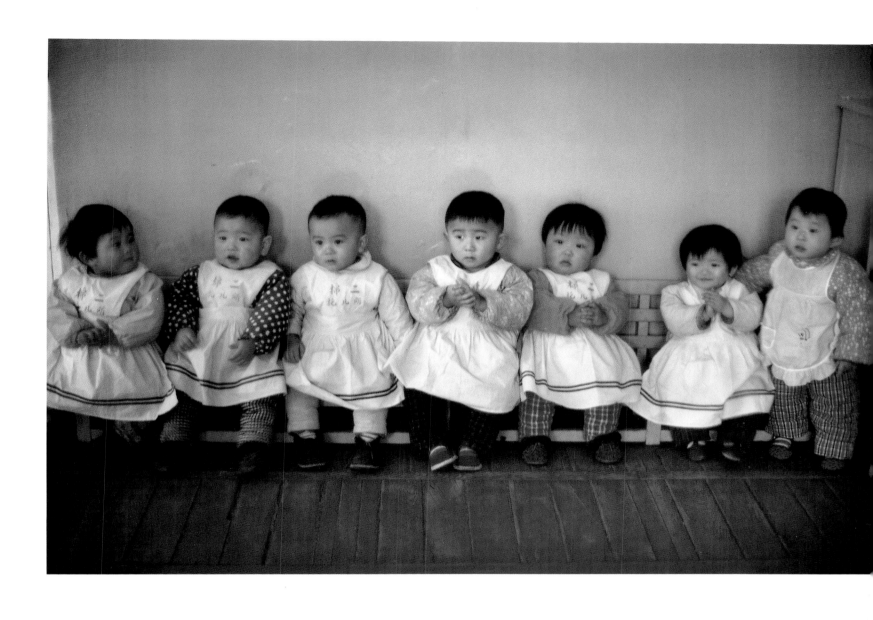

Dormitory for women oil workers

Peking, cotton-mill nursery

Peasant cadre preparing lunch

Making noodles

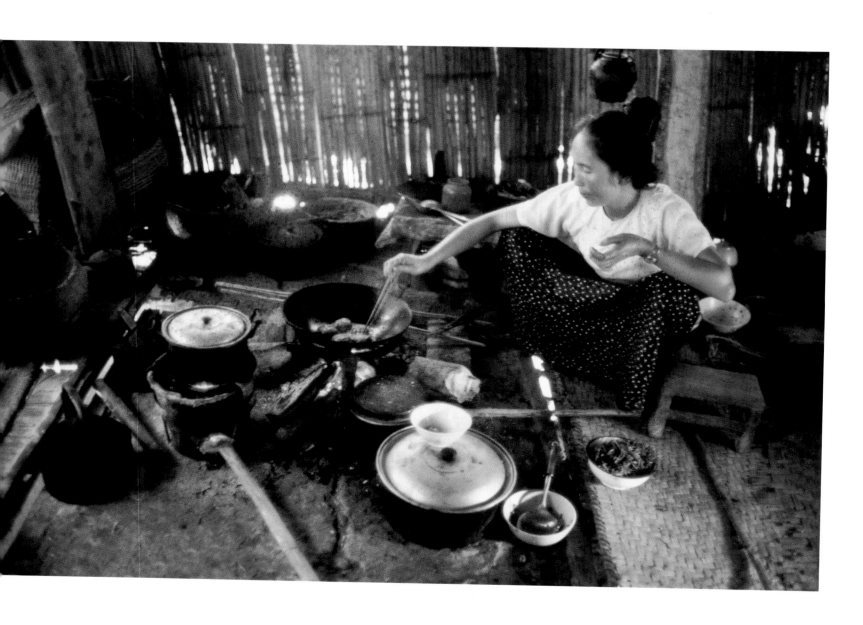

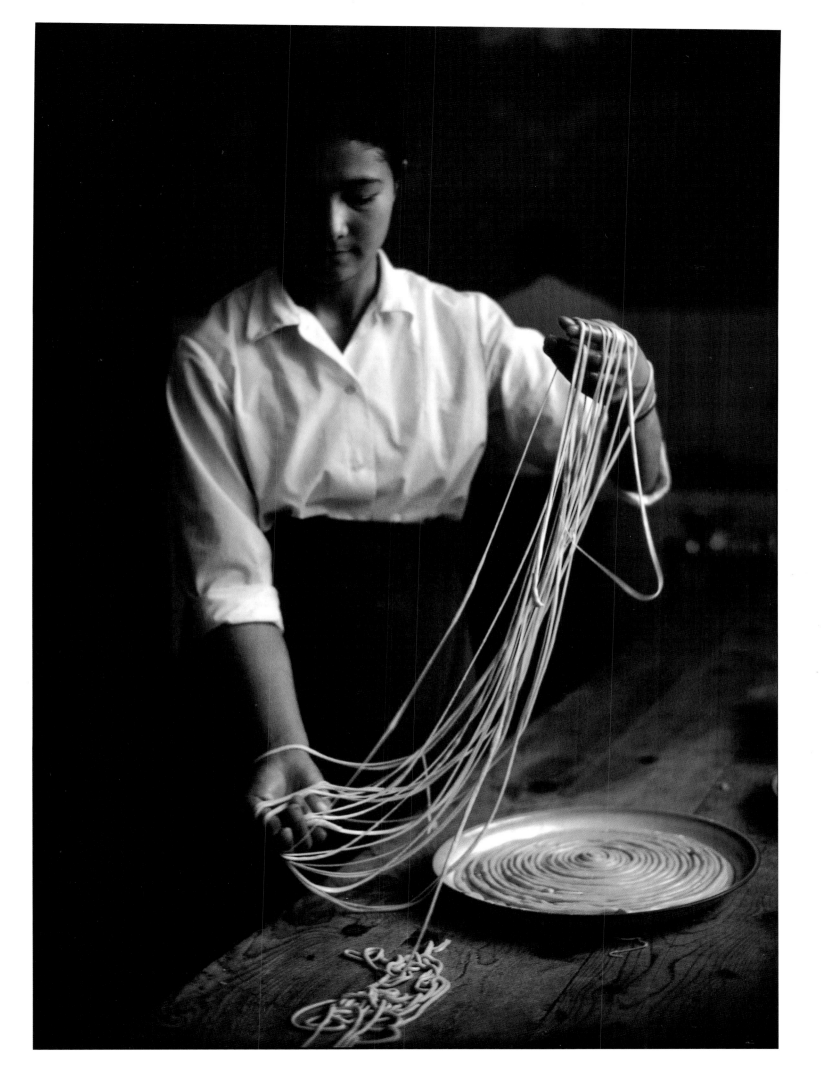

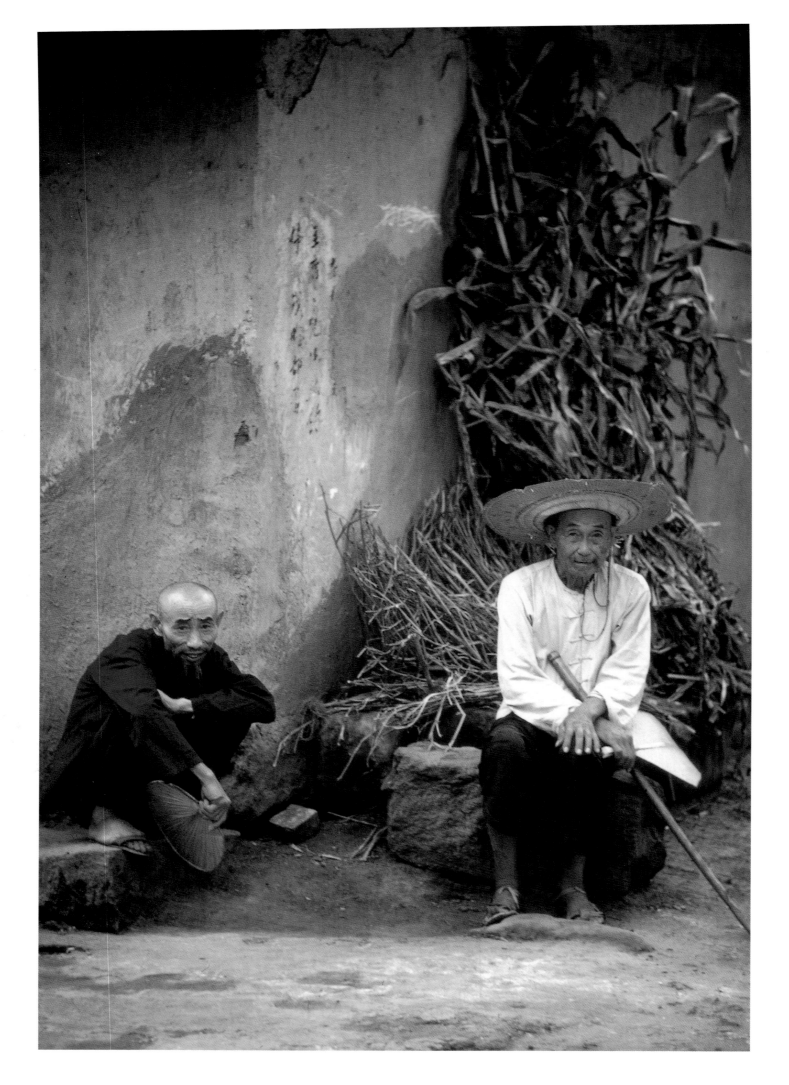

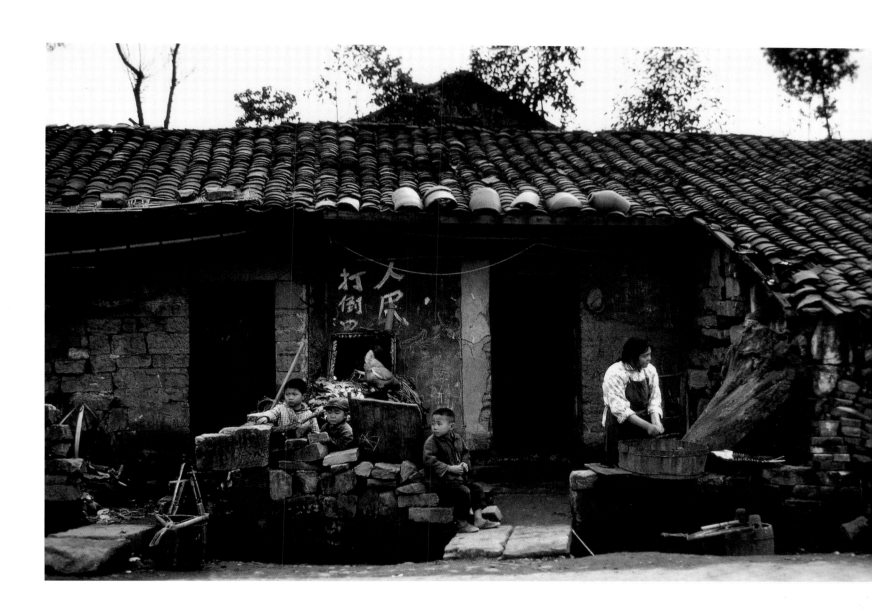

Retired peasants

Chungking, mother and sons

Retired worker

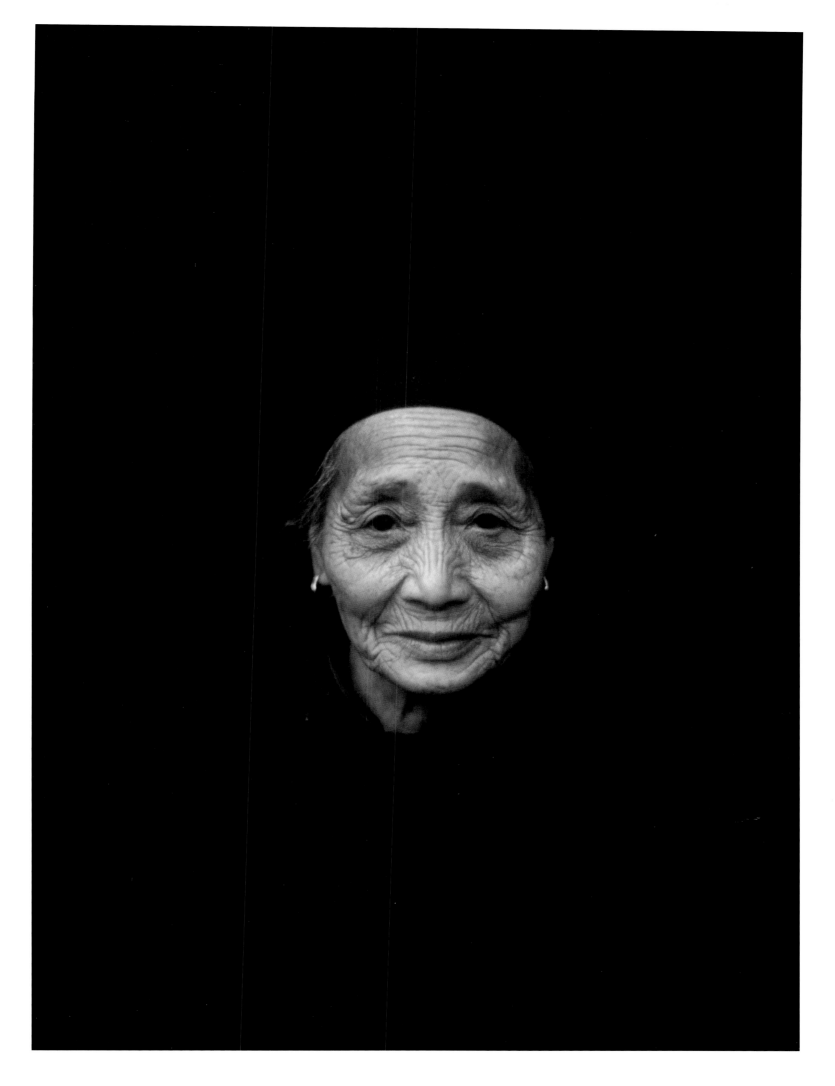

Lhasa, Tibet, playground of the Great Leap Forward

Sian, mother bringing newborn baby from maternity

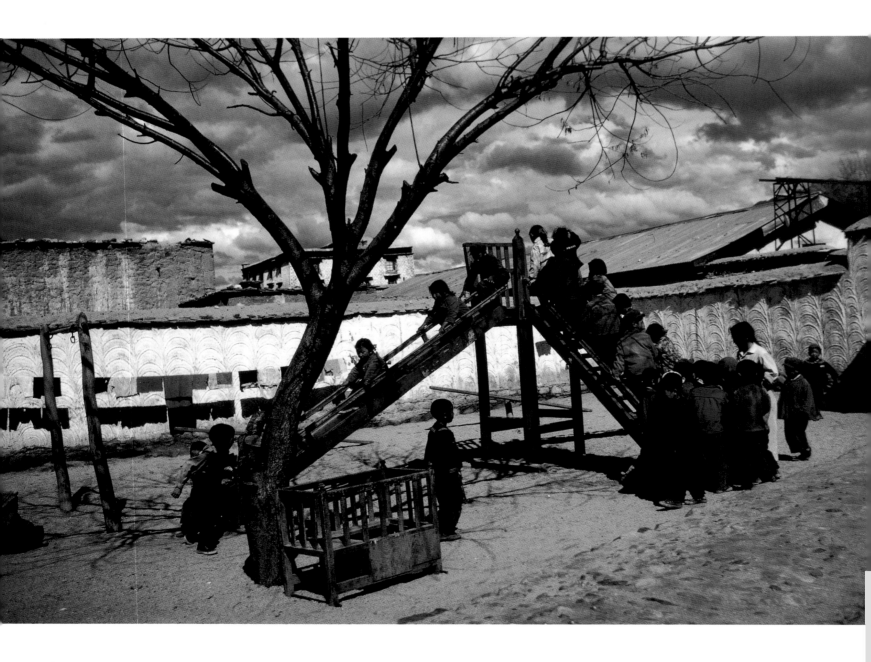

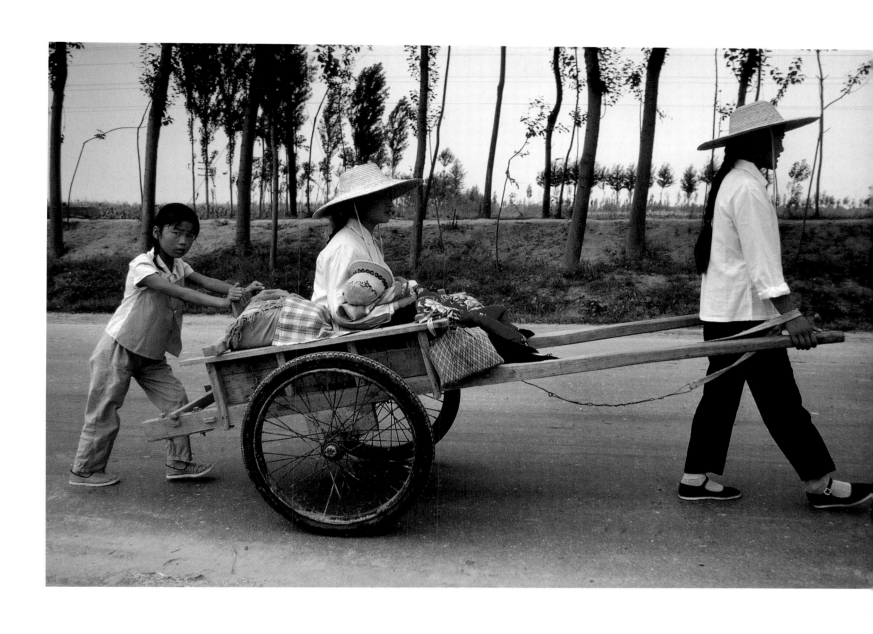

Inner Mongolia, general store ▷

Militia of Golden River White Horse Company singing a folk song ▷▷

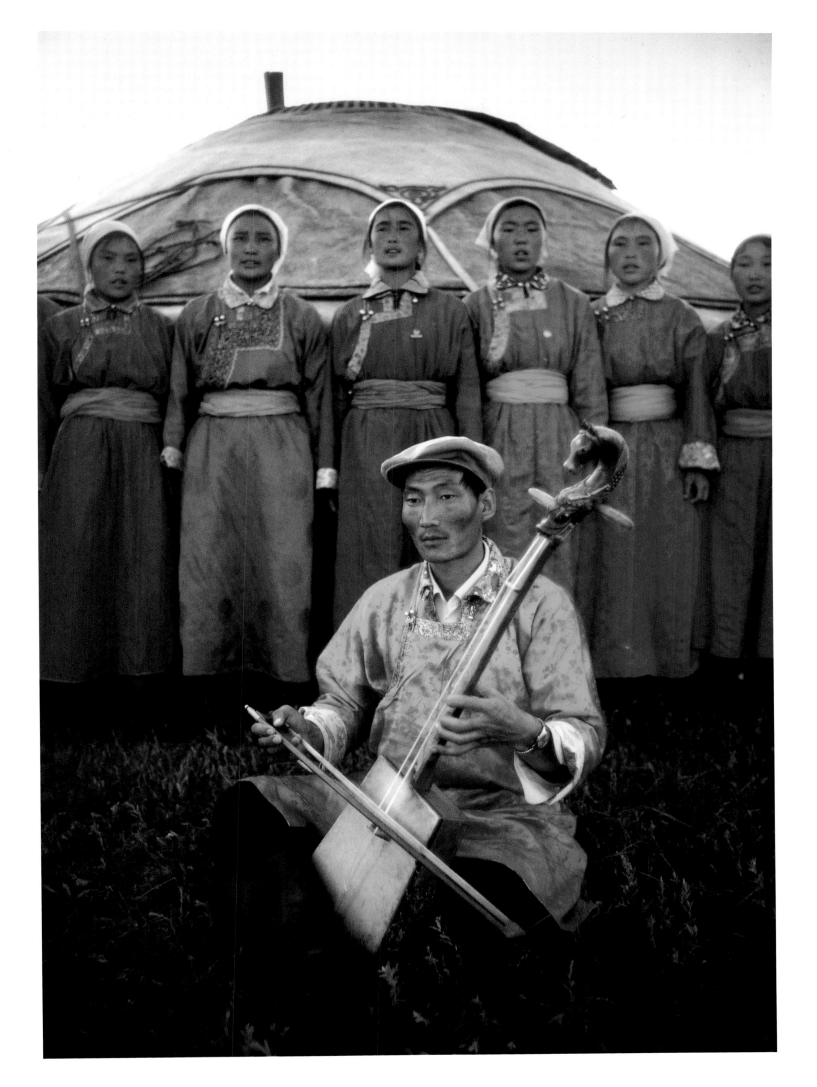

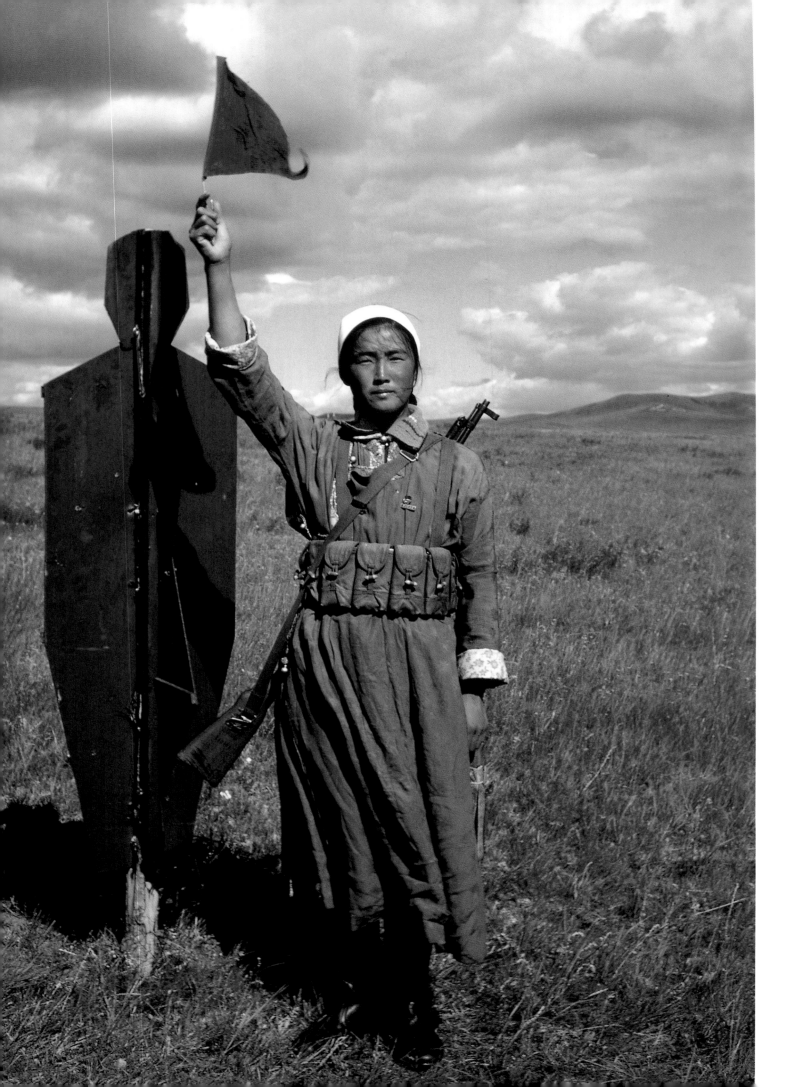

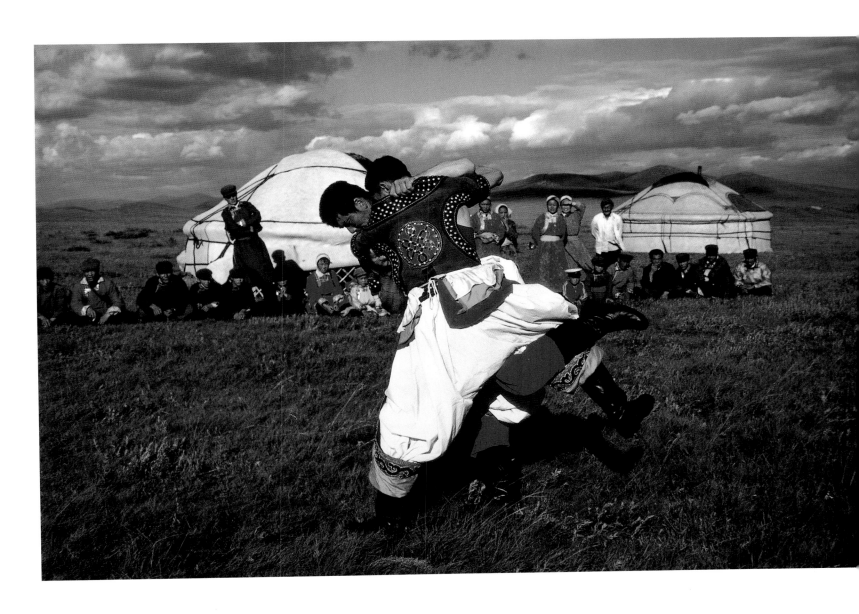

Inner Mongolia, member of militia

Inner Mongolia, wrestling

Song and dance troupe

Television

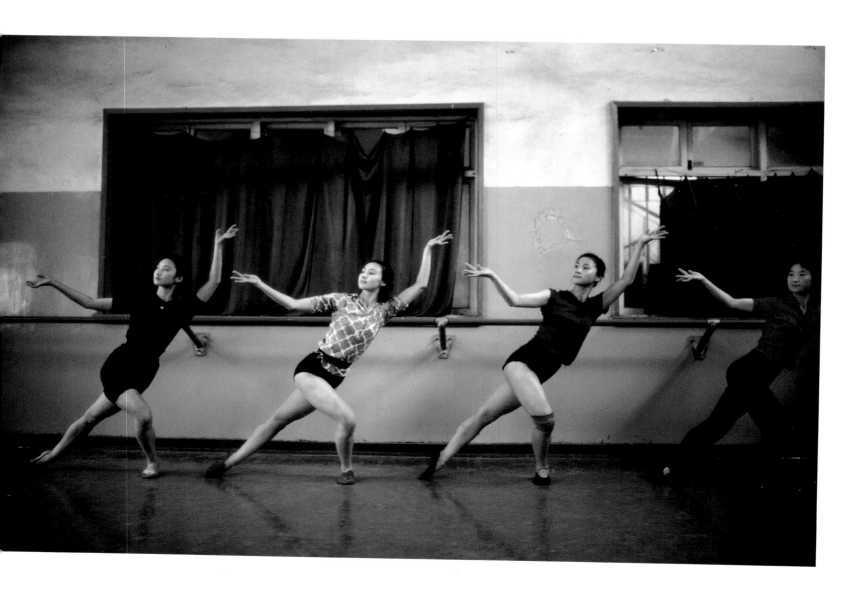

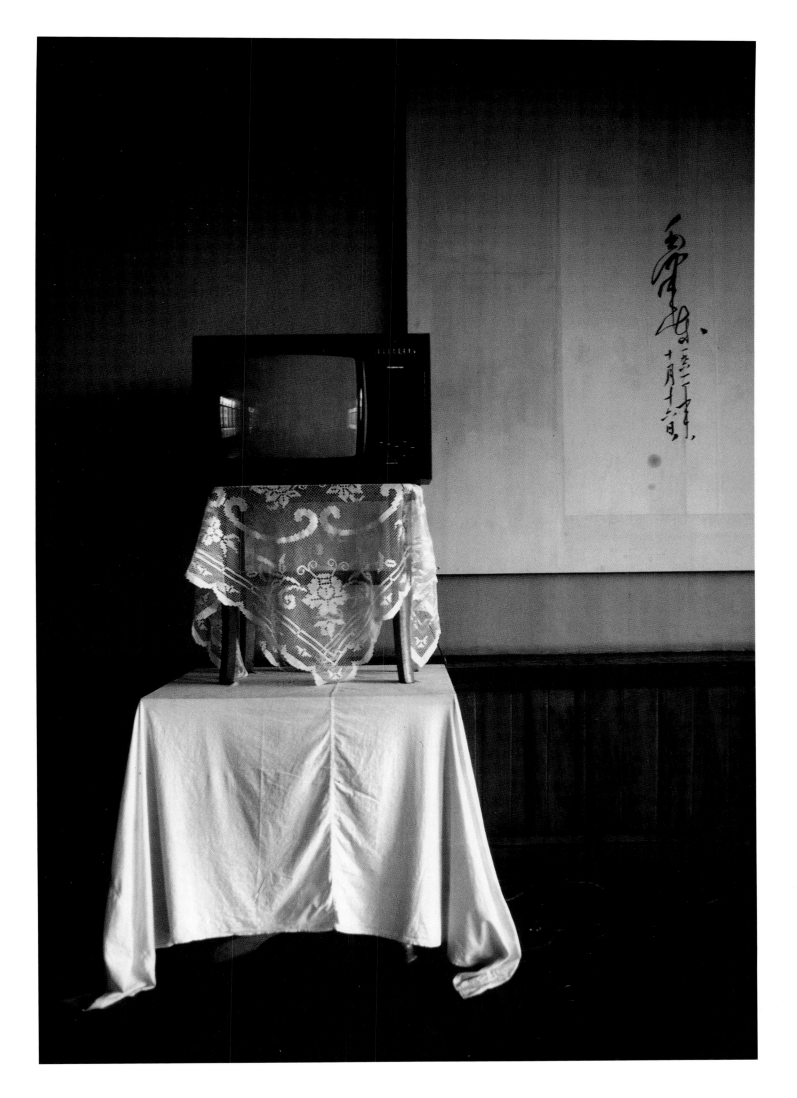

Born in Antwerp, Martine Franck spent her childhood in the United States. After studying art history at the University of Madrid and then at the École du Louvre in Paris, she began her photographic career as assistant to Eliot Elisofon and Gjon Mili at *Life*. In 1970 she was a member of the first Vu agency and was one of the founding members of the agency Viva before joining Magnum in 1980.

She has photographed many artists and writers and specializes above all in humanitarian reportage, having worked closely with Les Petits Frères des Pauvres since 1985. Another area close to her heart is theater, having photographed every production of the Théâtre du Soleil since its foundation by her friend, Ariane Mnouchkine. Among her many books and exhibitions, *One Day to the Next*, a retrospective volume published in 1998, gives an overview of the breadth of her work: from the 1967 portrait of sculptor Étienne Martin, who seems made of the same material he is working with, and the extraordinary trio of women in the 1970 Ariane Mnouchkine production of *1789*, through the 1987 group portrait of the Collège de France, her moving portraits of the lonely and the elderly, known and unknown, to children, and vast, cosmic landscapes. Martine's latest projects have been a series on Tory Island, off the coast of Ireland, and another on "Tulkus"—the young reincarnations of great Tibetan lamas, and how they are brought up and educated to grow into and continue the work of their predecessors.

Martine's work is marked by honesty, delicacy, and respect for her subjects. Most moving to me is the little 1998 book of photographs which was—and is—her tribute, on his ninetieth birthday, to Henri Cartier-Bresson, to whom she has been married since 1970.

Curiously, after all our years in Magnum, it was when I had pretty much given up photographing, having become a Buddhist nun, and Henri had pretty much exchanged the camera for drawing, that we became friends and I got to know Martine. It started in New York in the 1980s, continued in Paris in 1992, Nepal and Bodhgaya in 1996 when Martine came to work on her "Tulkus" and we went to Bodhgaya together to a nuns' meeting, bracketed by ghastly drives on India's lorry-choked Grand Trunk Road. Next a delightful Easter at their home near Avignon, and back in Paris. Martine has come again to Nepal and we have been in touch via fax and now, lately, by email.

In a fax exchange with John Berger which is the Foreword to *One Day to the Next*, Martine says: "The camera is in itself a frontier, a barrier of sorts that one is constantly breaking down so as to get closer to the subject. In doing so you step over limits; there is a sense of daring, or going beyond, of being rude, of wanting to be invisible. To cross on to the other side, you can only get there by momentarily forgetting yourself, by being receptive to others; hence, as a photographer, I am in two different worlds at once. That is all I can really say about what I feel when photographing—the rest remains in the domain of the unconscious." Elsewhere she speaks of "the mystery of life, the unexpected side of reality that is constantly taking us by surprise, off our guard. I think, basically, that is why I never get bored photographing." And again: "A photograph is not necessarily a lie, but it isn't the truth either. It's more like a fleeting, subjective impression. What I like about photography is precisely the moment that cannot be anticipated, one must be constantly on the alert, ready to acclaim the unexpected."

Yes, as she works, Martine is the invisible photographer (though not in the case of the Collège de France group portrait where the eminent gentlemen are quite obviously responding to their charming photographer—the two ladies perhaps less so). But in the end we photographers cannot get away from it—we *are* there. As Martine herself says: "A photograph is a subjective impression." It is what the photographer sees. No matter how hard we try to get into the skin, into the feeling of the subject or situation, however much we empathize, it is still what we see that comes out in the images, it is *our* reaction to the subject, and in the end the whole corpus of our work becomes a portrait of ourselves. Brava Martine!

Marilyn Silverstone

◁ Anne-Marie Rodgers, 1997

Landscape, 1993

On the ferry  to Tory Island, 1993

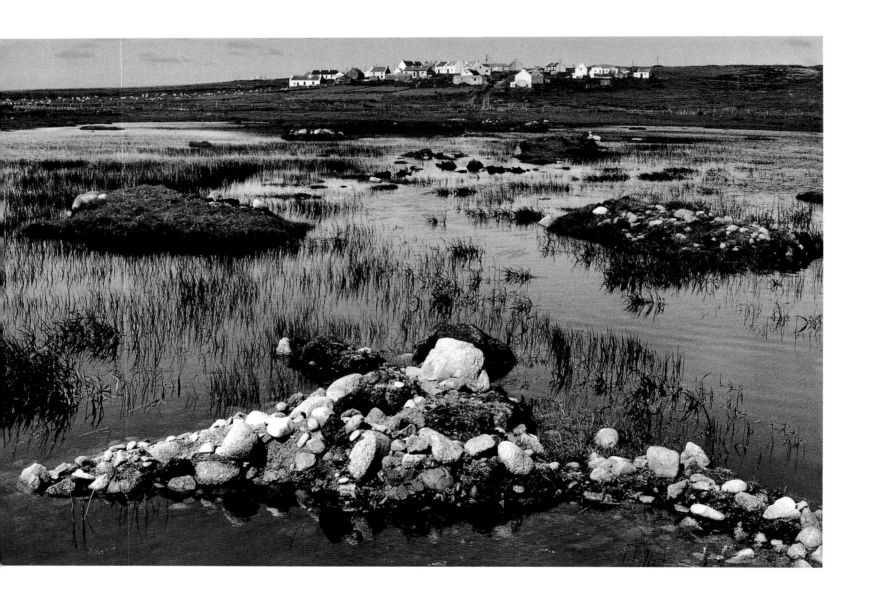

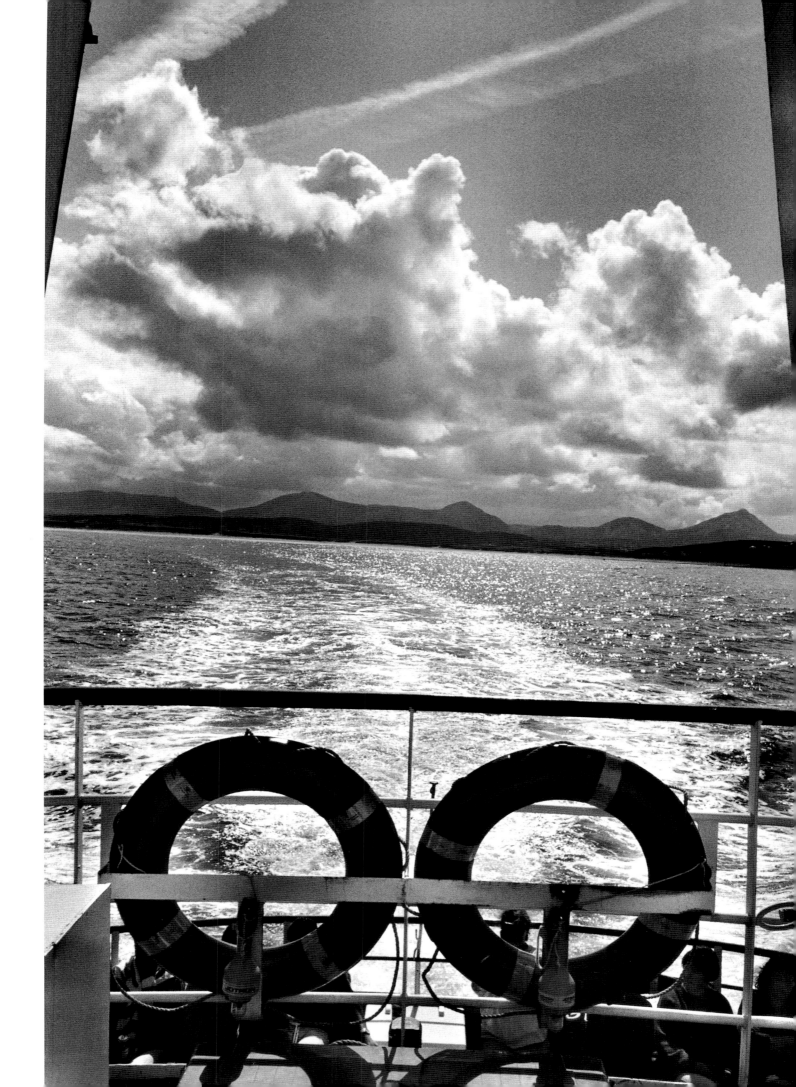

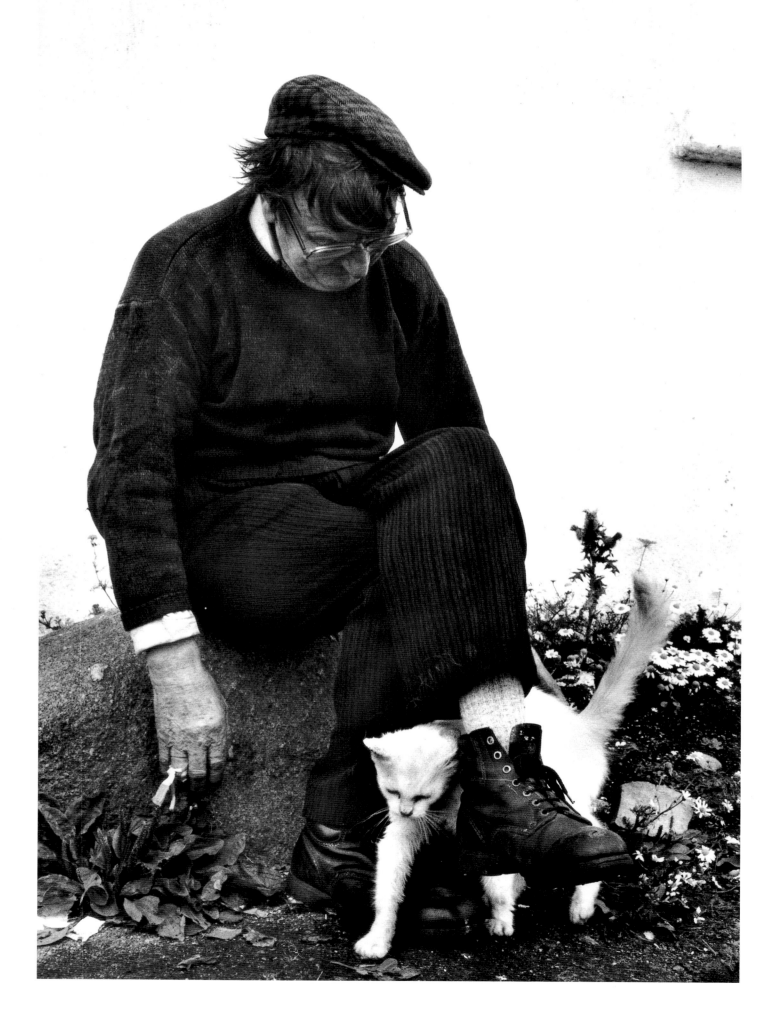

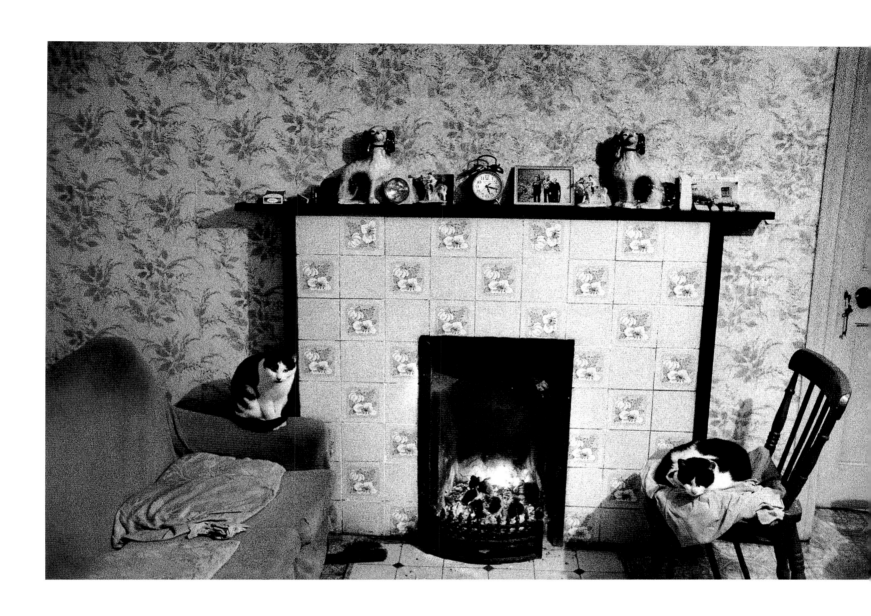

Jimmy Doohan with cat, 1993

John Meenan's living room, 1993

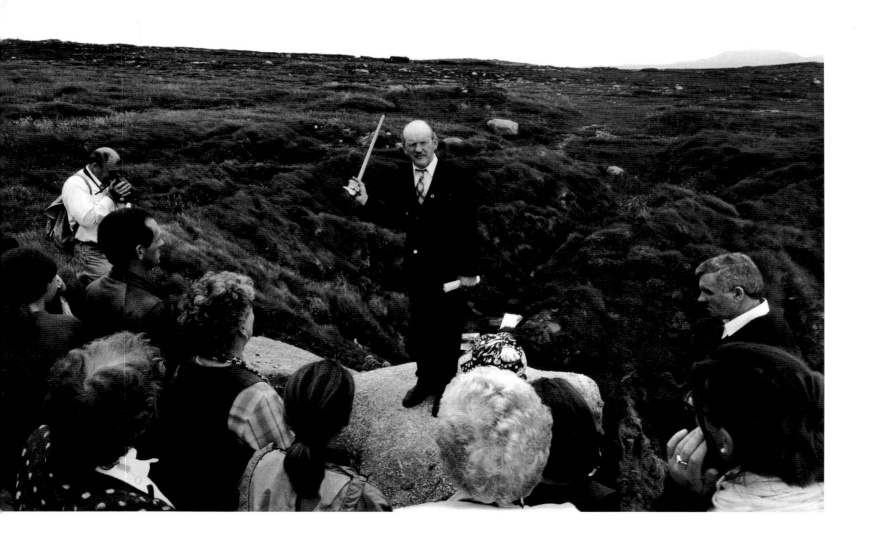

The king, Patsy Dan Rodgers, conducts a guided tour for the Historical Society of Donegal, 1994

Father Francis McAteer and the Tau Cross, one of only two such crosses in Ireland, 1993

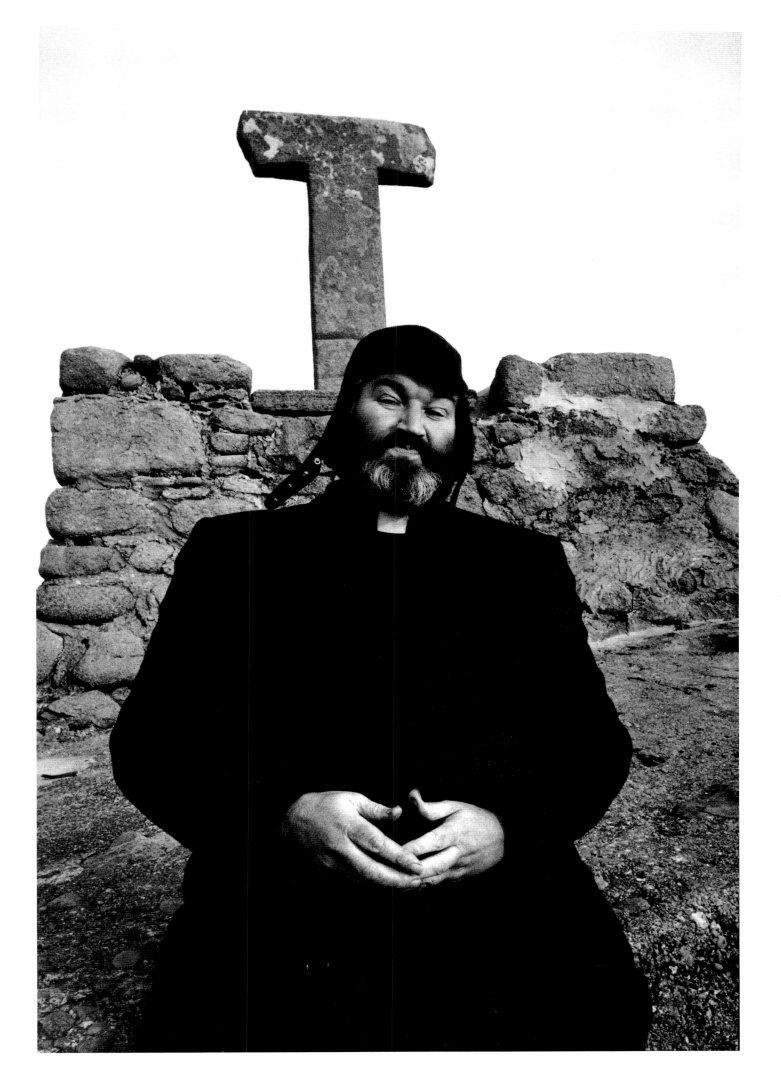

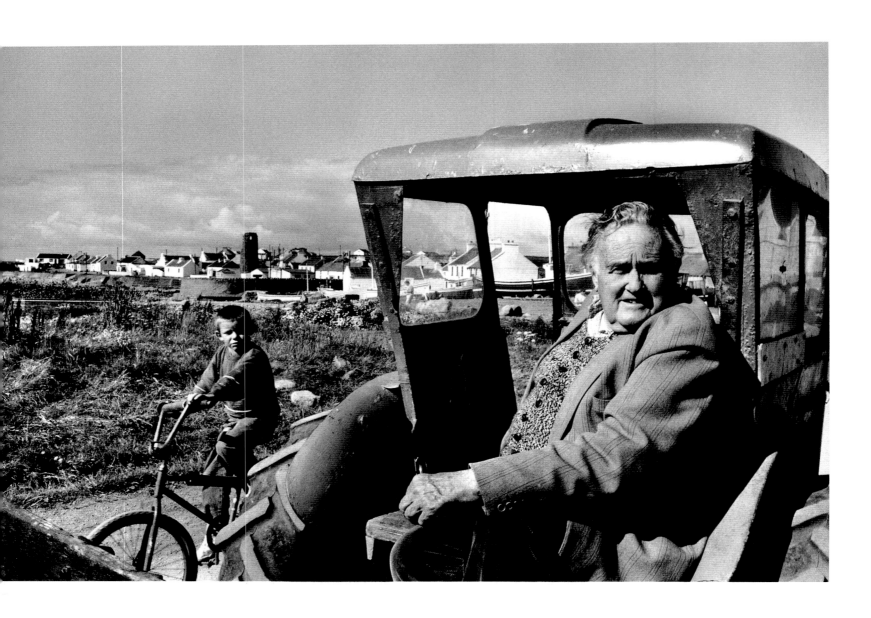

Derek Hill, the English painter, who has lived on Tory for many years and who introduced the photographer to the island, 1996

West Town with the tower of the former monastery which was founded by St. Colmcille, 1993

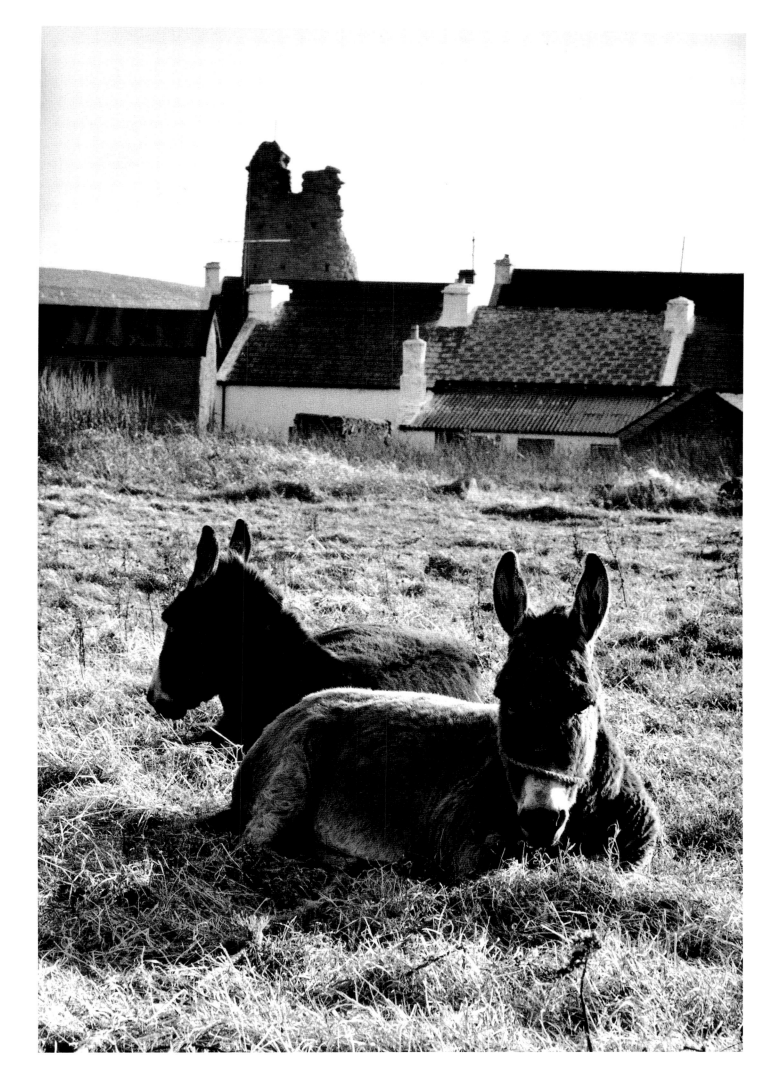

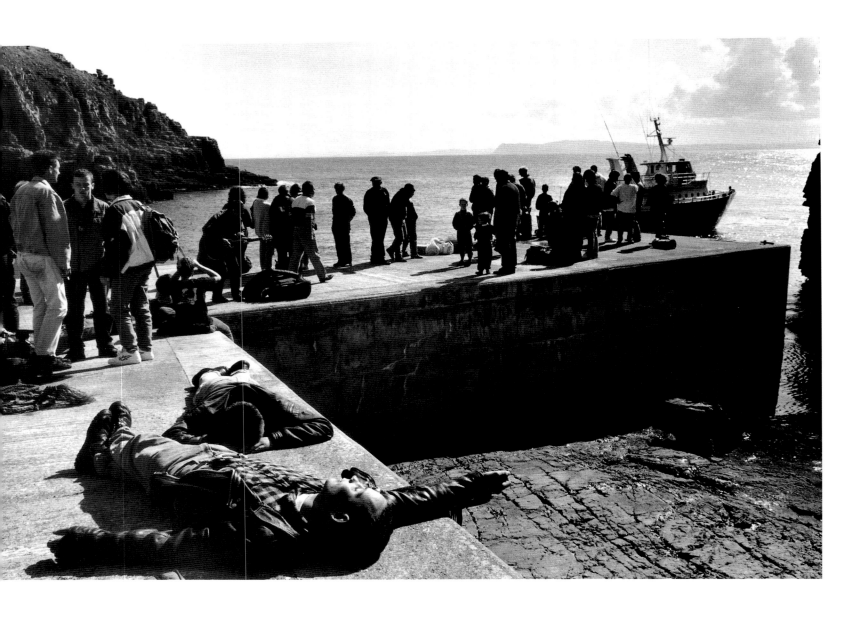

Waiting for the ferry, 1994

Arrival of the ferry "Lifeline Tory", 1994

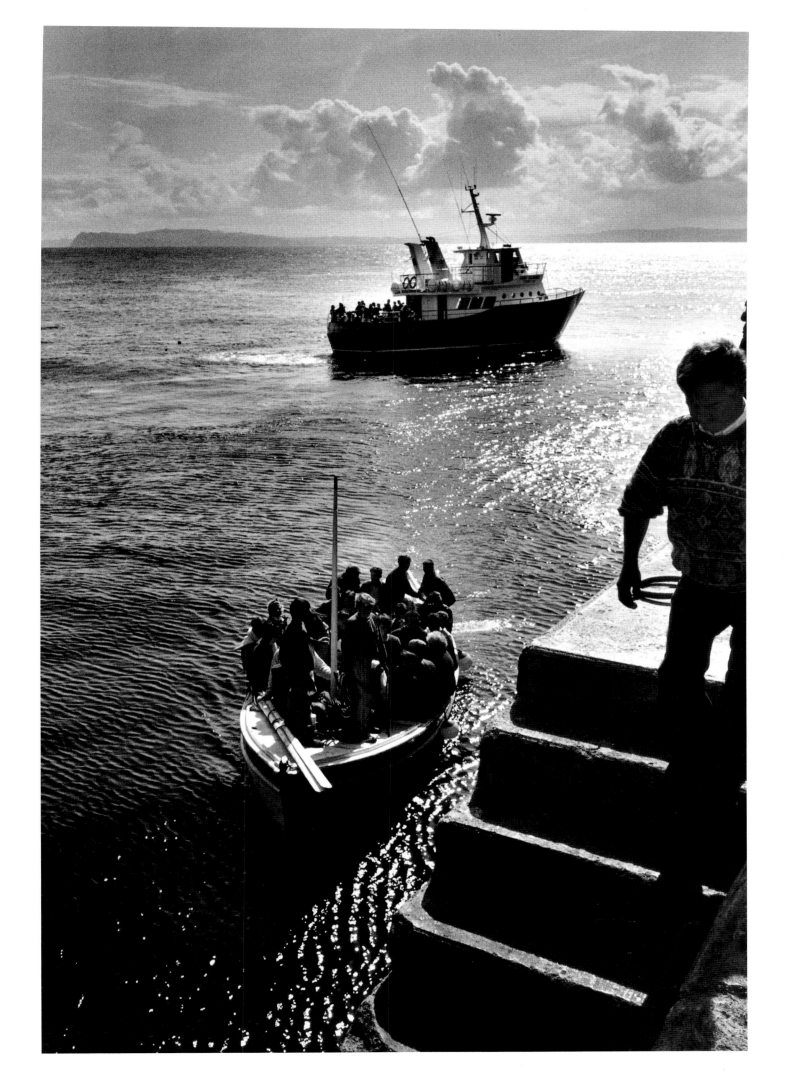

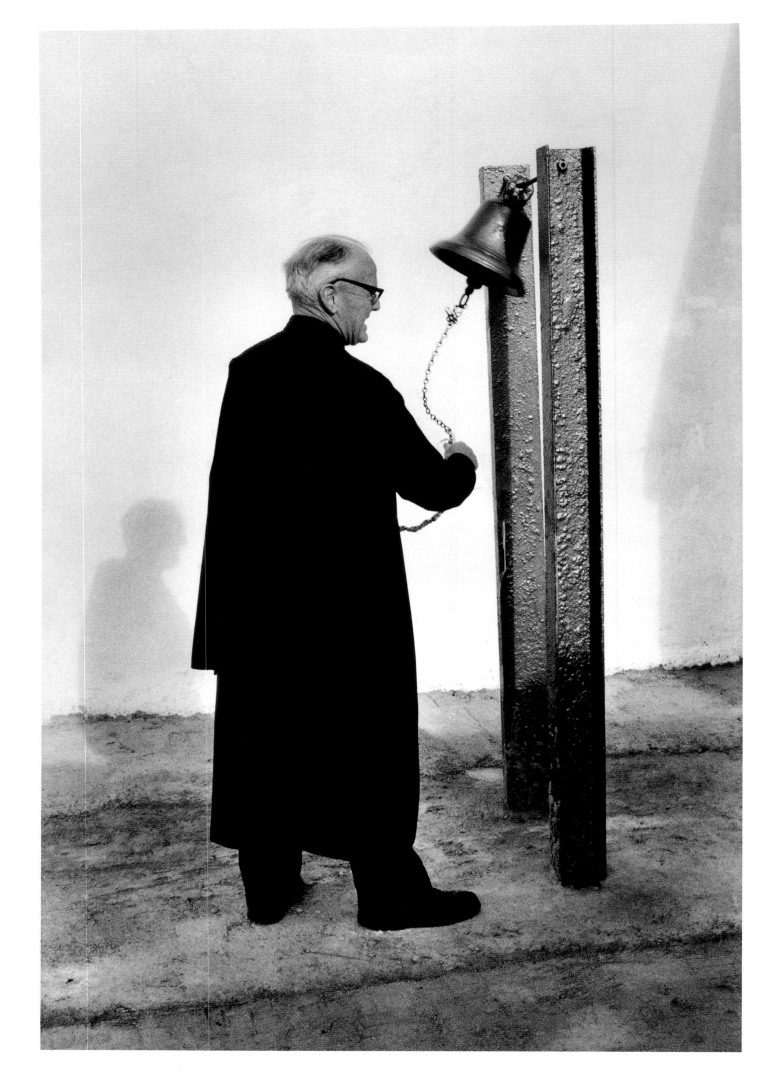

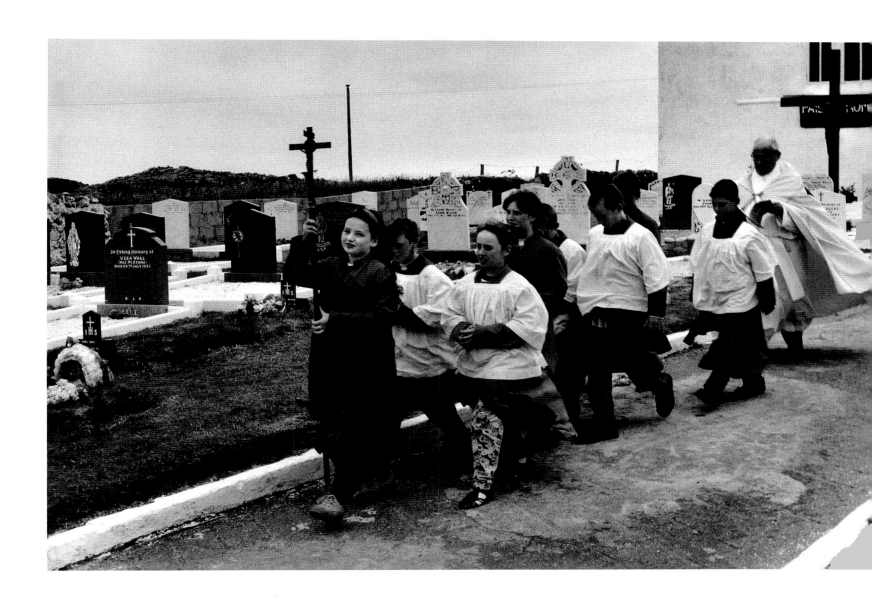

Father O'Neill ringing the bell for mass, 1994

Mass for the Holy Souls, Feast of the Assumption, 1996

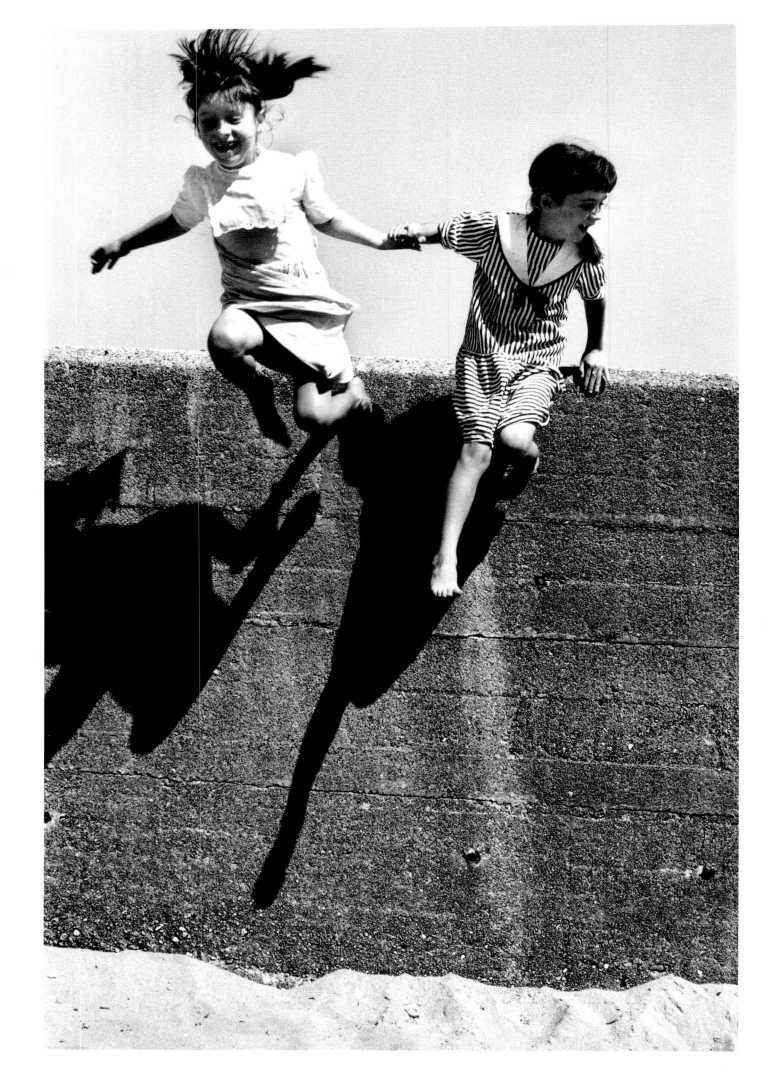

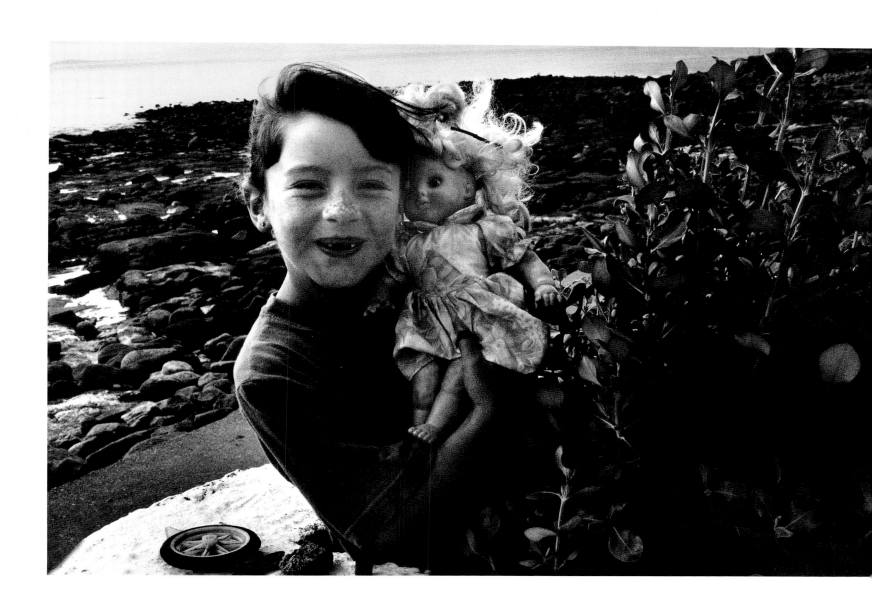

Anne Bridget Rodgers and Grainne Doohan, 1995

Anne Bridget Rodgers, 1995

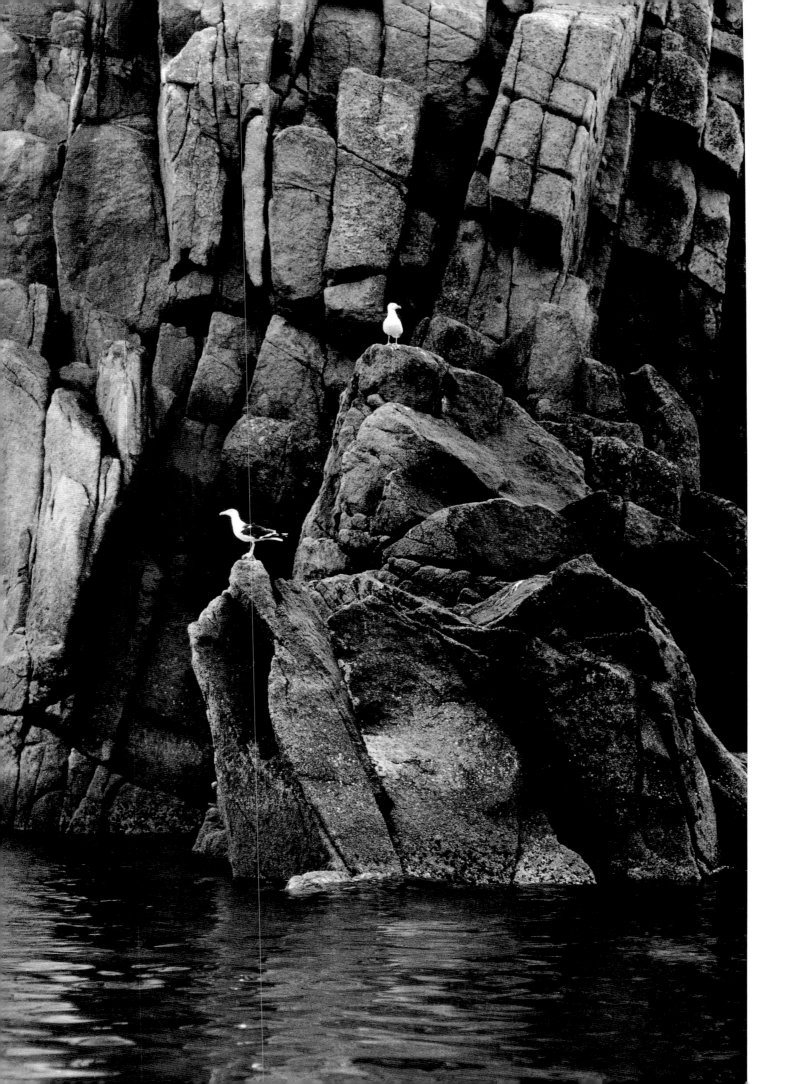

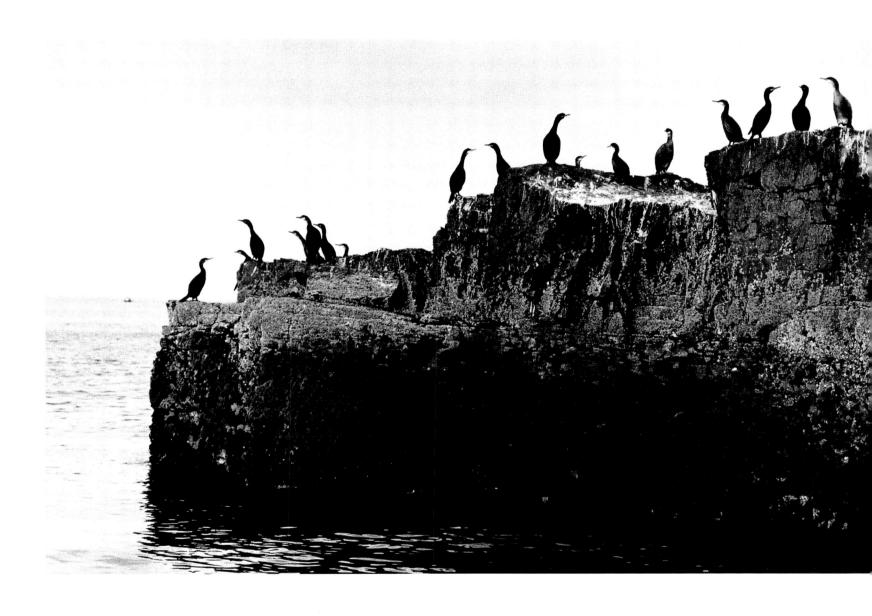

Seagulls on the northern coast, 1995

Cormorants on the northern coast, 1995

A house on Tory Island, 1996

The wedding of Tory Islander Pauline Doohan to Brian Gallagher, 1996

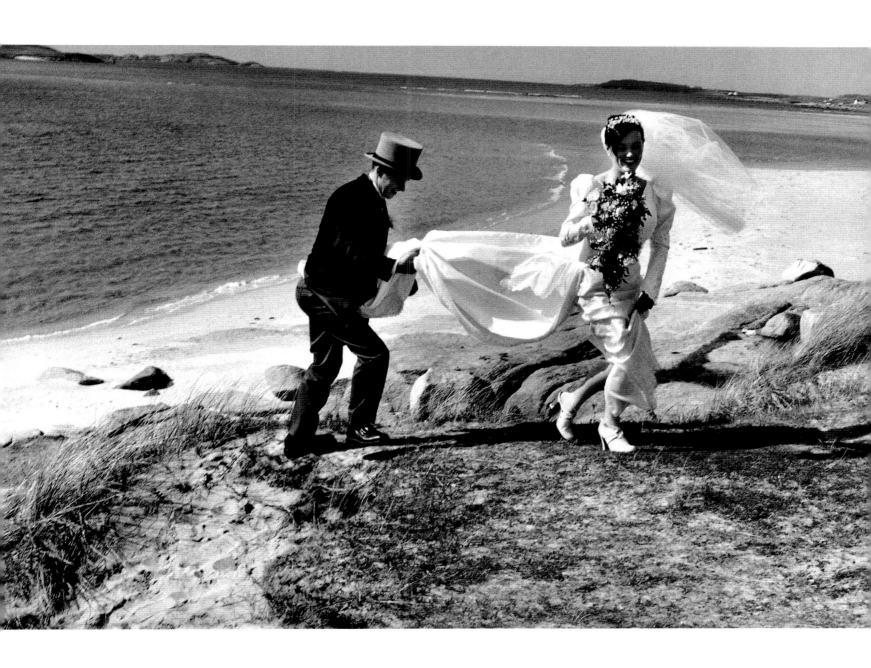

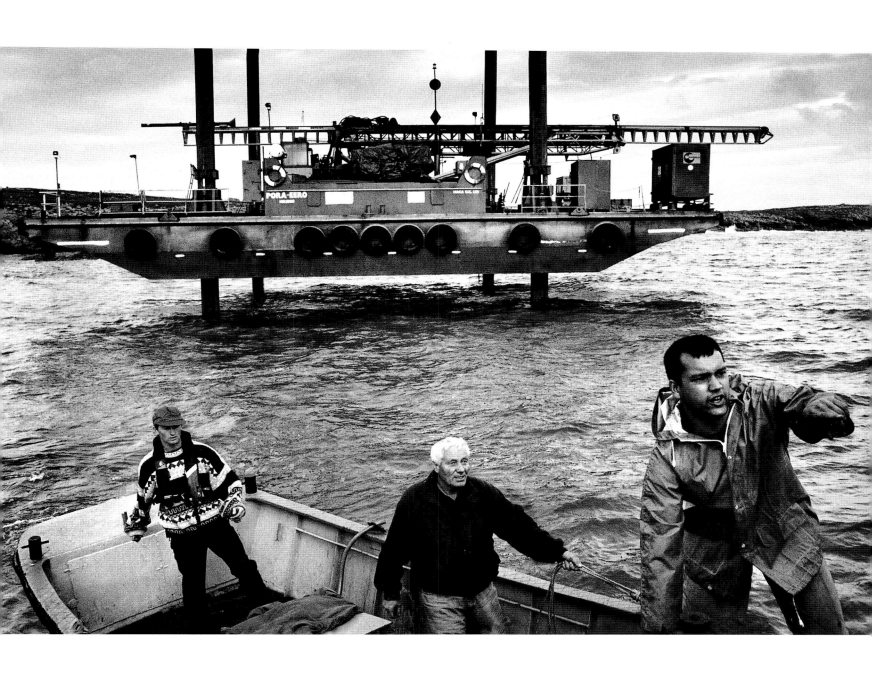

Eamonn Rodgers putting the finishing touches to his boat, 1995

Working on the new port, which is being built with aid from the European Community, 1997

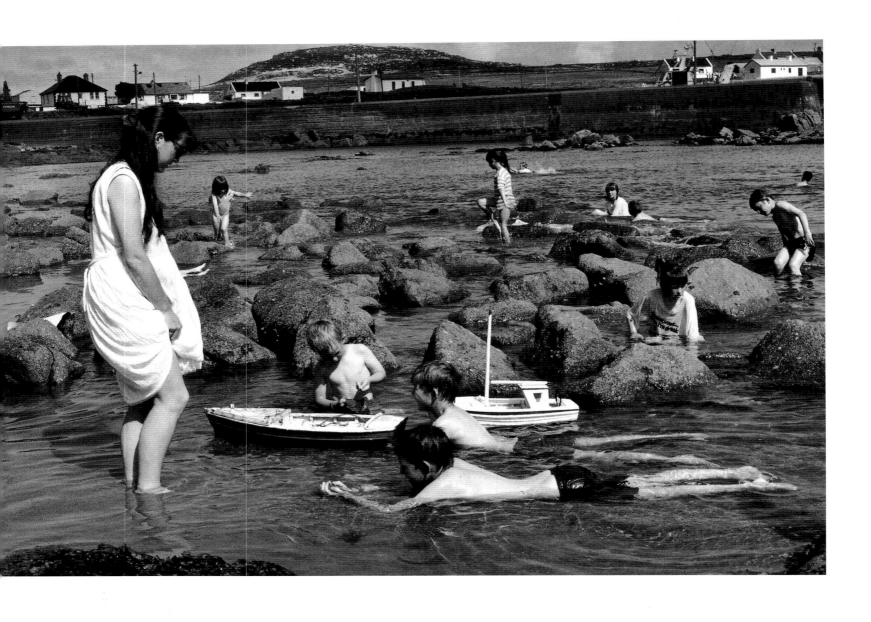

Children playing in the West Town, 1996

Children playing in the rocks at low tide, 1996

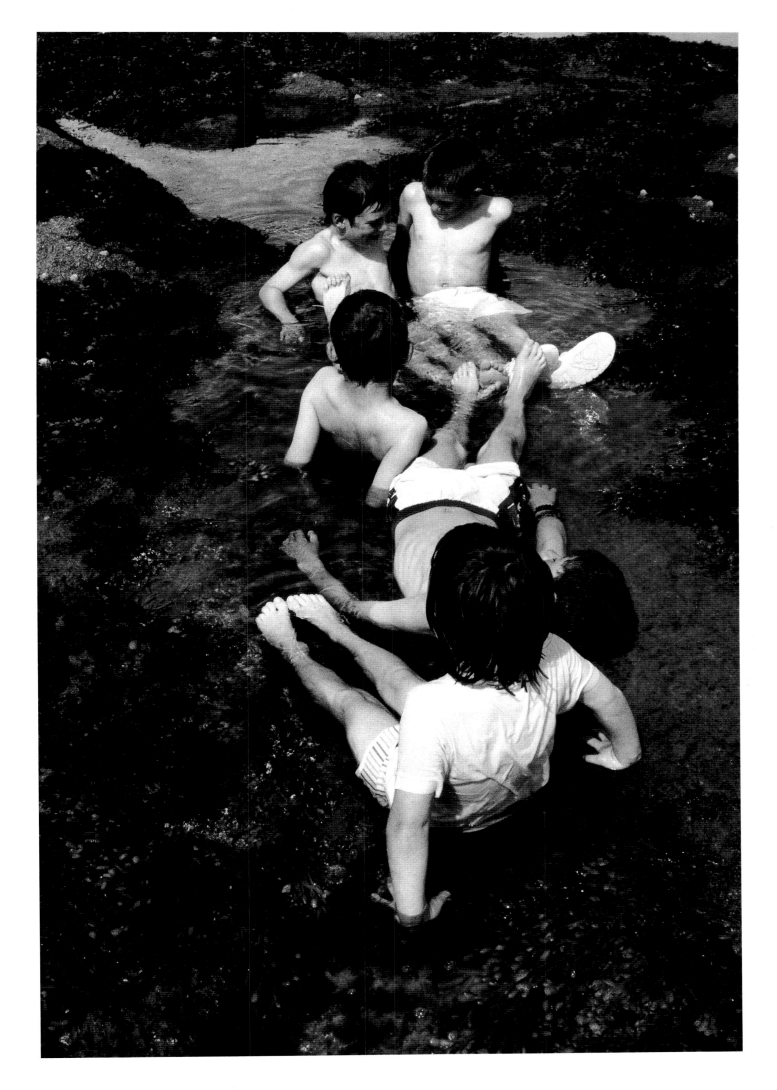

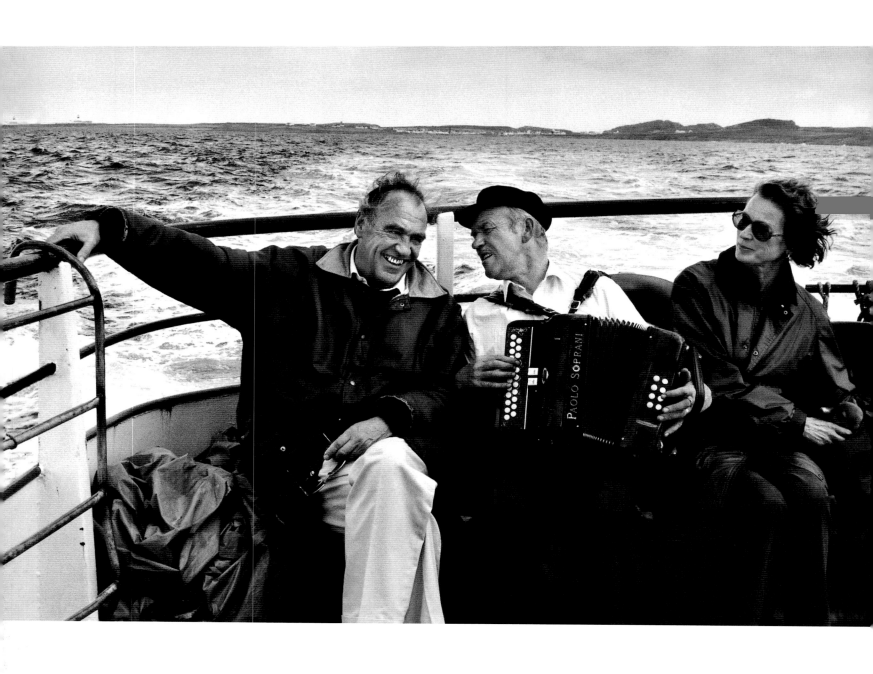

Patsy Dan Rodgers, Anne and Harry Erne on the ferry, 1996

Gerry Adams, Sinn Fein president, on vacation, 1996

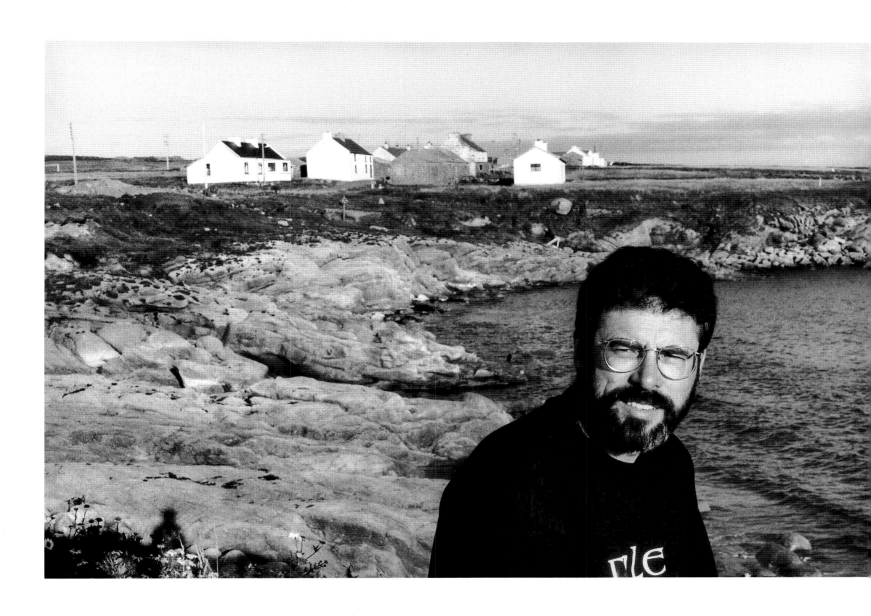

Patrick Meenan in his tractor, 1996

Father O'Neill walking his dogs, 1997

East coast, 1996

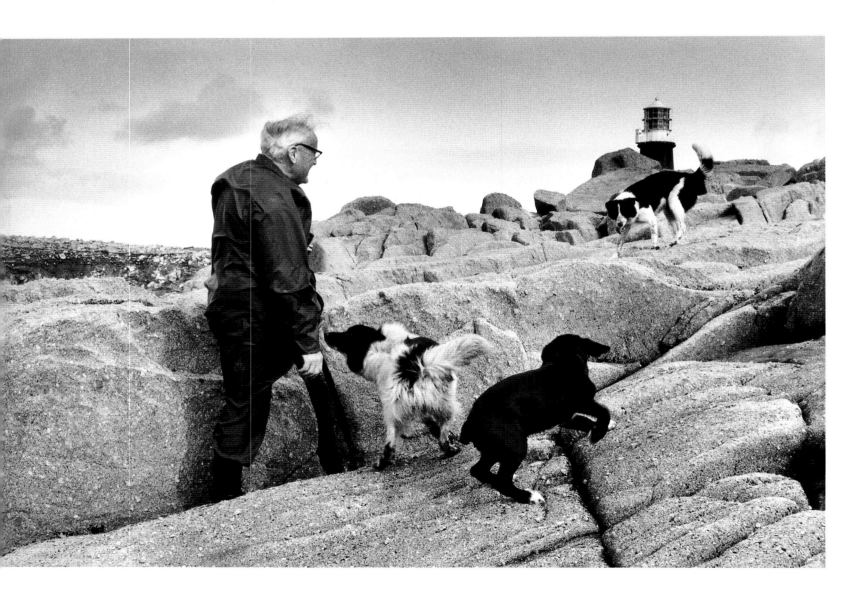

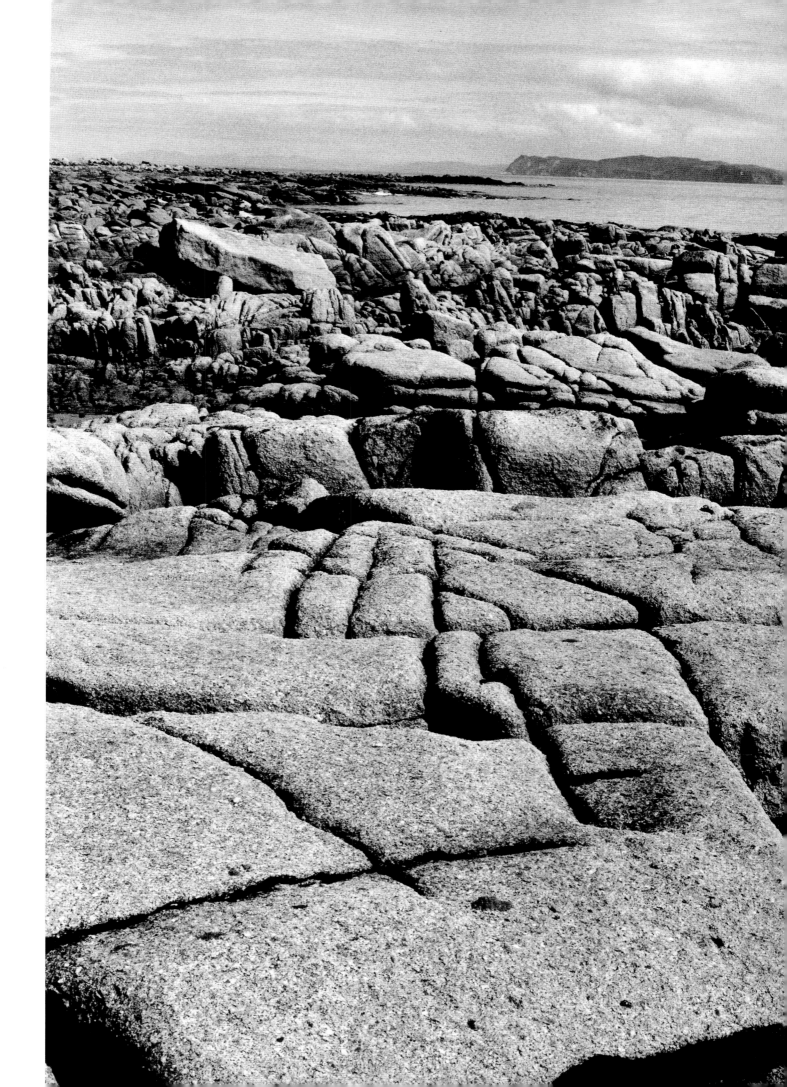

Patrick Meenan, 1997

Paul Rodgers with a portrait of his father, Patrick Rodgers, former king of the island, painted by Anton Meenan, 1993

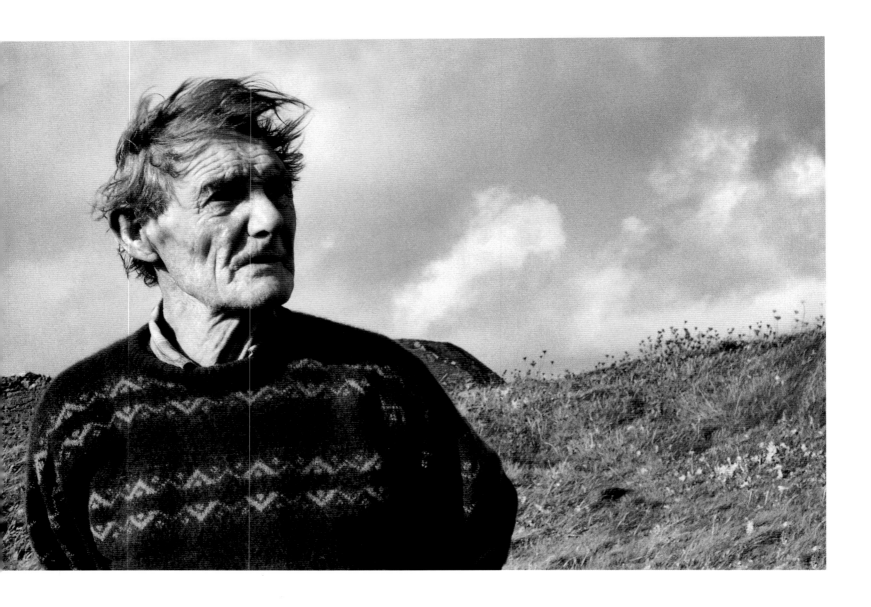

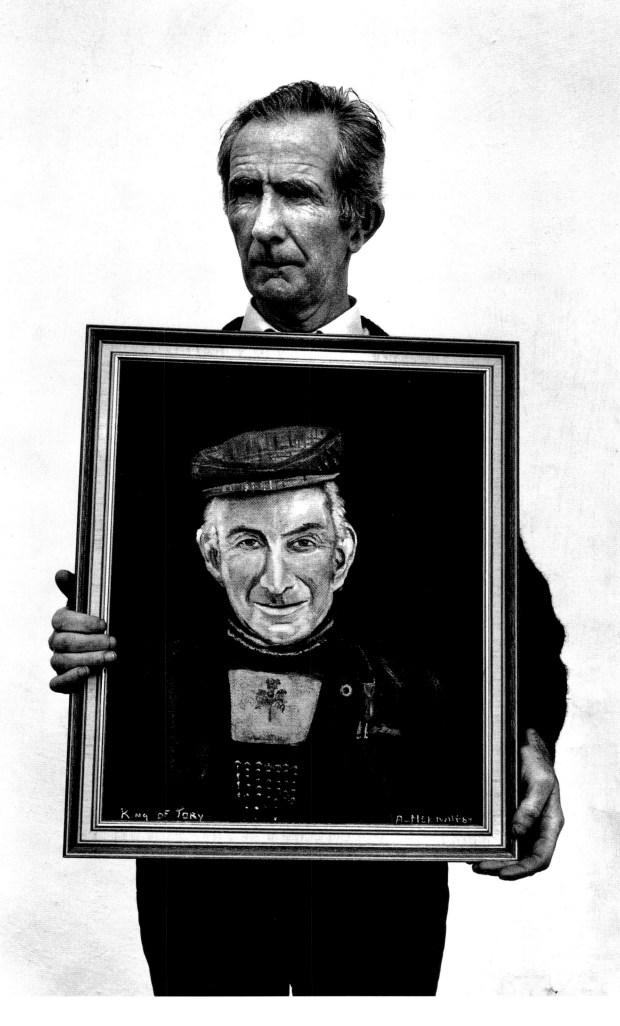

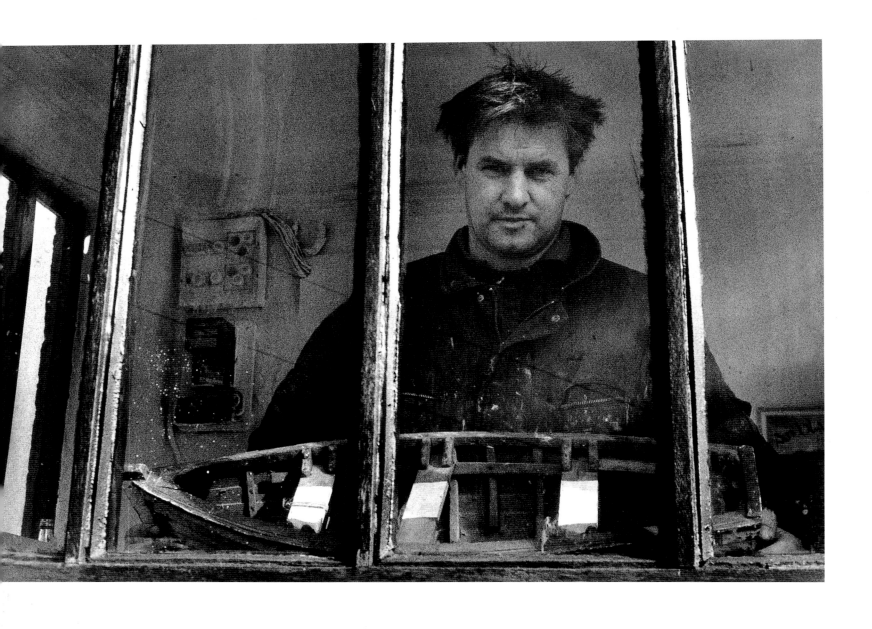

Painter Anton Meenan in the late James Dixon's house, which is now an art gallery, 1997

East village, Jimmy Diver Dooley's house, 1996

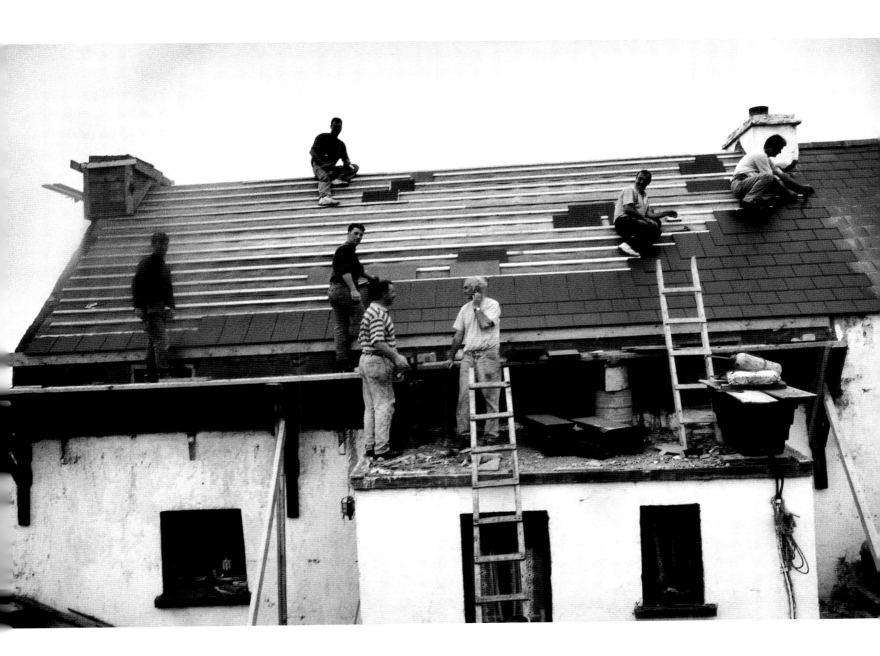

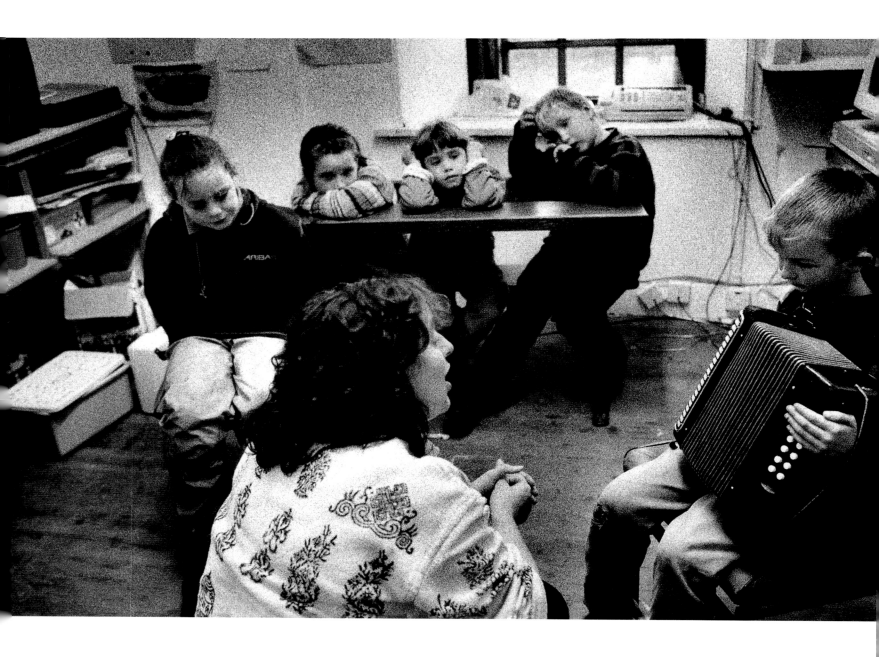

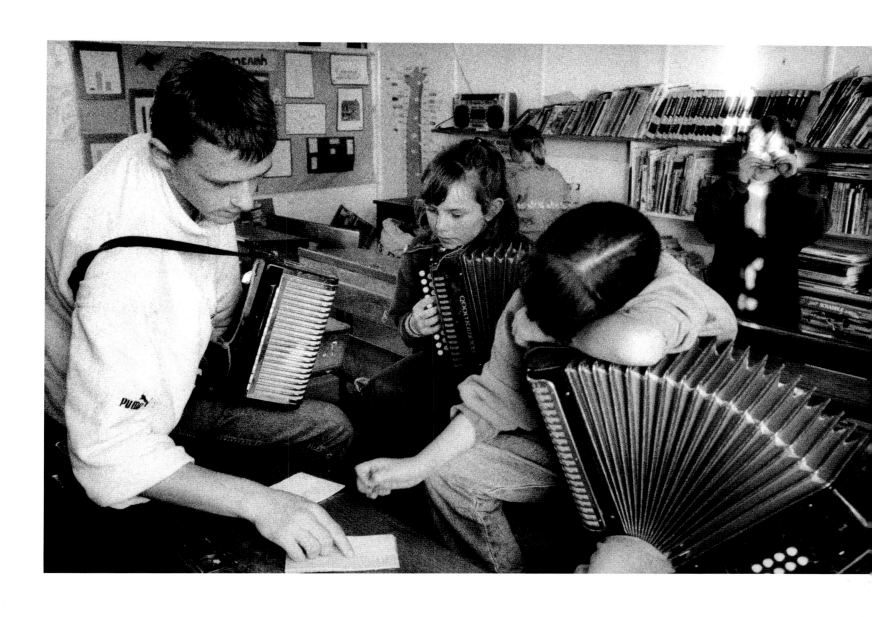

Teacher Mary Clare McMahon gives an accordion class, 1997

Accordion lesson, 1997

Ancient well of St. Colmcille's monastery in West Town, 1997

Winter storm, 1997

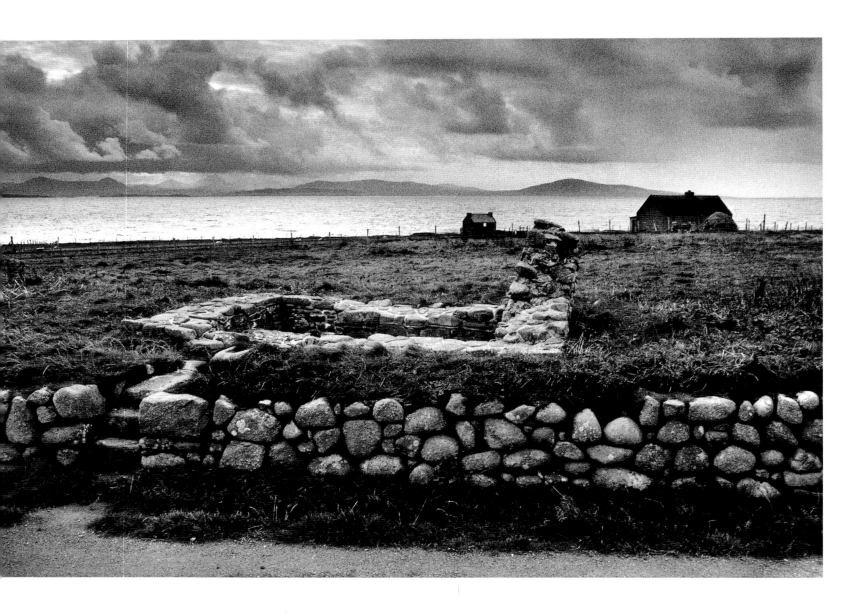

The newspapers have arrived, 1997 ▷

# Susan Meiselas

Susan Meiselas is an amazon with a social conscience and a sense of history. What her eye (and therefore her camera) catches are the injustices of the world, dictatorships, wars, and their victims.

I first met Susan when she joined Magnum Photos in 1976. By then she had already accomplished a lot; she had worked as an assistant film editor on the Frederick Wiseman documentary "Basic Training", she had been photographic advisor to the Community Resource Institute developing curricula using photography and animated film, and had run workshops for teachers and children in the South Bronx. She had set up film and photography programs in rural Southern schools—supported by grants from the NEA and the State Arts Commissions of South Carolina and Mississippi. She had been a consultant to the Polaroid Corporation and in that capacity produced a source book of teaching ideas and projects using Polaroid photography in the classroom entitled "Learn to See". Finally she had developed a Bicentennial project collecting photographic and oral history for the exhibition "A Photographic Genealogy—the History of Lando", a company-owned mill town in South Carolina. All these early activities and preoccupations continue to be woven into the fabric of her work.

It is therefore somehow surprising that the first thing I knew she had done was a wonderful photographic essay focused on the lives of carnival strippers in New England. It was these pictures that provoked our curiosity and enthusiasm and made us invite her to join Magnum in 1976. The photographs stick in your mind. I remember especially a photograph of one stripper casually stepping over the naked body of another one relaxing on the floor. I recall studies of the greedy faces of male customers, of the fatigue of the girls in what seemed to be the small hours of the morning. She had been let into their trust with her camera, and managed to reach that state of near-invisibility and empathy that is required in the approach of delicate subjects.

New York is a big busy city. We do not meet each other as often as we should or would like to. I would always be happy to see Susan, appearing in a helmet and tight pants, pushing her bike out of the elevator and expertly stashing it wherever it would fit. Her gestures are rapid, purposeful, only the pushing back of her long straight hair, sometimes just with a shake of her head, introduces a bit of indulgence. There is no time for conversations beyond information on work, office matters (she soon would be a leader in these affairs), the showing of photographs, or a publication. I regret the passing of the early days when we seemed to have more time to sit in cafés or spend evenings together. Yet that does not prevent my feeling close to Susan, a closeness that comes out of our common dedication to our work, to our colleagues, to our ideals, maybe also because we are women.

Soon, Susan found one of the big subjects in her life as a photographer. She decided to go to Central America, shortly before the hostilities broke out, and then stayed to cover the insurrection with rare courage and insight. For many years Central America became the focus of her life. The extraordinary work she sent back was widely published; the faces of the guerrillas hidden under masks that resembled the made-up faces of girls looked at you from everywhere. Honors and prizes started to come her way. Her Nicaragua book appeared, followed two years later by a book for which she was editor and contributor, *El Salvador. The Work of Thirty Photographers.* In *Chile from Within* together with Chilean photographers she edited their work from the 1973 coup through the Pinochet regime. There was the Susan of the beginnings: the editor, the comrade, the planner and executor of projects. But now, also, the established photographer. There are many ways to photograph war—brutally, newsy, from the outside. Or, as Susan did, humanely, almost as an insider, understanding the roots. Another great endeavor by Susan was the compilation of an extraordinary book about the Kurds, documenting their history, their culture, their fate. This took years of labor and speaks, like all of Susan's work, of her vision and her fierce dedication.
Thank you, Susan, for constantly making us care more deeply.

Inge Morath

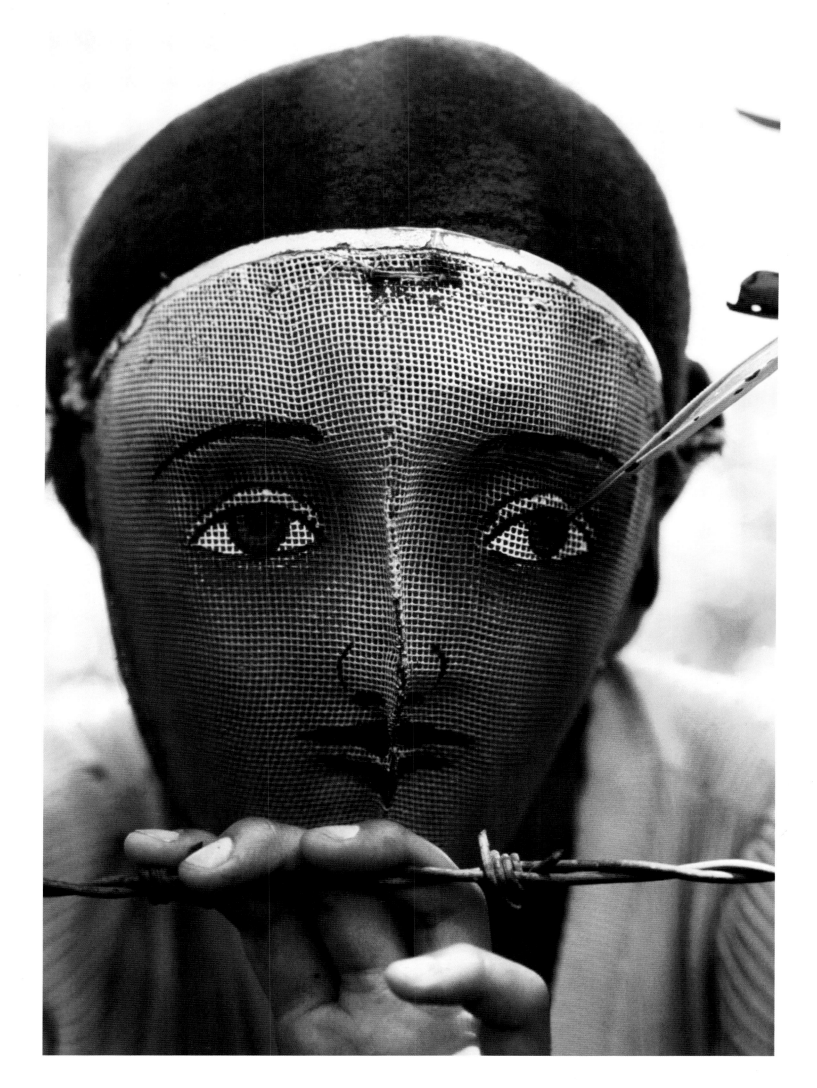

◁ Traditional Indian dance mask from the town of Monimbo,
adopted by the rebels during the fight against Somoza to conceal identity

At the Border, for those who are crossing, an arrest is a stopping — paths are temporarily reversed, people are often sent back to the countries and conditions they fled.

For those undocumented workers who have crossed successfully, we Americans rarely ask who they are or why they have left their homelands. We pass their silent faces on the street, in stores, even within our own homes. We see their eyes, but we don't know what their eyes have seen.  *S.M.*

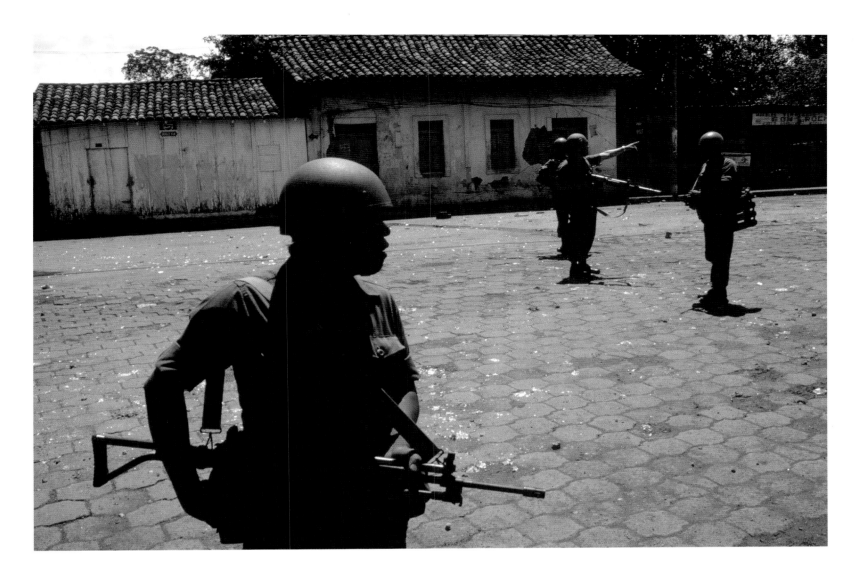

1:00 a.m. Arrest of undocumented worker by
US Border Patrol in hills near Tijuana, Mexico, 1989

Guard patrol beginning house-to-house search for
Sandinistas. Masaya, Nicaragua, 1978

3:00 a.m. Car load of undocumented workers captured by Border Patrol, Chula Vista, Ca., 1989

Street fighter. Managua, Nicaragua, 1979

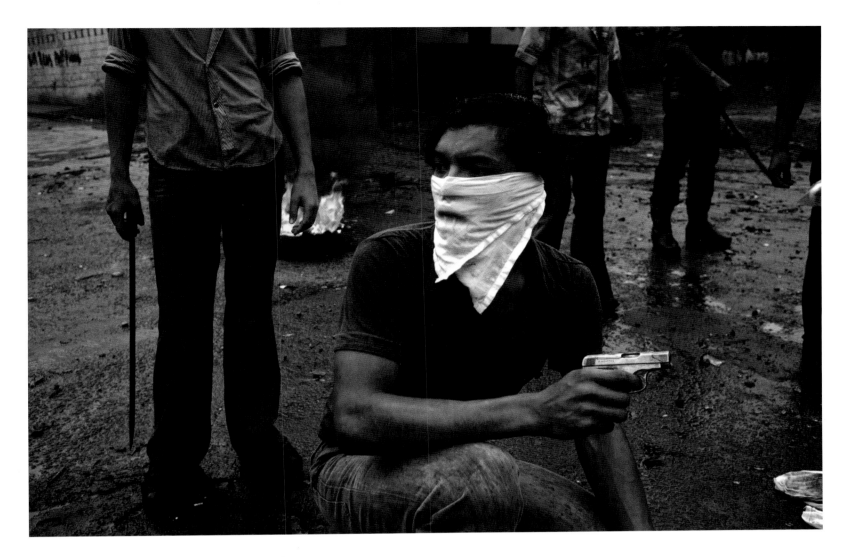

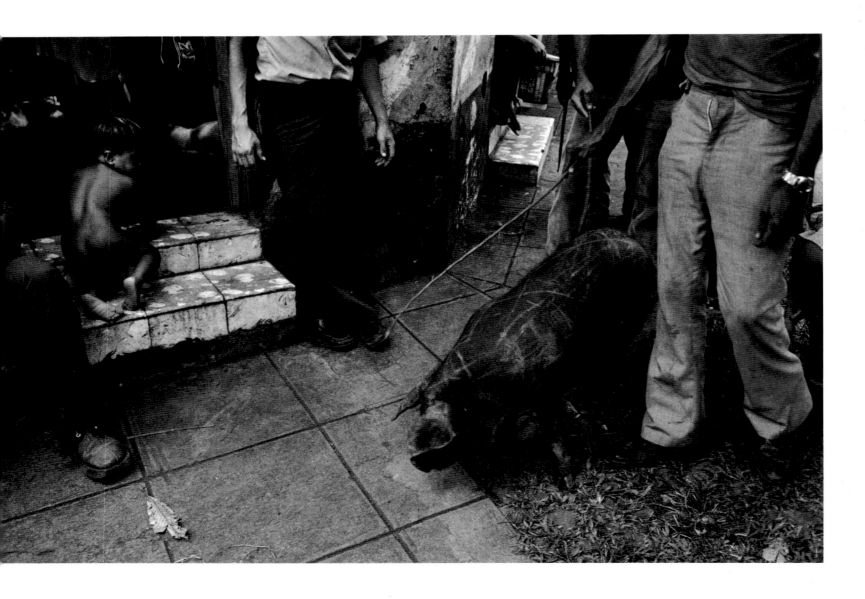

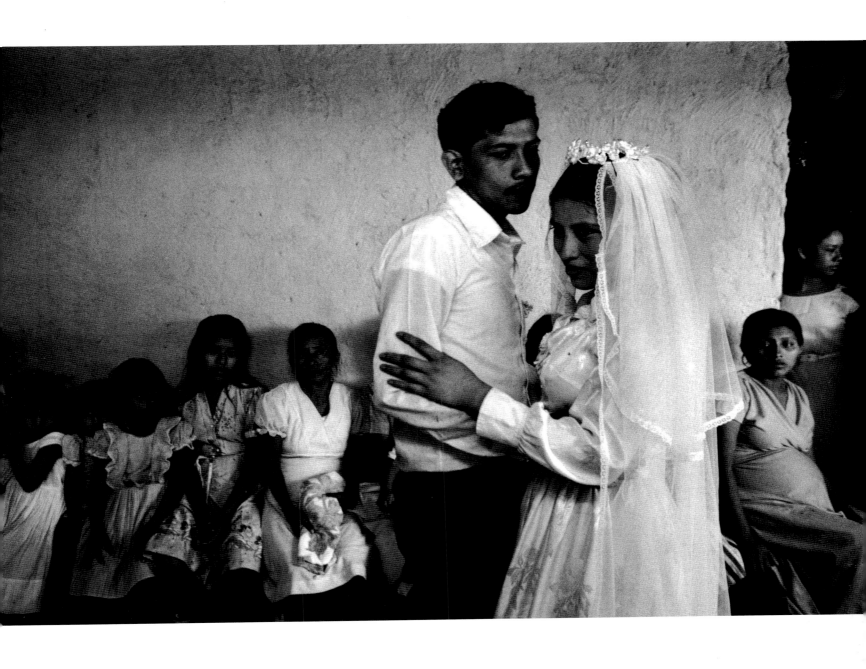

Streets of Sonsonate. El Salvador, 1980

Wedding reception in the countryside. Santiago Nonualco, El Salvador, 1983

7:30 a.m. Arrest of undocumented worker by US Border Patrol, downtown San Diego, Ca., 1989

Road to Aguilares. El Salvador, 1983

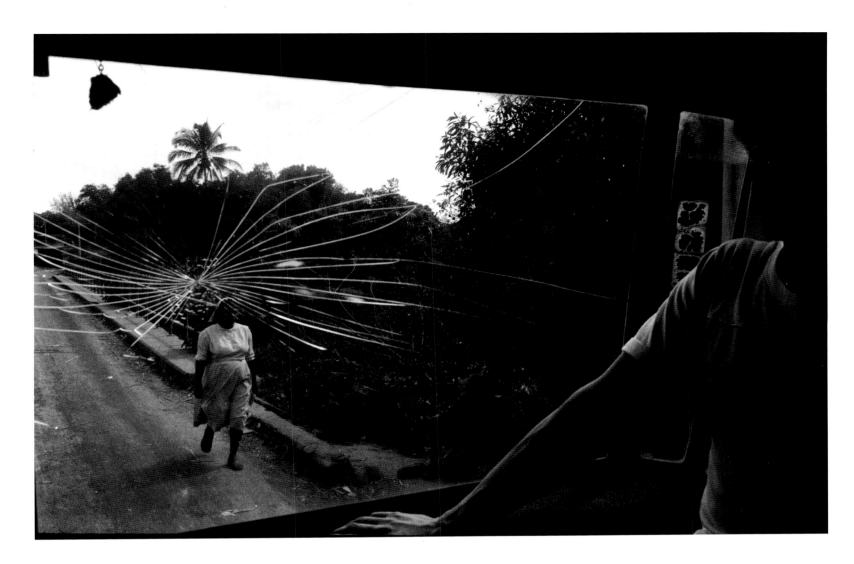

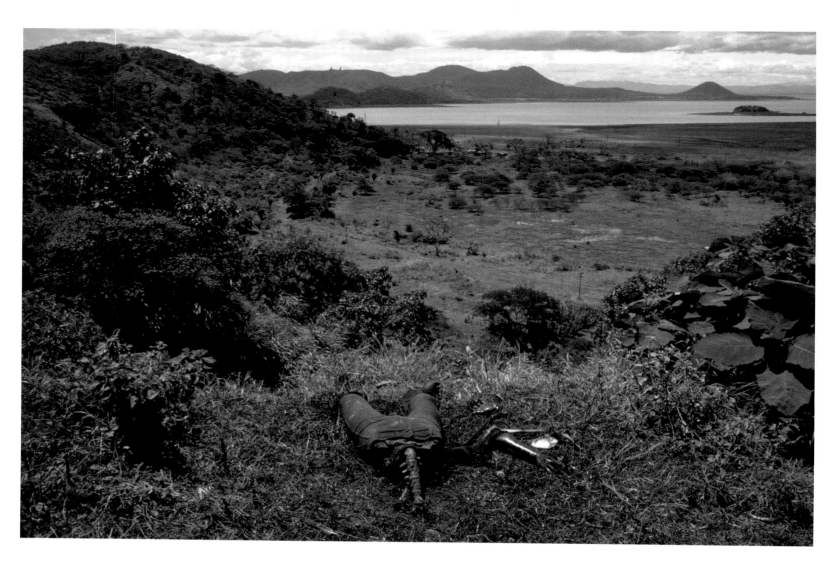

"Cuesta del Plombo", a well-known site of many assassinations carried out by the National Guard. People searched here daily for missing persons. Outside Managua, Nicaragua, 1978

6:00 a.m. Search, outside Encenitas, Ca., 1989

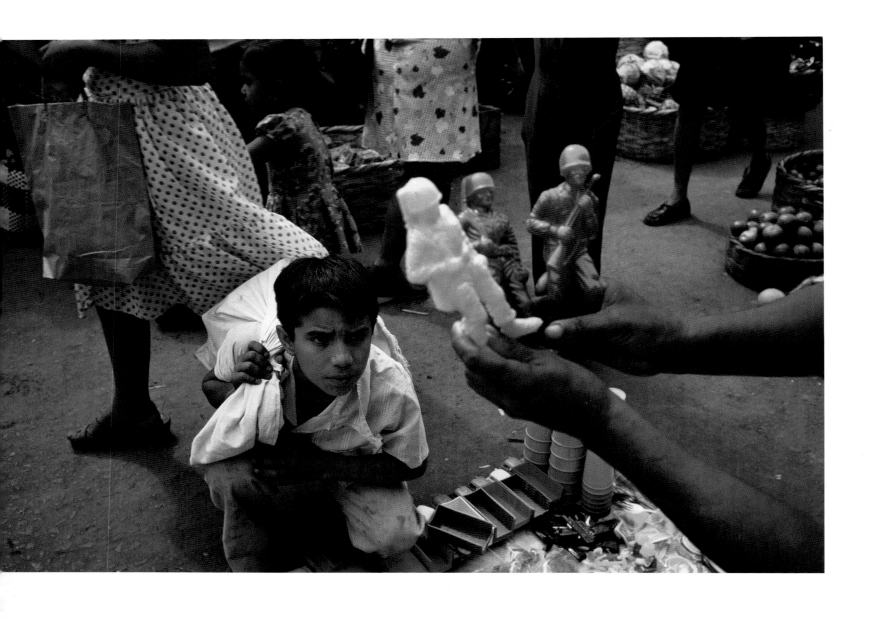

Market place in Diriamba, Nicaragua, 1978

Guerrilla dragged through the streets of Cuscatlancingo. El Salvador, 1982

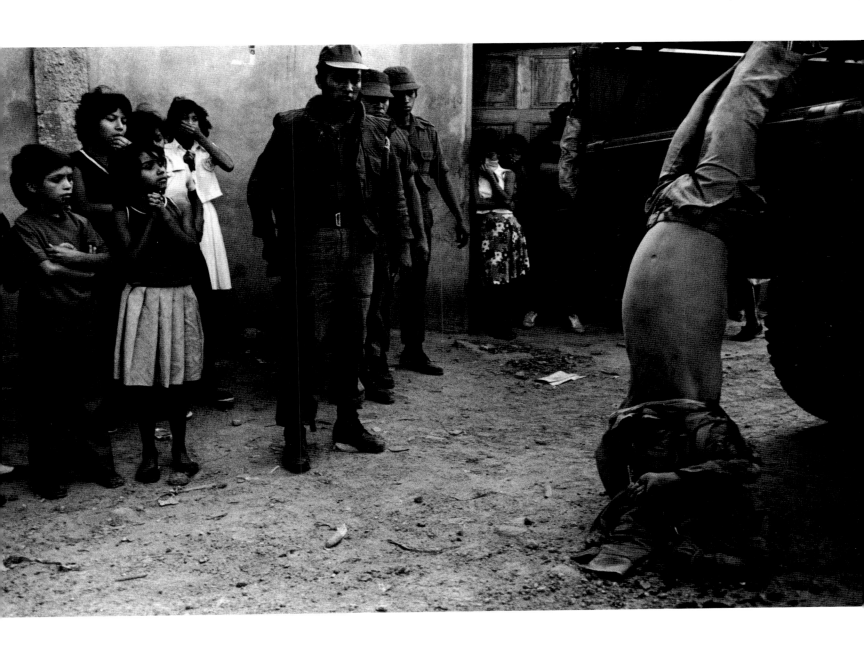

10:00 a.m. Caught heading north along Interstate 5, San Diego County, Ca., 1989

Firing range used by US-trained Atlacatl Battalion. Sonsonate, El Salvador, 1983

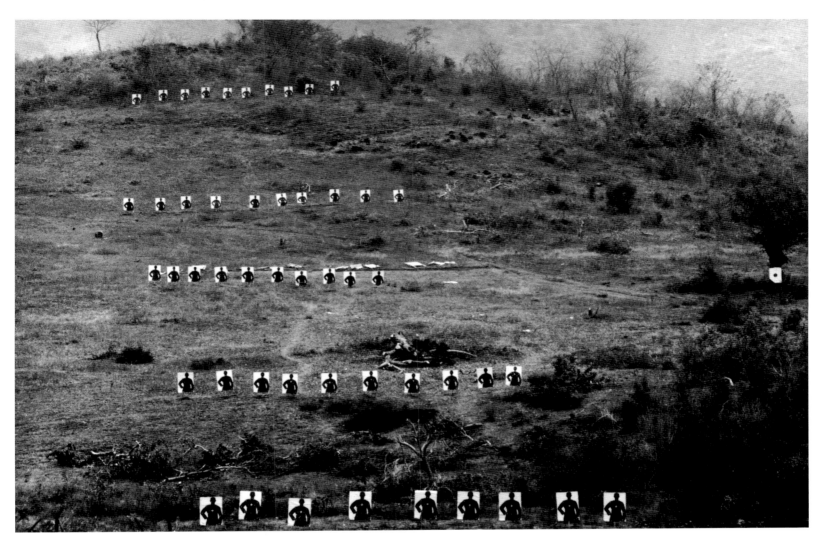

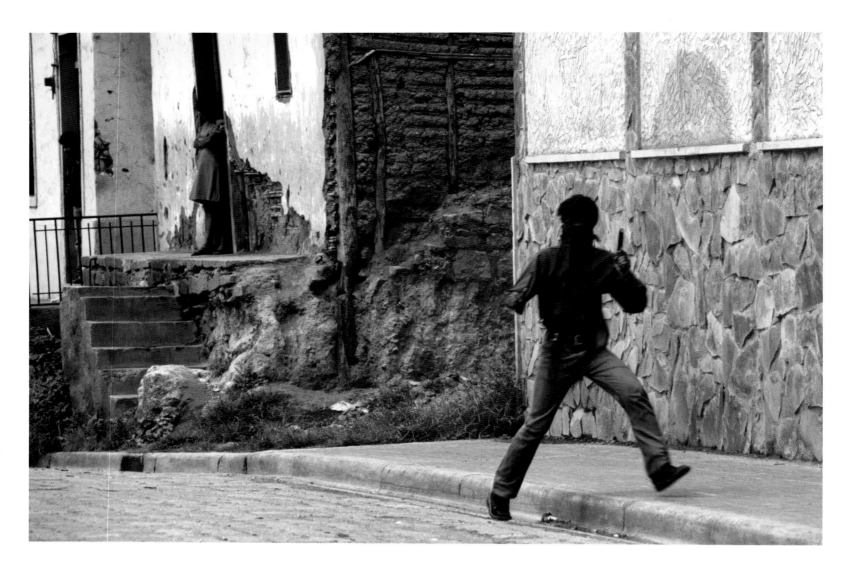

First day of popular insurrection. Nicaragua, 1978

8:00 a.m. Undocumented workers discovered in "drop off" site, Interstate 5, Oceanside, Ca., 1989

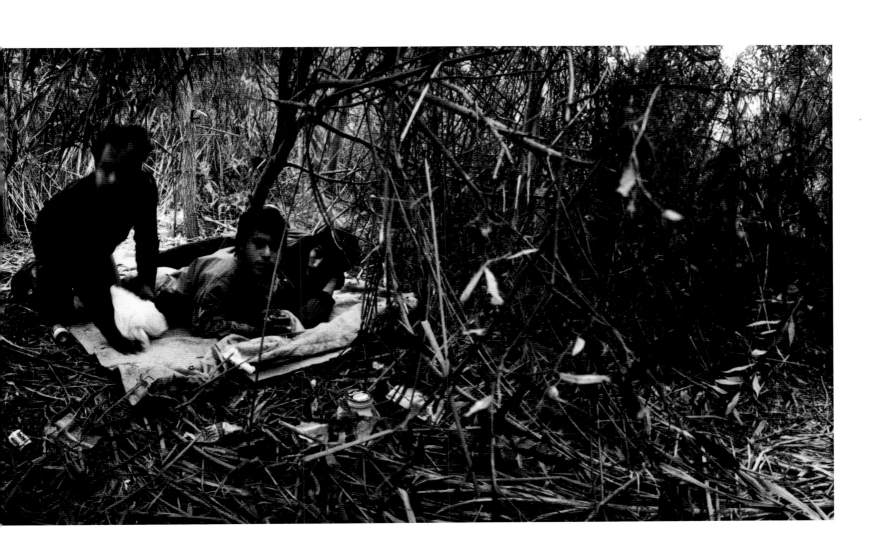

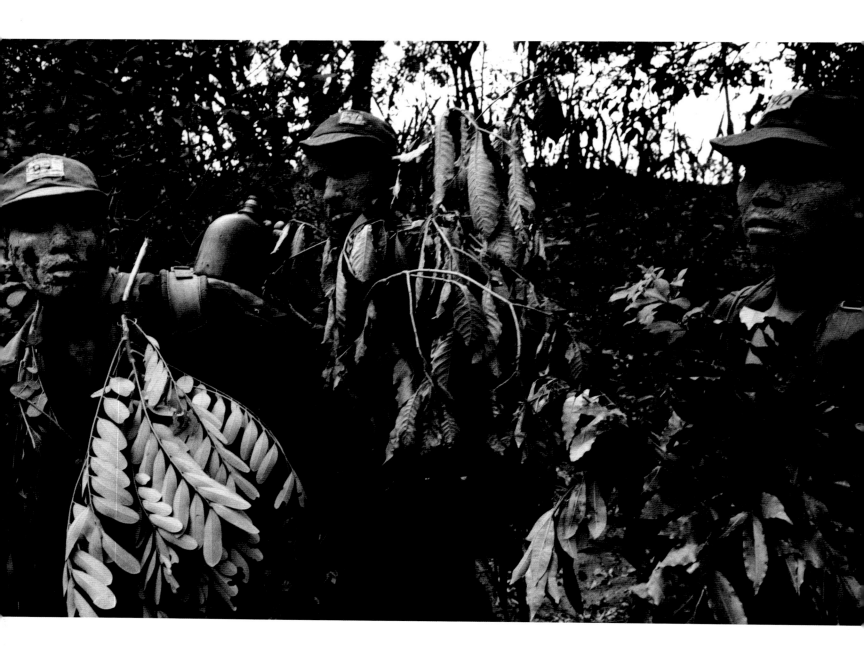

Survival training of US-trained Atlacatl Battalion. Sonsonate, El Salvador, 1983

Children rescued from a house destroyed by a 1,000-pound bomb dropped in Managua. (They died shortly after.) Nicaragua, 1979

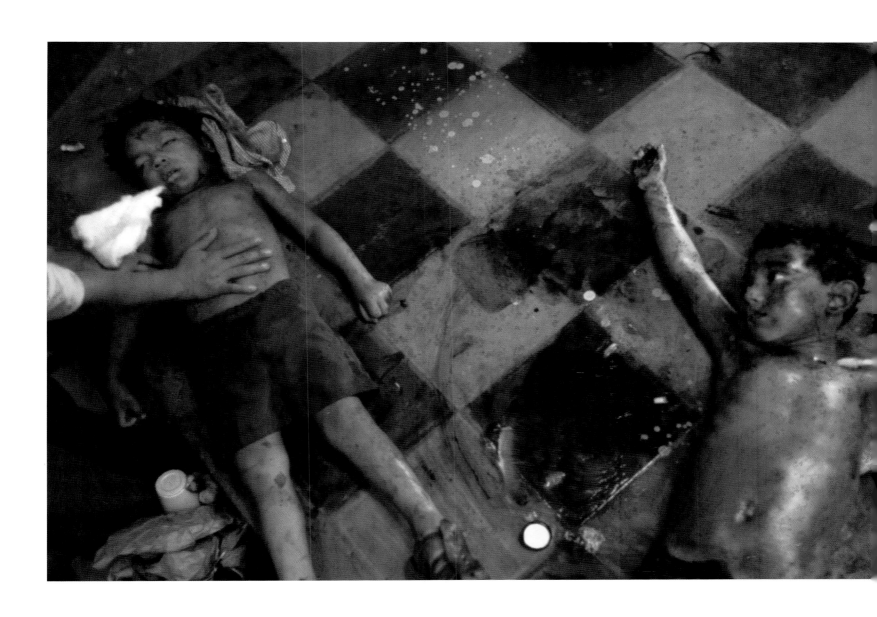

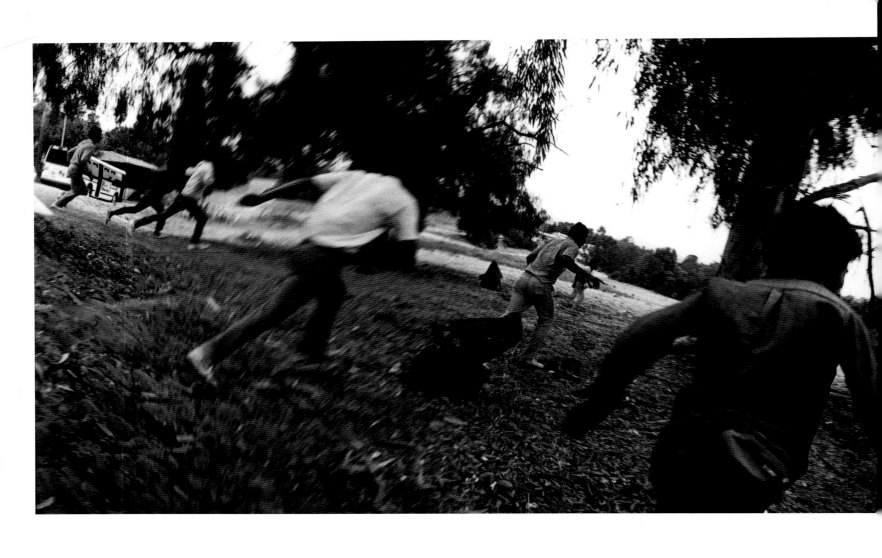

7:00 a.m. Flight from US Border Patrol, Encenitas, Ca., 1989

Fleeing from the bombing to seek refuge outside Esteli, Nicaragua, 1978

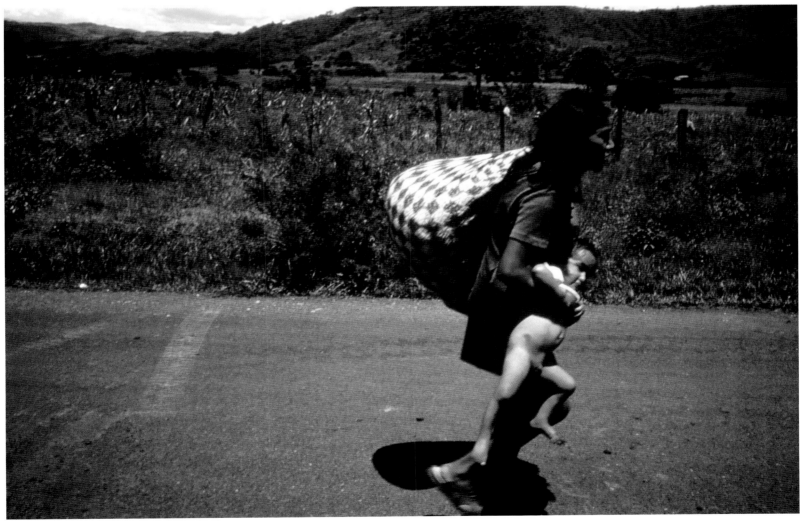

3:00 p.m. Arrest alongside Interstate 5, Oceanside, Ca., 1989

Soldiers searching bus passengers. Northern Highway, El Salvador, 1980

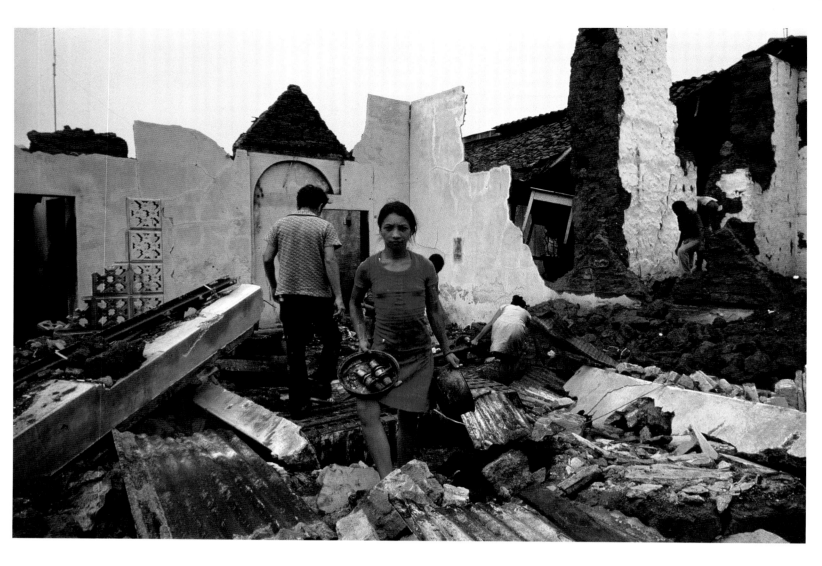

Returning home after bombing of downtown. Masaya, Nicaragua, 1978

2:00 a.m. Arrest and documentation of twelve-year-old boy, Imperial Beach, Ca., 1989

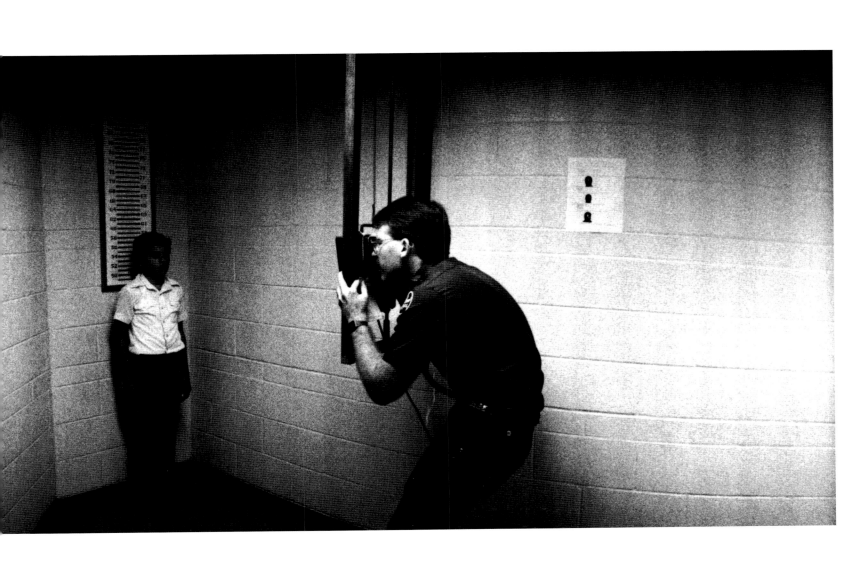

2:00 p.m. Holding cell for undocumented female detainees, El Cajon, Ca., 1989

Monimbo woman carrying her dead husband home to be buried in their backyard. Nicaragua, 1978

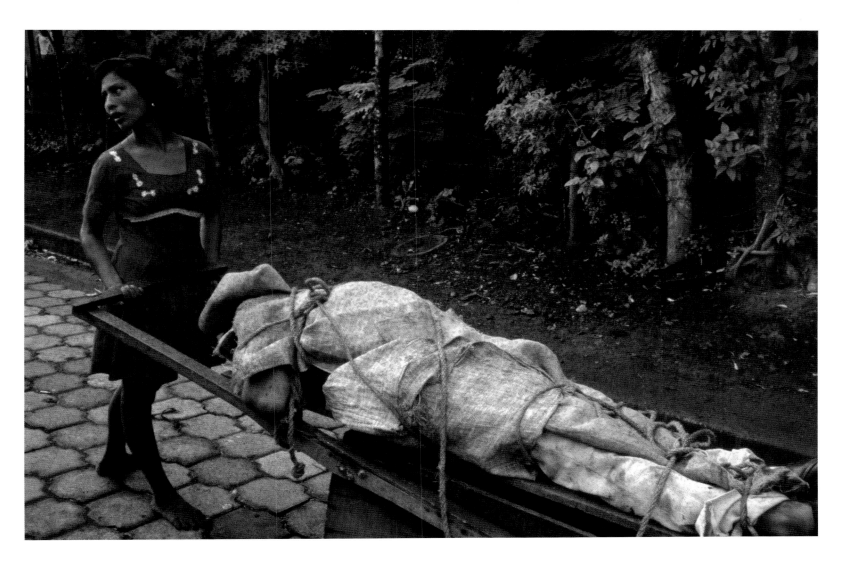

2:00 a.m. Arrest of undocumented workers by US Border Patrol,
El Bordo, Ca., 1989

6:00 p.m. United States seen through the border fence,
Tijuana, Mexico, 1989

126

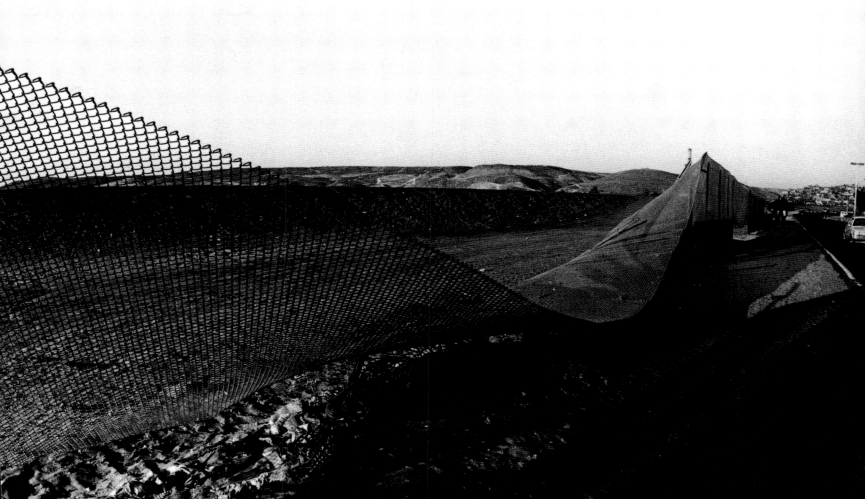

Inge Morath

Dear Inge,

I am delighted to be asked to write a few words about you and your photographs. I have admired you for so long, admittedly from far across the Atlantic Ocean, but I have always felt that we had more than a few things in common and maybe that is why I can identify so closely with your itinerary.

We both live in countries we were not born or even brought up in; we live in similar worlds surrounded by painters, writers, actors, photographers; we both married "famous" men with whom we share a daughter; and soon I am to be a grandmother like you. Both our companions were married before and we've had to come to terms with their past and formidable presence.

We seem to have a common fascination for painting and sculpture and a love of foreign languages, although you speak many more than I do. By the way, how did you ever make time to learn Chinese and Russian, plus being a mother, wife, cook, gardener, photographer? Oh, and I almost forgot, yoga as well. I am always amazed to see how supple you are, how you manage to cross your legs like a Buddha, and leap up the stairs as though arthritis does not exist.

Maybe it is partly due to your eating habits. Long before anybody else I knew you were highly selective of what you ate and never indulged in chocolate cake and Coca-Cola. This is where we begin to differ.

I think what I like so much about your photographs is your love and empathy for people, and they in turn reflect your warmth and generous approach. You have obviously had such fun photographing, you have enjoyed meeting people and they too have enjoyed the encounter. Arthur Miller wrote so well about your work: "Inge's signature is her unsentimental tenderness and the absence of aggression in her invitation to the subjects being photographed." This is revealed so well in your portraits of Louise Bourgeois, Gloria Vanderbilt, Mary Frank, Roy Lichtenstein. You let the person present themselves to the camera as they wish, and do not have preconceived ideas about how they should look or be.

Your impeccable composition and humor show in your "Mask" series. I think the image I prefer and that always stays with me is the "Young woman with mask and fur coat" of 1961: the bag, the mask, the background all rhythm together, and what's more the spotted fur coat is totally incongruous and sets off the lines of the mask.

More subtle humor can be seen in the two "Magnum accountants" with their beautiful legs and mountainous hairstyles. It could have been cruel but it is not because you have caught and observed them in an intense moment of concentration which renders them human. The navel piercing episode is hilarious—the piercer looking so earnest, and the pierced looking so absorbed by the situation and slightly fearful.

The "Window washers at Rockefeller Center" is another one of my favorites—when you see reality and frame it the way you do, it surpasses anything one could imagine.

Dear Inge, keep on delighting us with your memorable images and thank you for everything you have inspired in us and given us.

Martine Franck

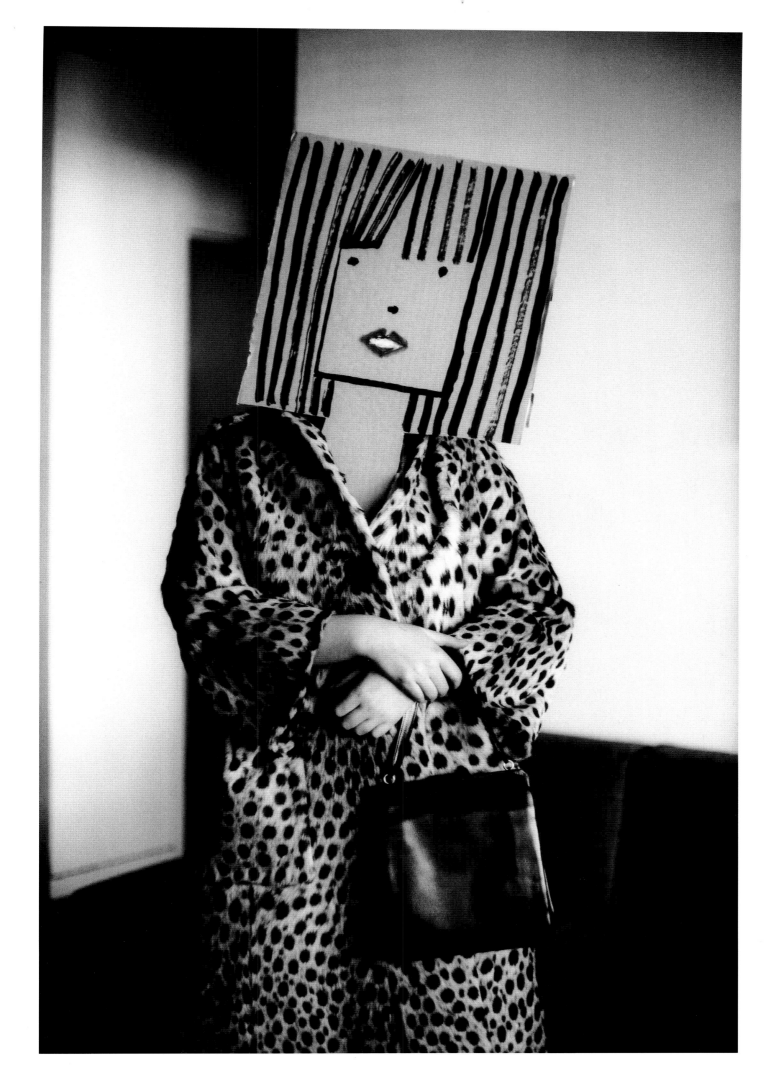

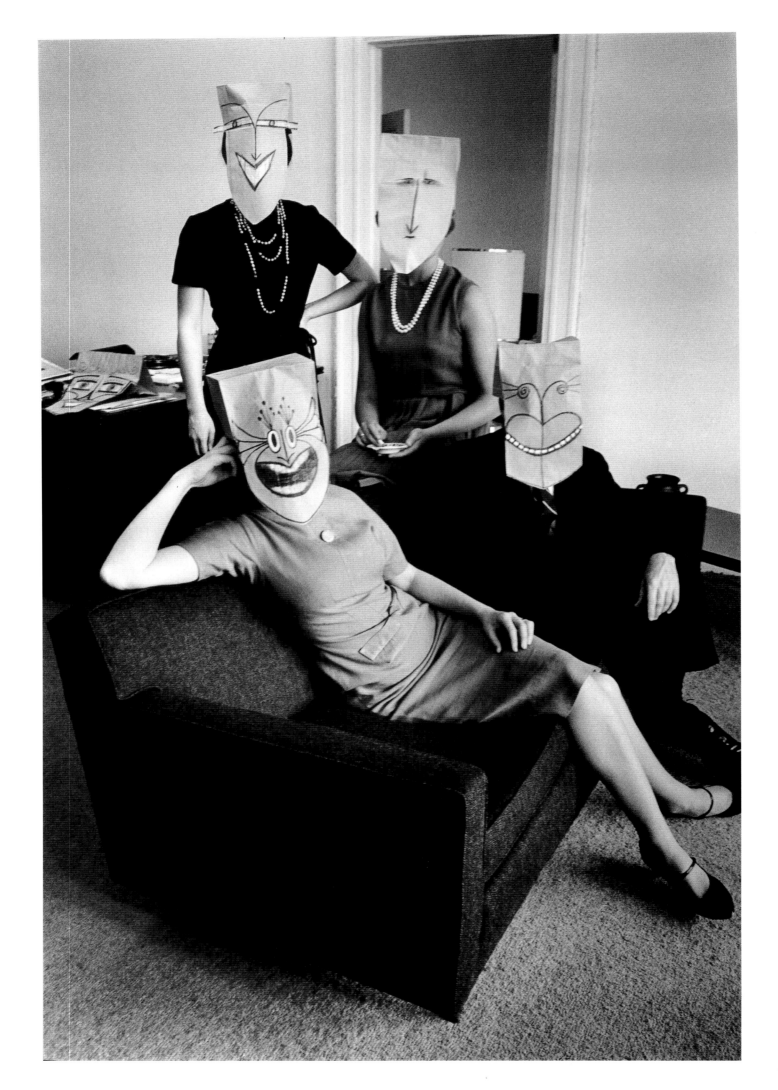

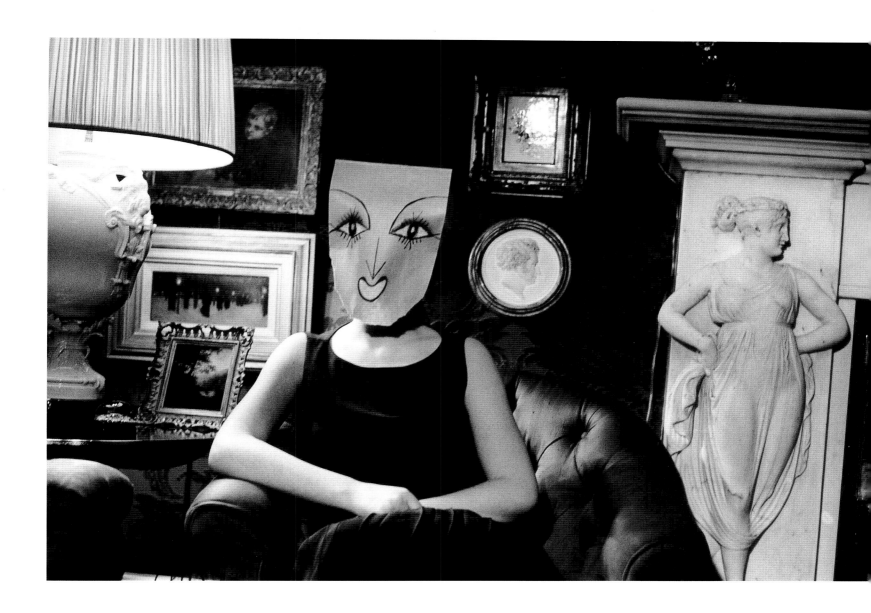

◁ Young woman with mask and fur coat, 1961

Four women with Steinberg masks, 1962

Lady with mask next to marble mantelpiece, 1961

Saul Steinberg with self-portrait masks, 1959 ▷

Saul Steinberg masks – "The sad phonecall", 1959 ▷▷

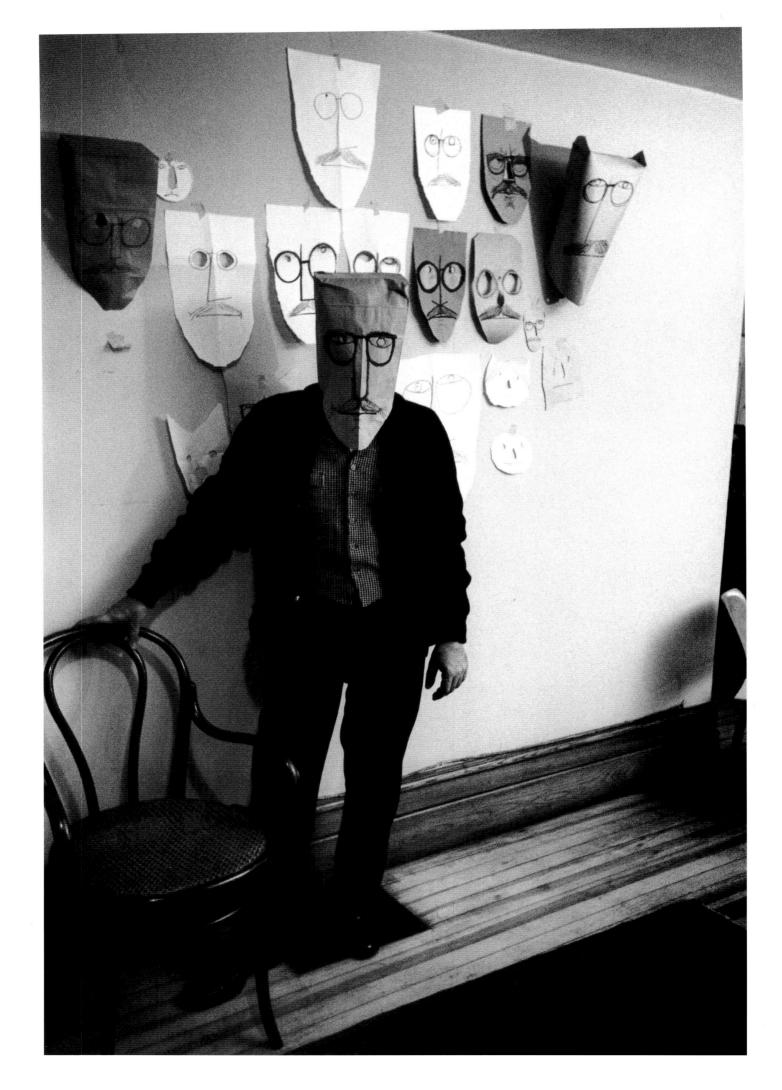

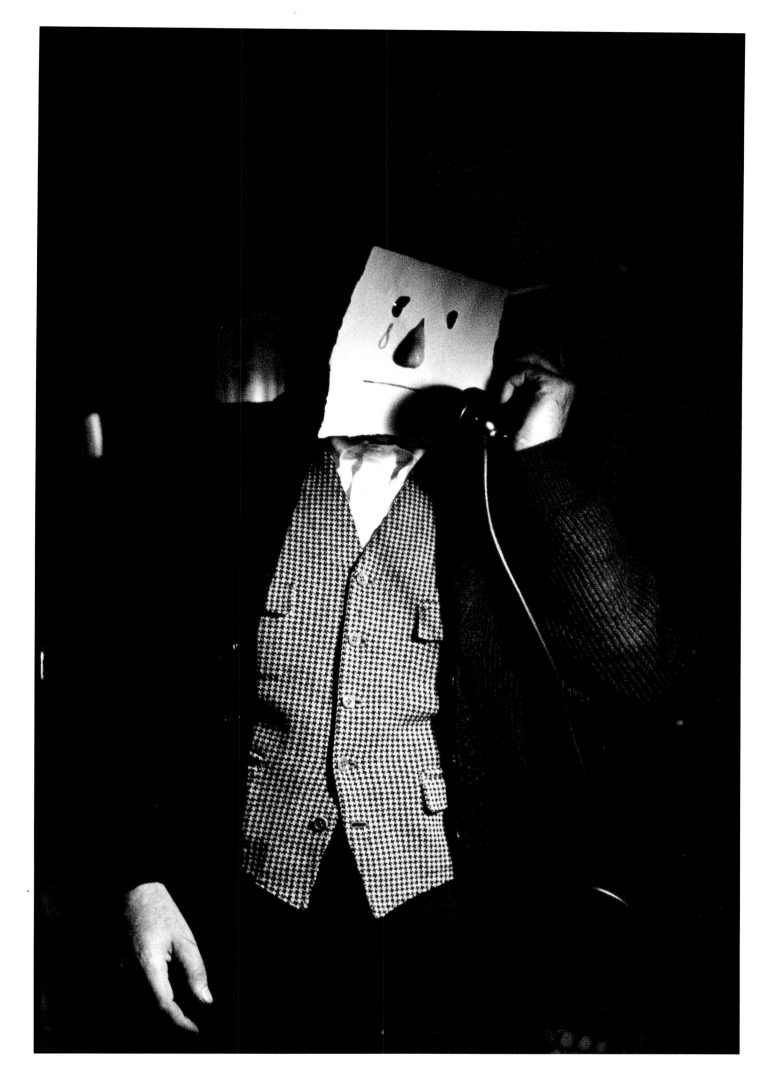

Saul Steinberg with mask in his garden, 1959

Beauty class. Helena Rubenstein Salon, 1958

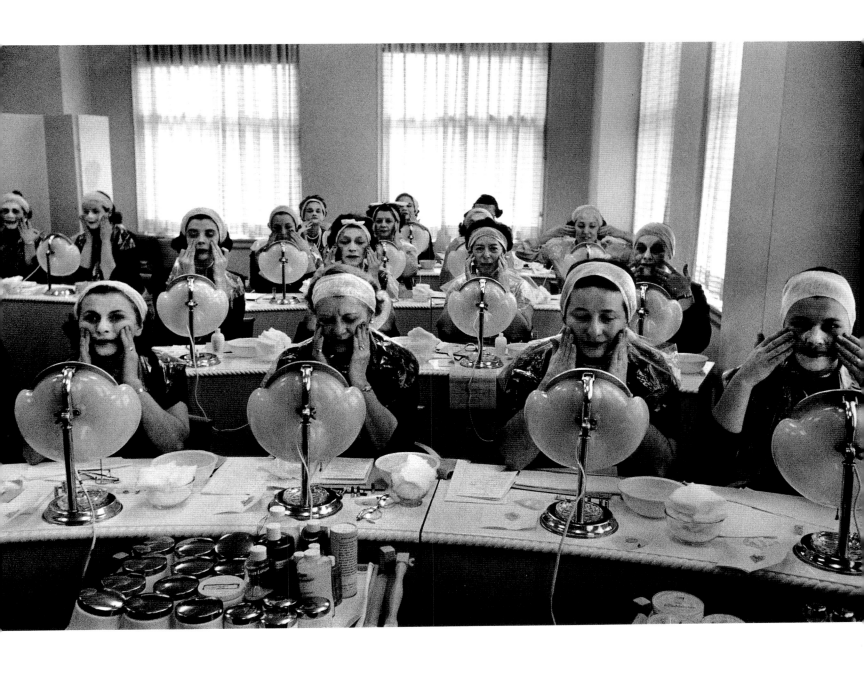

Françoise Gilot, 1995  ▷

Eleanor Roosevelt and Adlai Stevenson, 1961  ▷▷

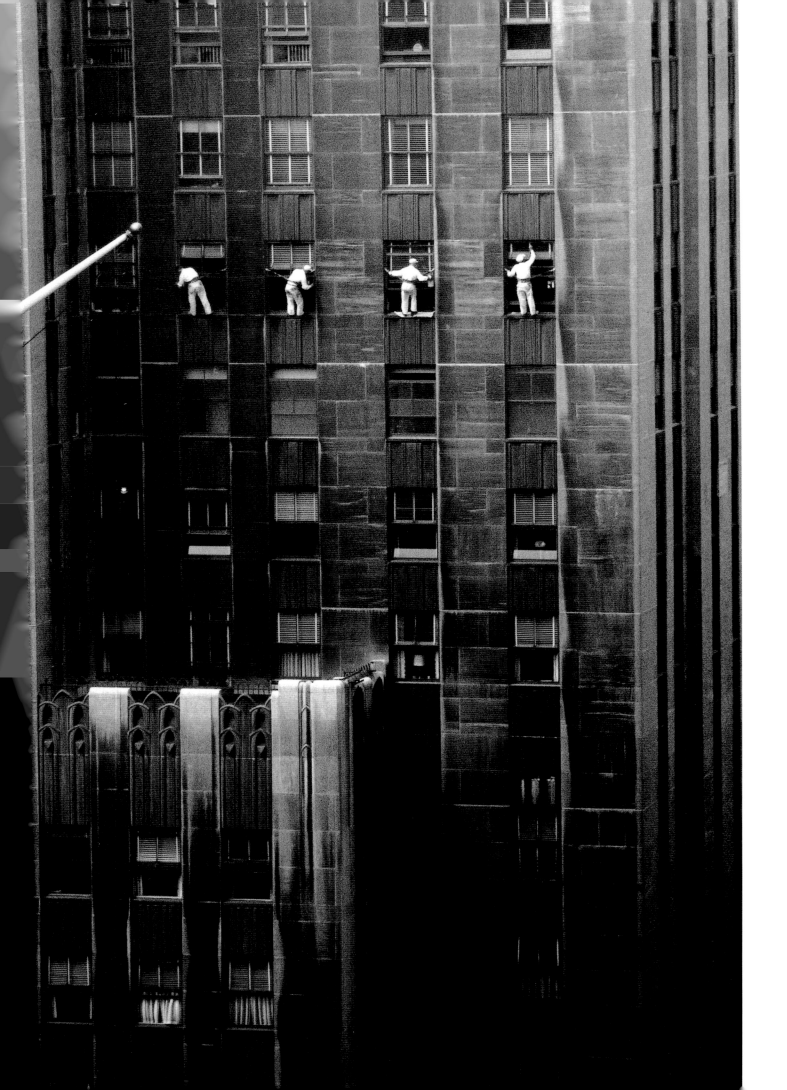

Window washers at Rockefeller Center, 1958

Rebecca Miller, 1987

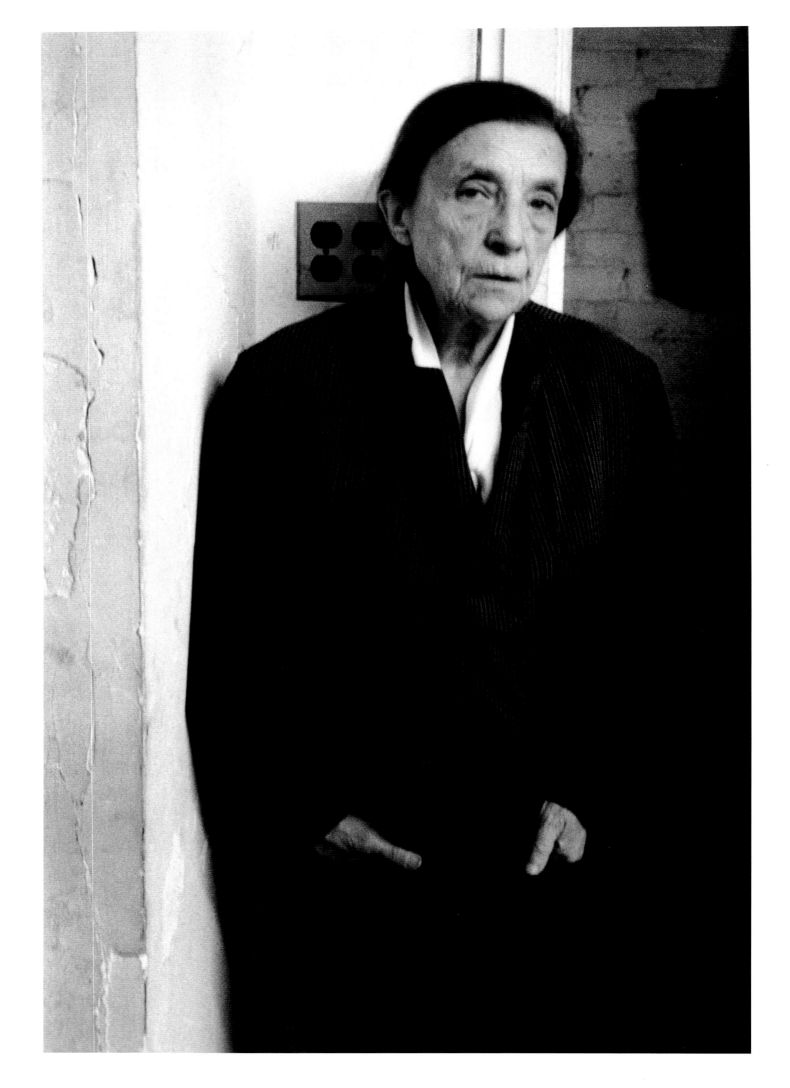

Louise Bourgeois, 1982

Playwright Edward Albee, 1987

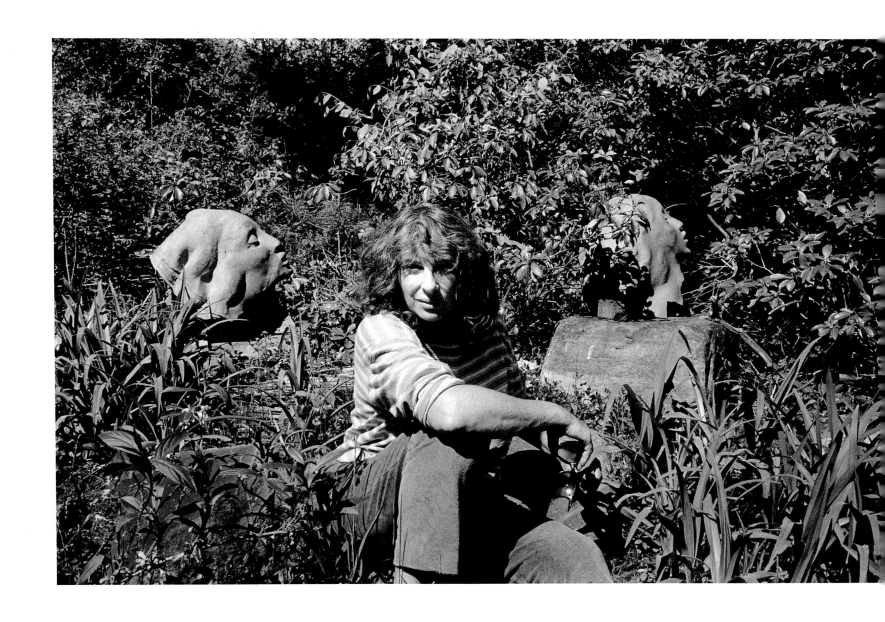

Tama Janowitz, 1988

Mary Frank, 1991

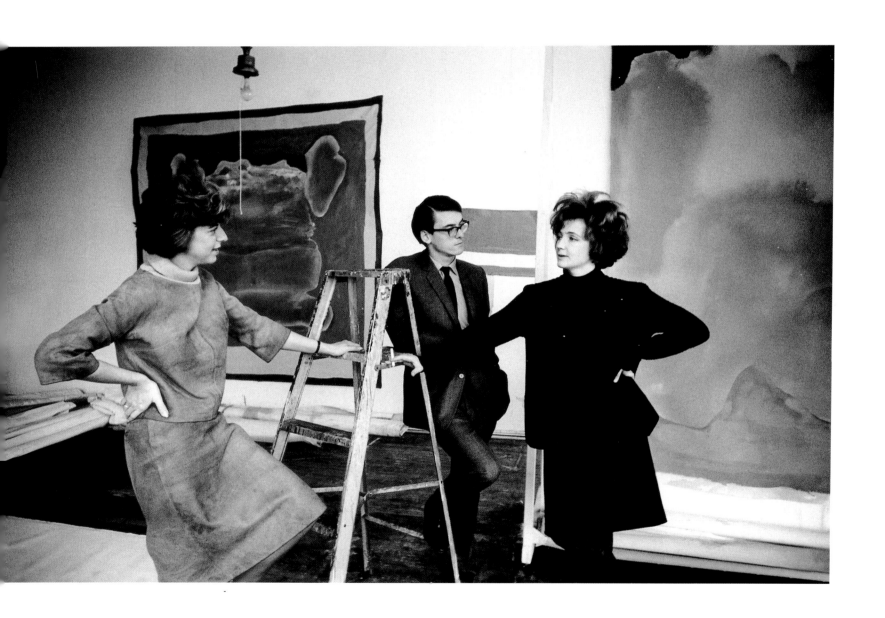

Helen Frankenthaler with Lord and Lady Duffin, 1964

Magnum accountants, 1965

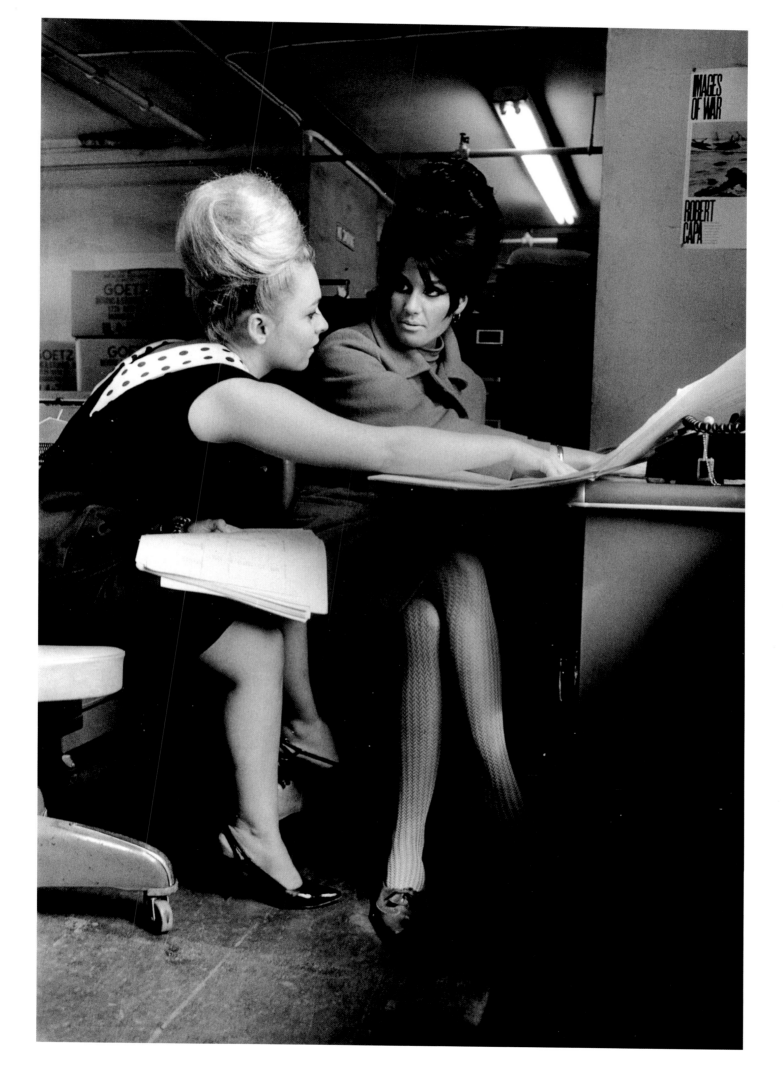

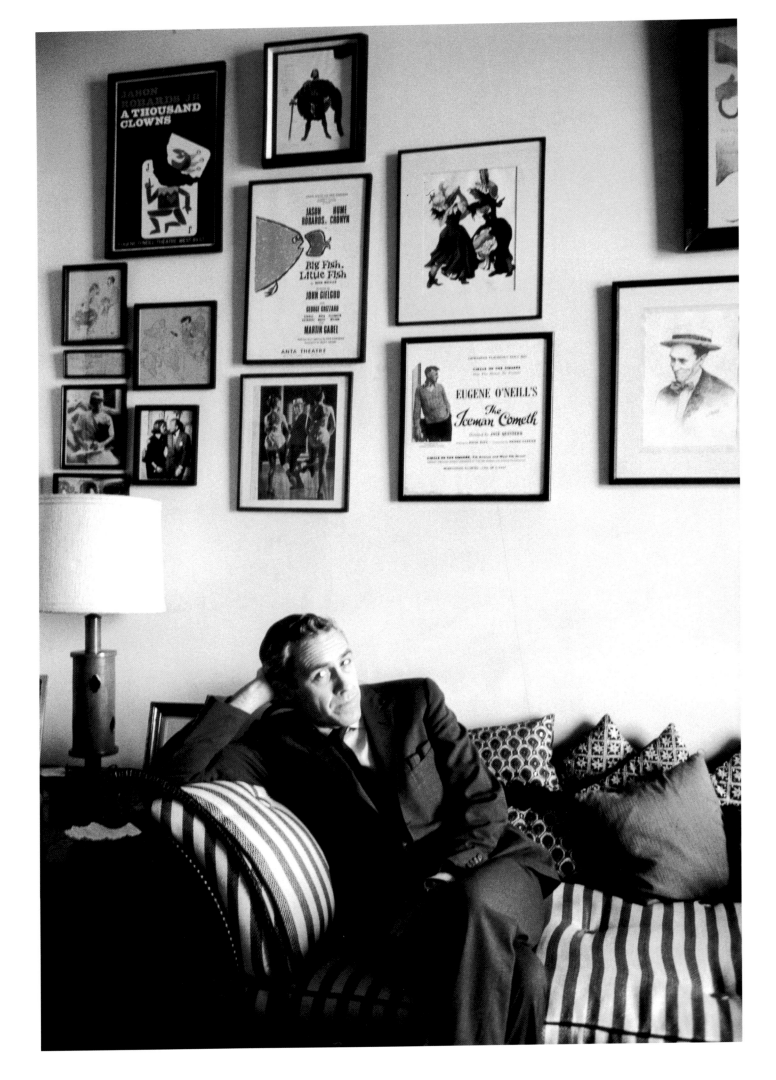

Actor Jason Robards, 1963

Gjon Mili, Michel Chevalier, Otto Preminger, 1958

"Death of a Salesman" with John Malkovich, Dustin Hoffman, 1984

Arthur Miller, Saul Bellow, and John Steinbeck, 1966

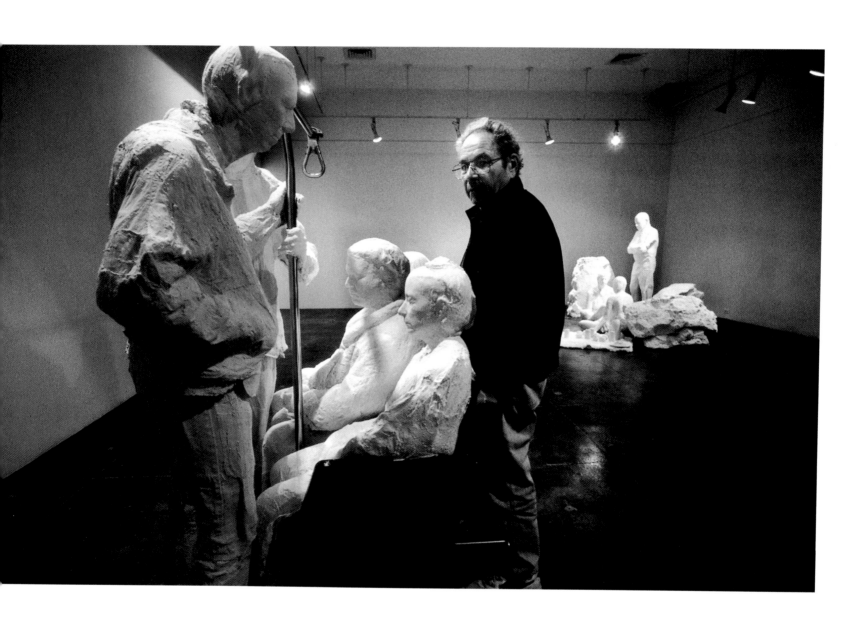

George Segal with sculpture, 1997

Sculptor Marisol in studio, 1995

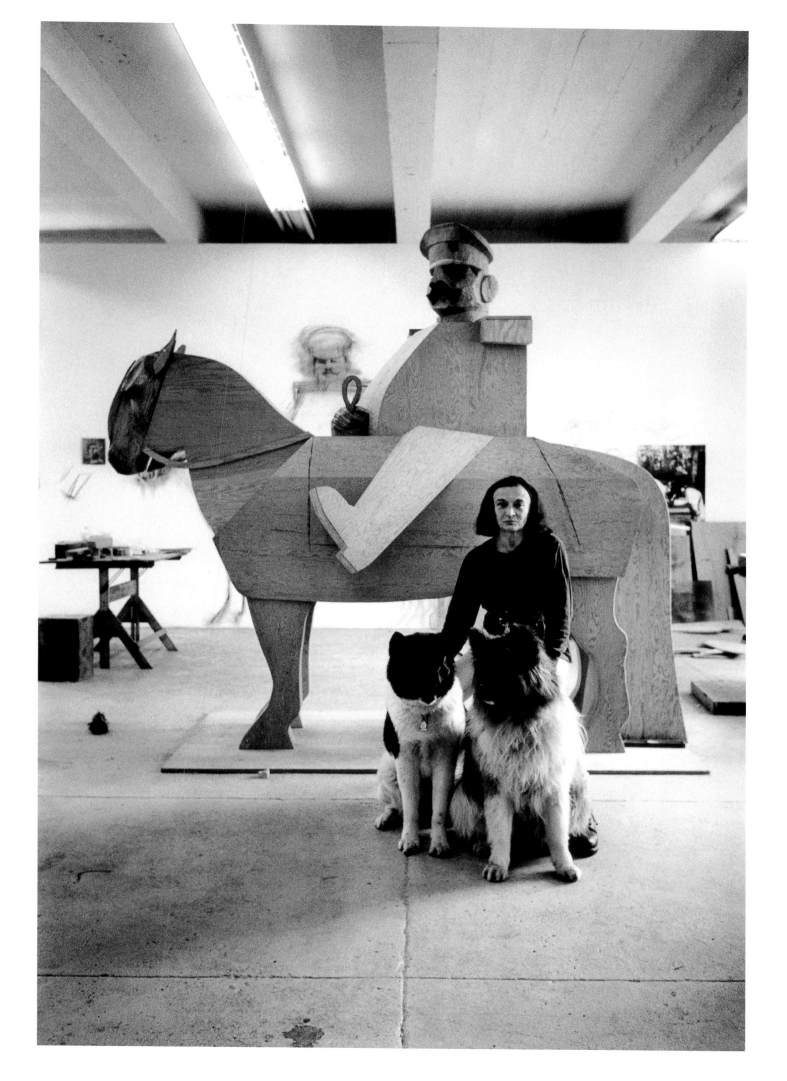

Fifth Avenue in Harlem, 1958

Igor Stravinsky and Mr. Fromm, 1959

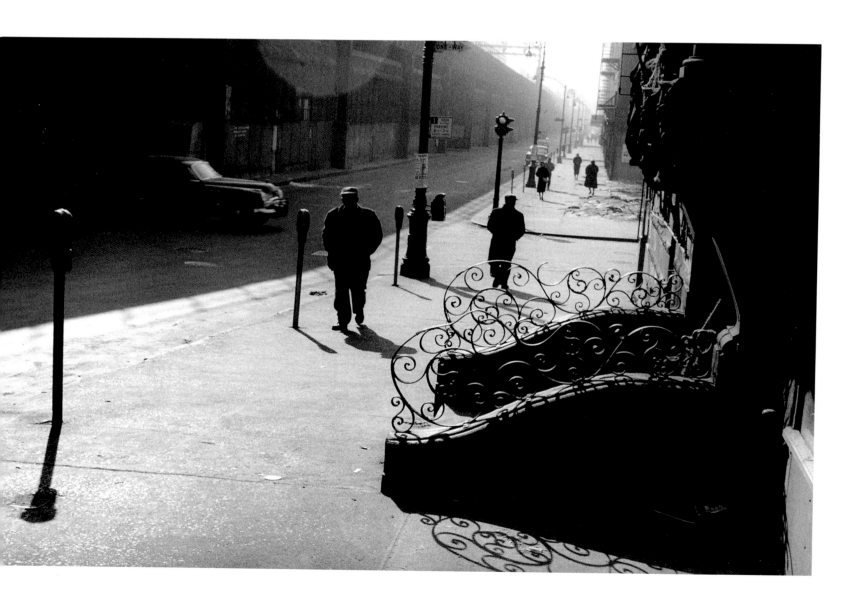

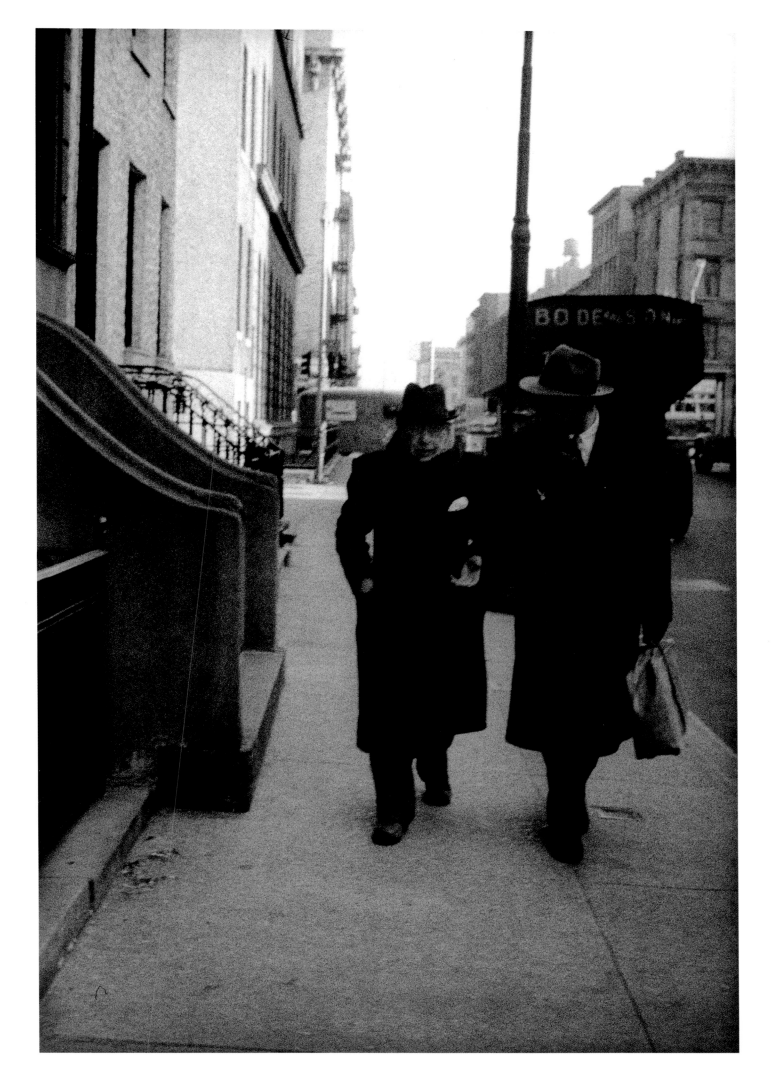

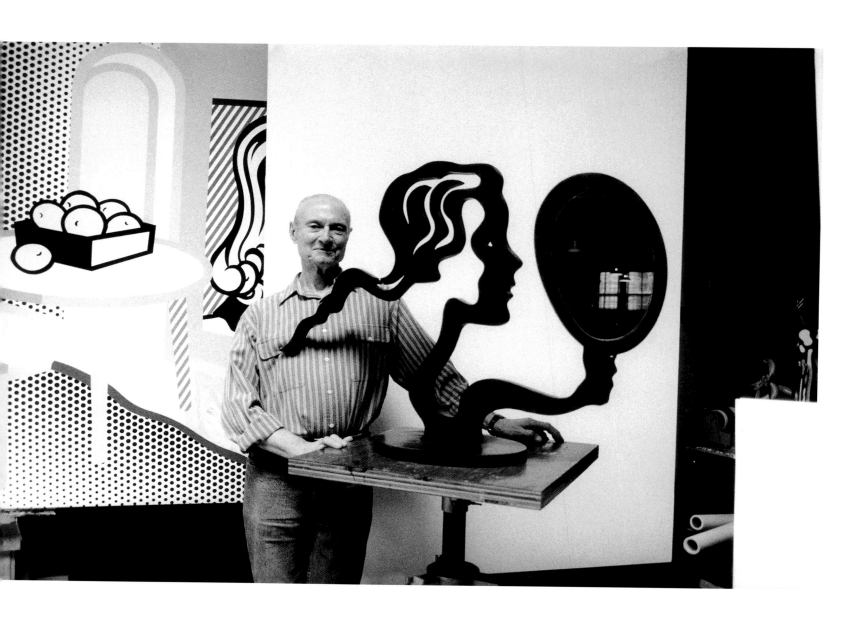

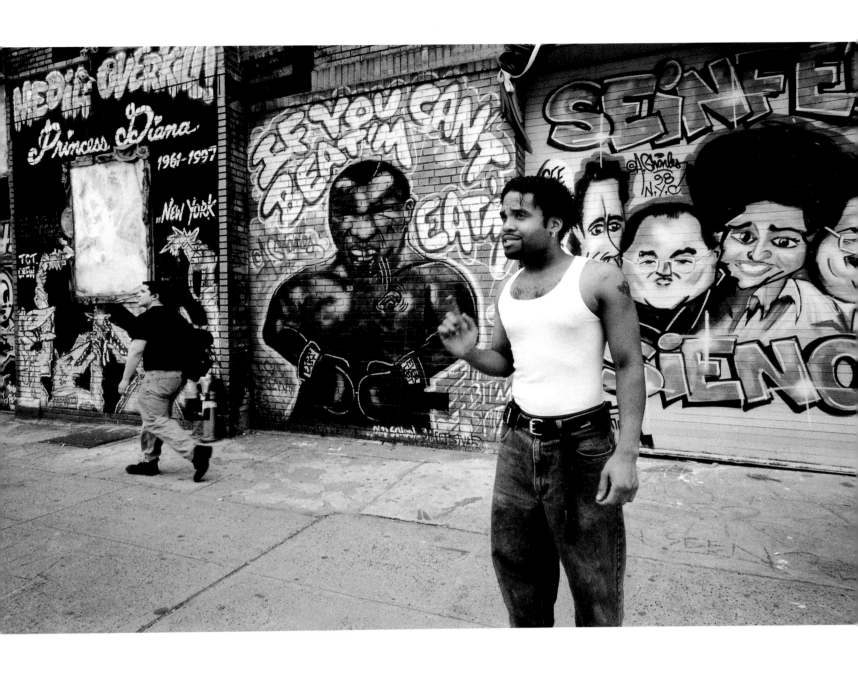

Roy Lichtenstein, 1997

Graffiti artist André Charles, 1998

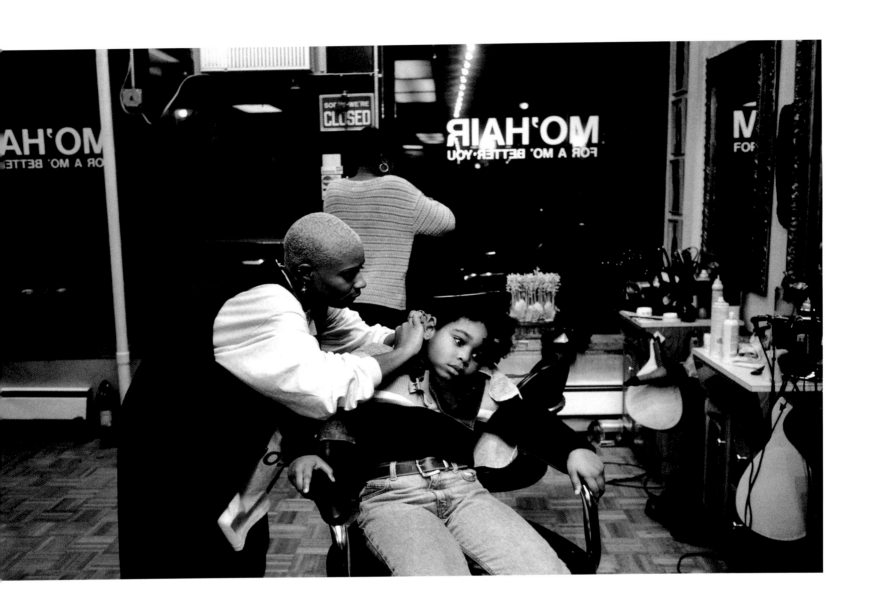

Mo' Hair Salon, 1997

Cooking school, 1997

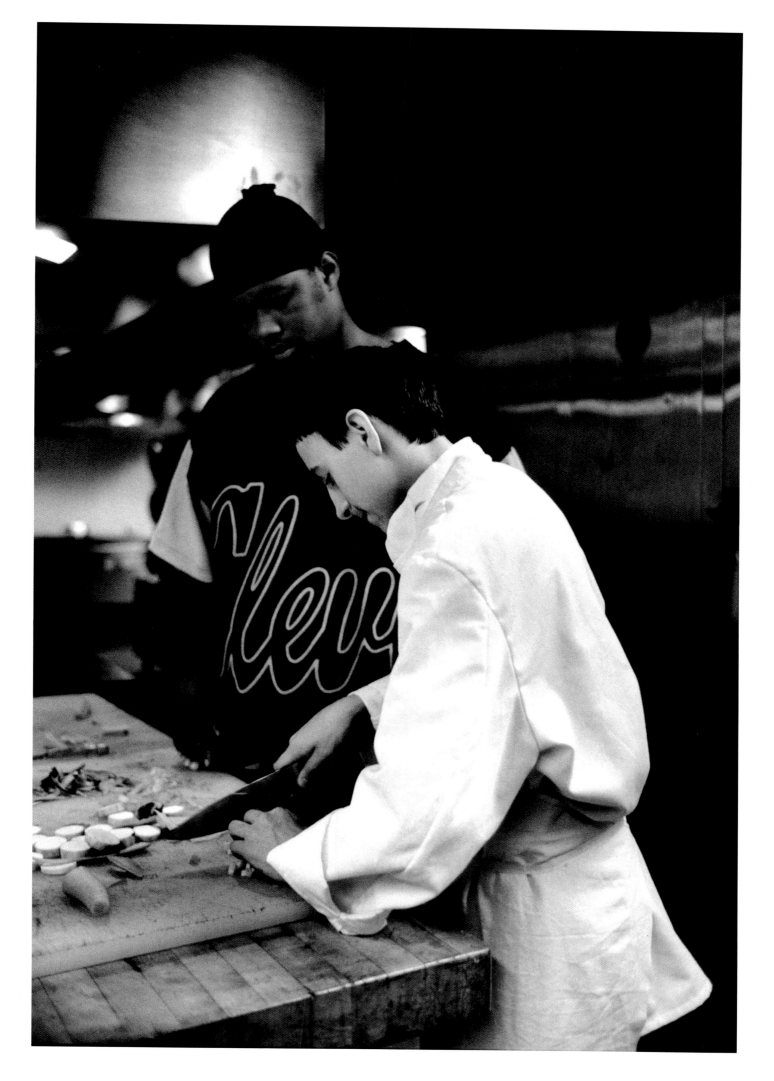

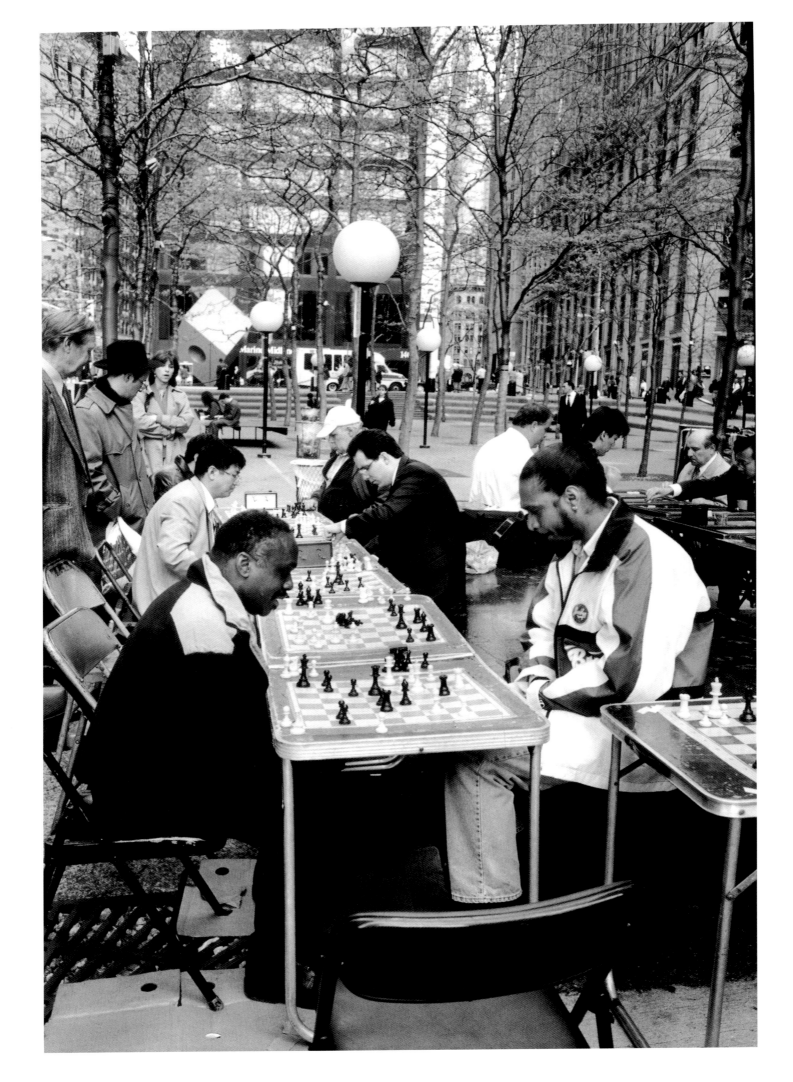

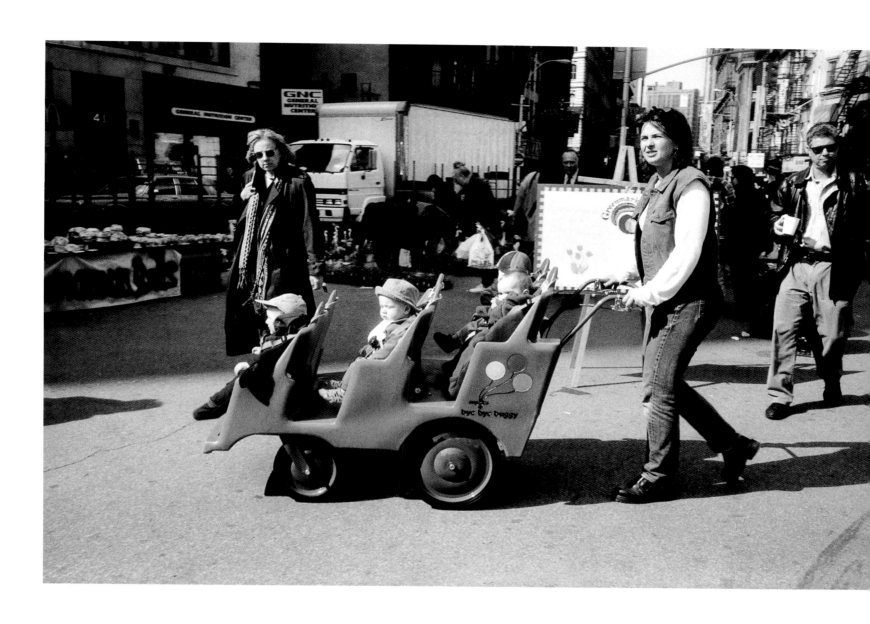

Chess players in Wall Street district, 1997

Union Square. Woman with baby carriage, 1997

Ninth Avenue. Food fair, man with albino boa constrictor, 1998

Navel piercing, 1997

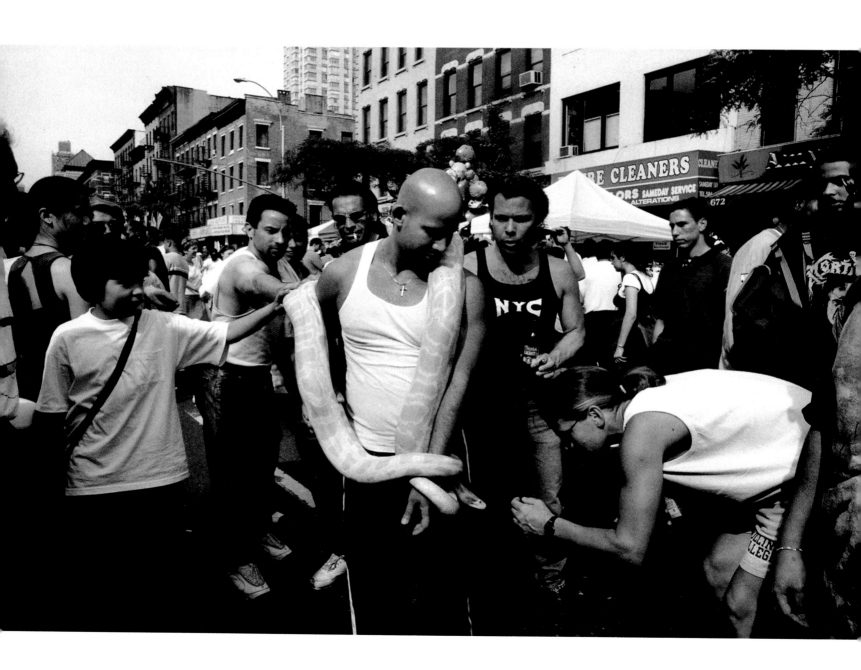

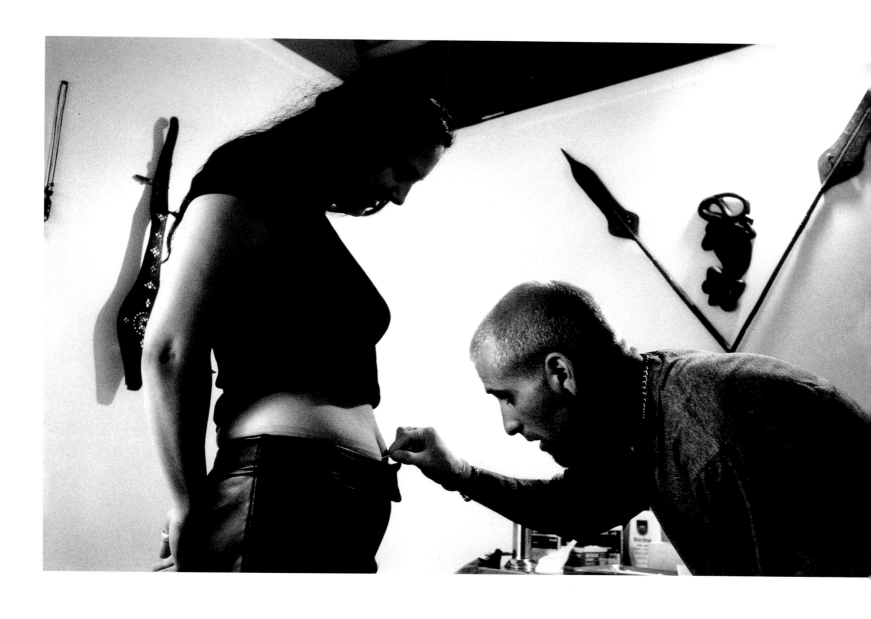

Gloria Vanderbilt, 1956 ▷

Llama encounter near Times Square, 1957 ▷▷

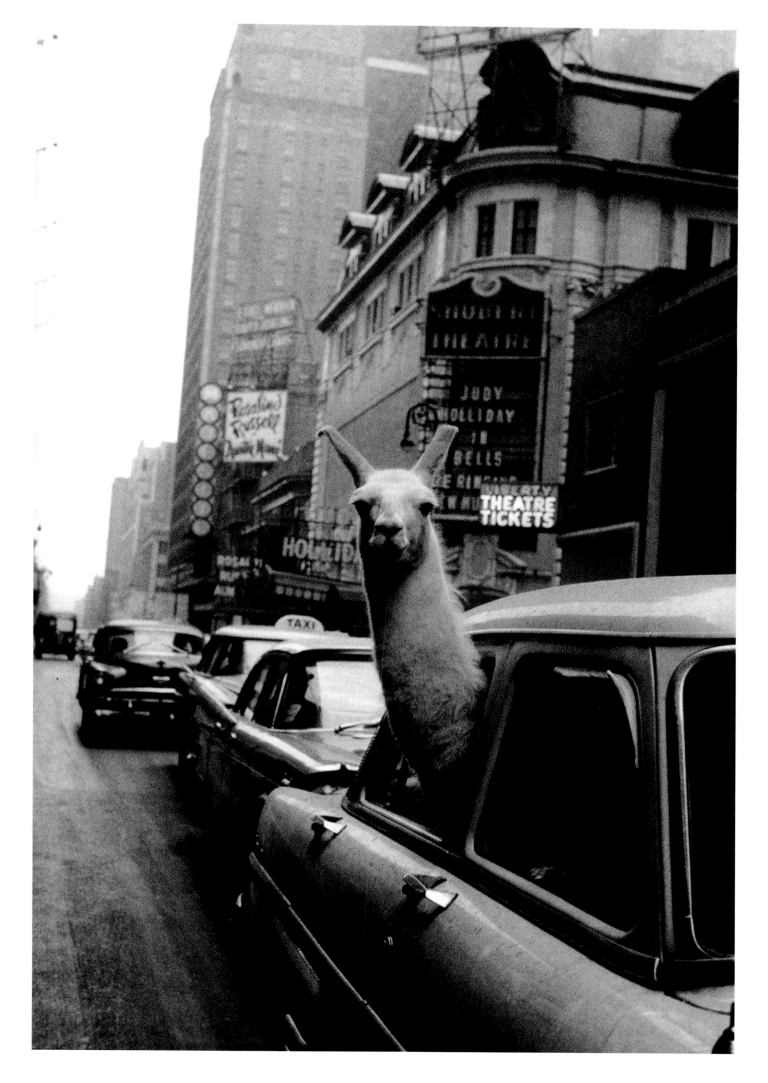

The suit was French, stylish, expensive, and probably designed by Dior. The fair-haired, tall woman who wore it was heedless of its chic. There was a camera draped across one shoulder that spoiled the line of the jacket. She wore her clothes carelessly as if to say there are more important things in the world to think about.

This was the first time I met Marilyn Silverstone. It was at the Magnum office in New York where she was being vetted for the first steps toward membership. Usually prospective members are nervous; she was cool. That was thirty-five years ago.

I contrast her appearance then with her appearance now. The garments are important in describing her: a stalwart figure, with a shaved head, her running shoes are dyed to match her maroon robes. She is now a fully ordained Buddhist nun living at a monastery in Nepal, co-founder of a new nunnery, and has been renamed Ngawang Chodron.

Between the Dior suit and the nun's robes, what has her life been like?

She says that if she had not become a photojournalist she never would have become a Buddhist. Let us trace her steps over these three-and-a-half decades. But first let us acquaint ourselves with the woman who started on that journey in the 1960s.

Marilyn's grandparents were Jewish immigrants who fled Poland to America to escape from the pogroms. Her father became a movie mogul for 20th Century Fox and her mother was an intrepid lady who would go to university to get a college degree when she was eighty. Marilyn herself was a graduate of Wellesley College. She broke into freelance photography when a friend taught her how to use a camera.

In 1959 she went to India and for fourteen years she worked and lived in Bombay then New Delhi with the eminent Indian journalist and editor Frank Moraes. There she lived a very social life where she knew everyone from the prime minister to the diplomatic corps and visiting dignitaries. She photographed floods, famine, and wars, and the entire subcontinent up to Iran and east to Japan became her stamping ground. She worked for major magazines worldwide, covering the arrival of the Dalai Lama in India (where she was arrested), the wedding of the American Hope Cooke to the Chogyal of Sikkim, the coronation of the Shah of Iran. She met Lumumba, Kenneth Kaunda, Haile Selassie, Albert Schweitzer, and got to know Nehru and his family.

She says that when she was fifteen she read Fosco Maraini's book *Secret Tibet* and that she had been haunted by it ever since. When Frank Moraes died she began to realize that although hers had been a full life, still photography now seemed a predatory pursuit and that she had, almost unconsciously, been moving toward Tibetan Buddhism and found herself studying the Tibetan language.

A friend asked was she unequivocally happy with this new life?

"Oh yes." Her face lit up with a radiant smile. "It's so joyful. And I feel good about this way because I worked for twenty-five years first. I worked my ass off. I can say that I did it all. The secret though is just keep walking through life without analyzing it too much or clinging to it too much. Just walk on."

Eve Arnold

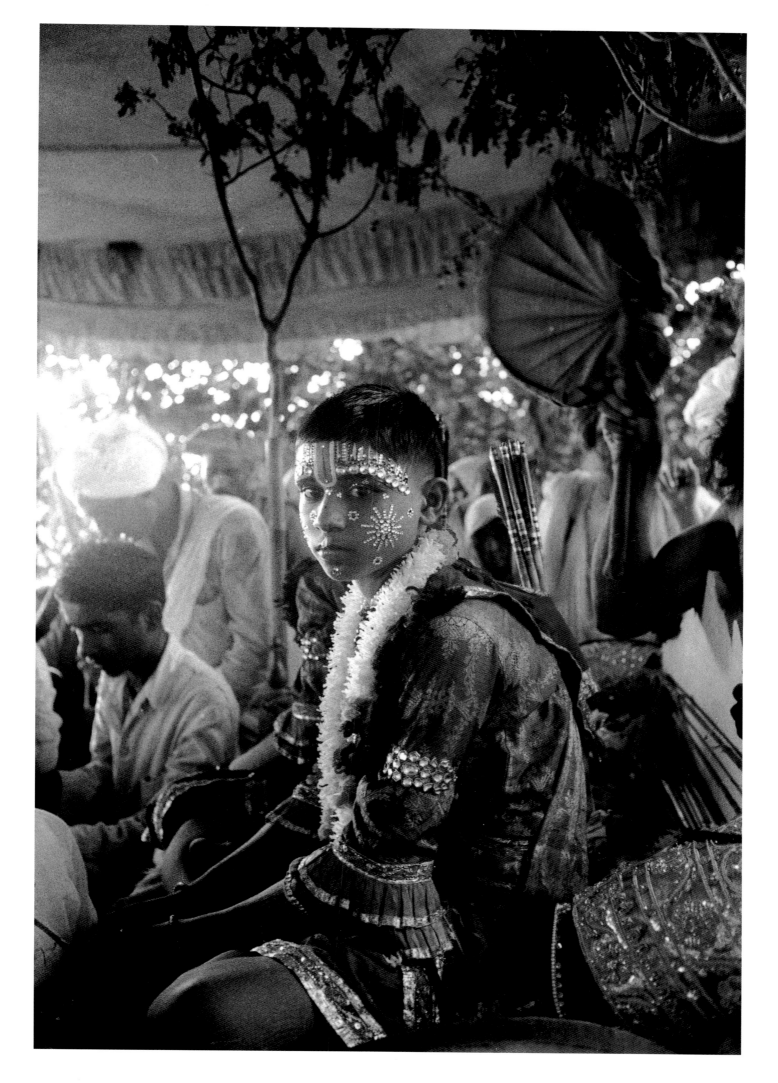

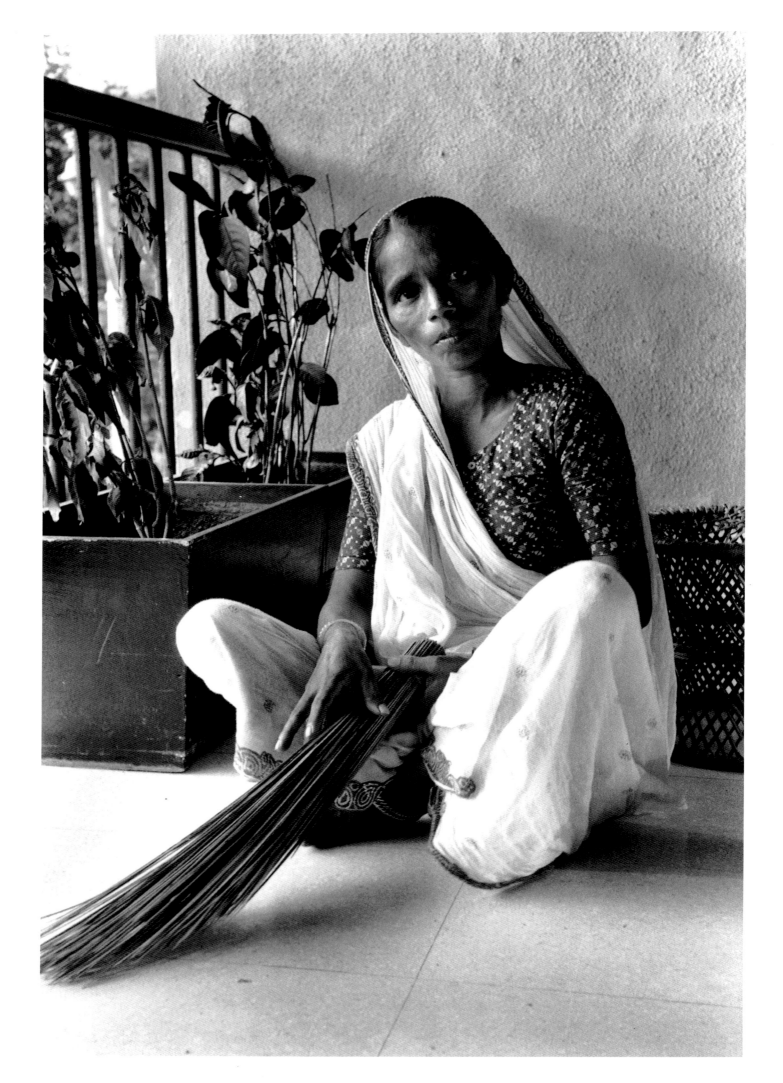

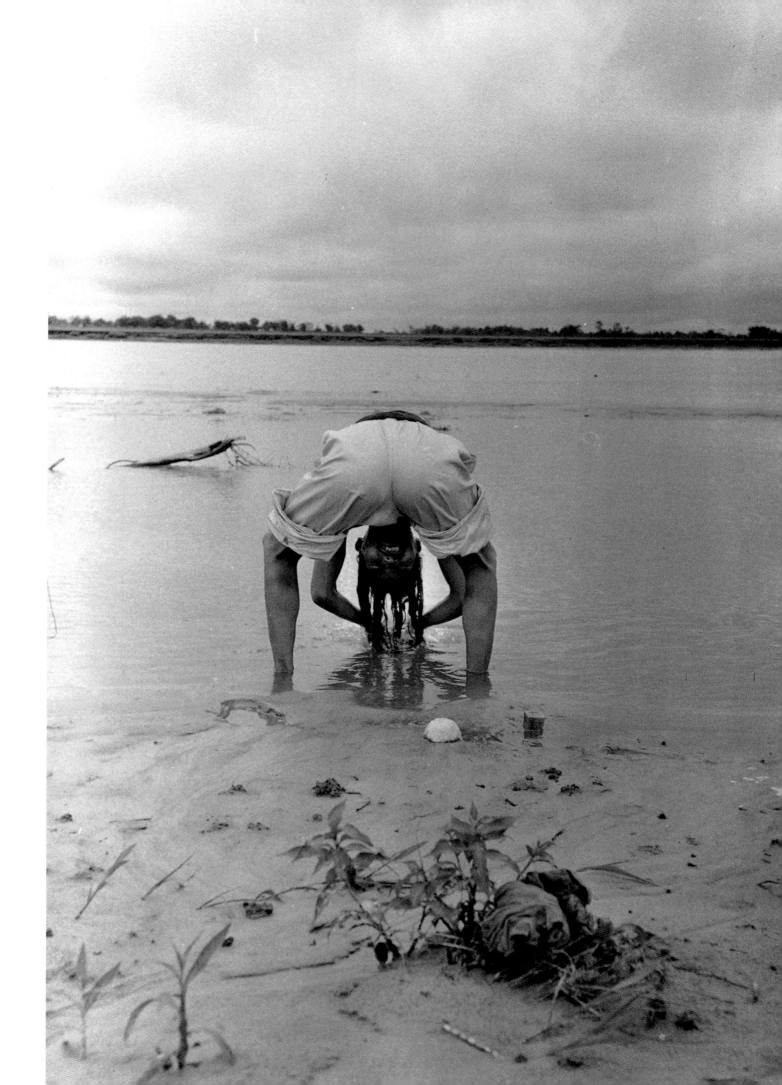

◁◁◁  Young boy dressed as Rama, Kamlila Festival, 1959

◁◁  Prema Mathur Solanki, 1960

◁  Tibetan refugee washing his hair in river, 1959

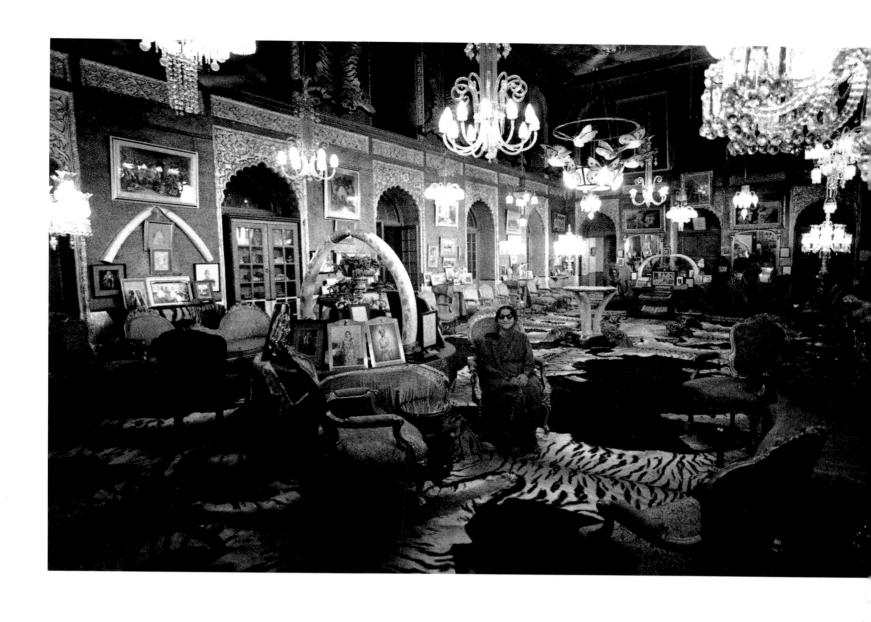

India. Dalai Lama at Siliguri station, West Bengal, 1959

India. Lady "Vizzy" with tiger pelts, 1959

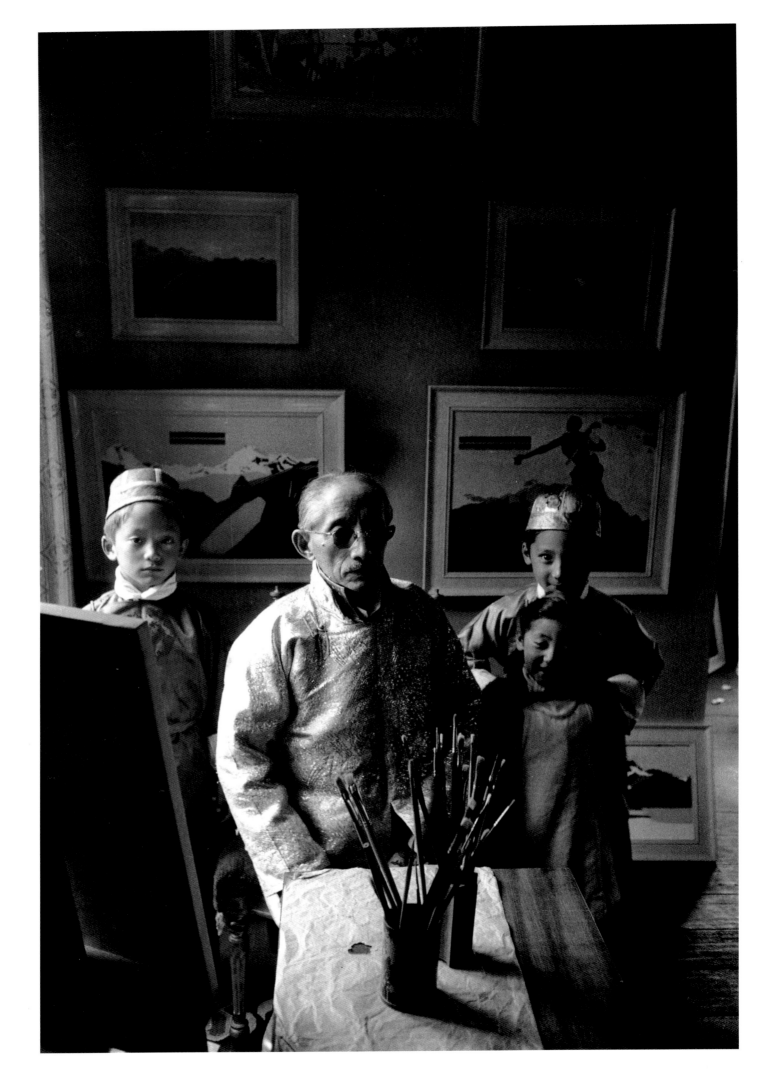

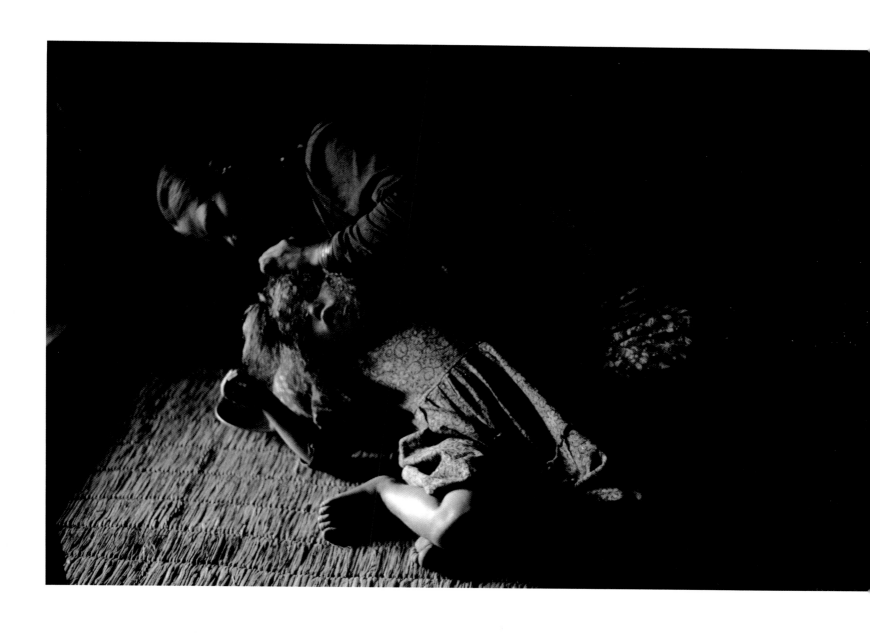

Sikkim. Sir Tashi Namgyal with his grandchildren, 1960

West Nepal. Gurung mother and daughter, 1962

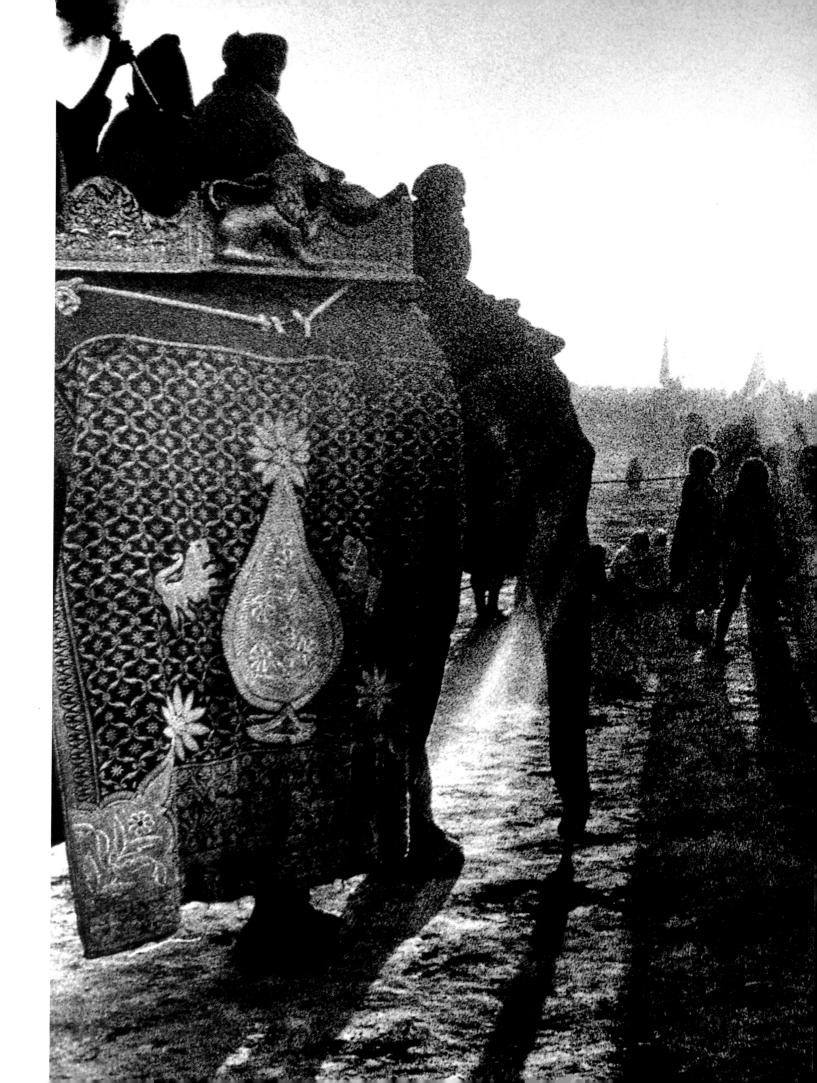

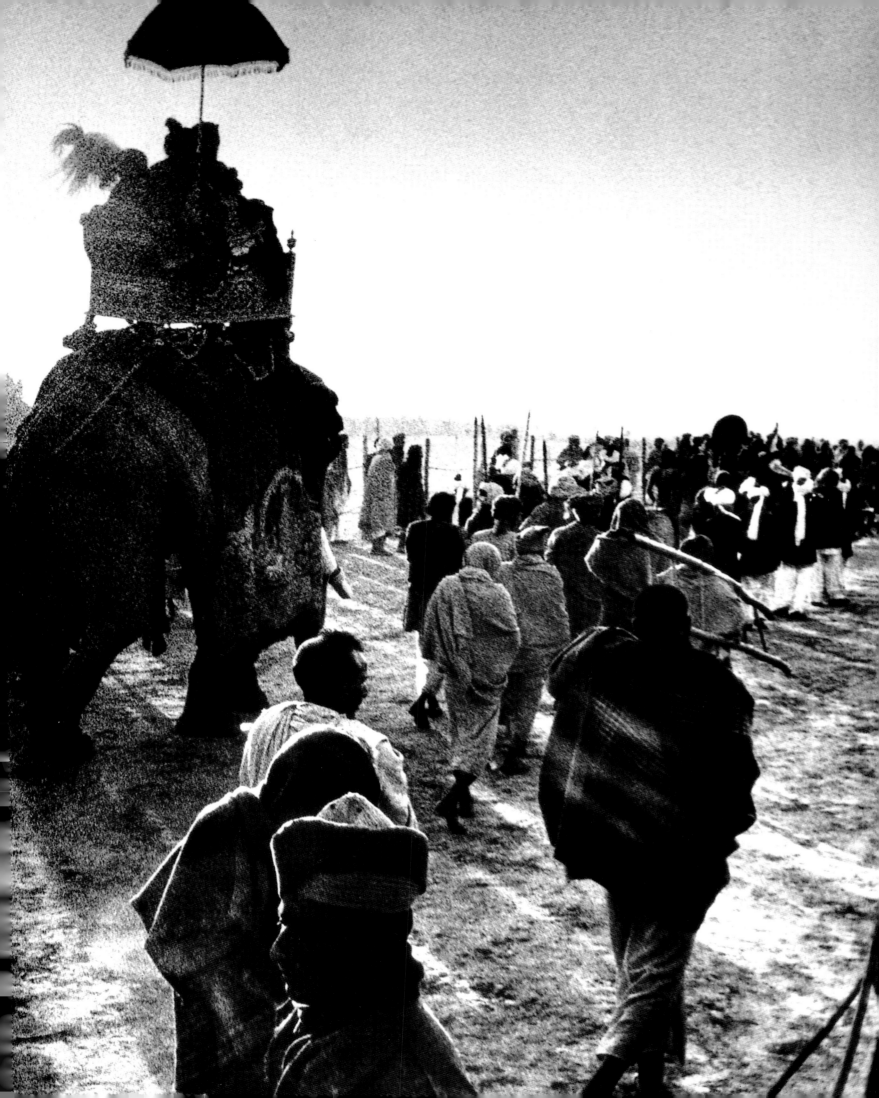

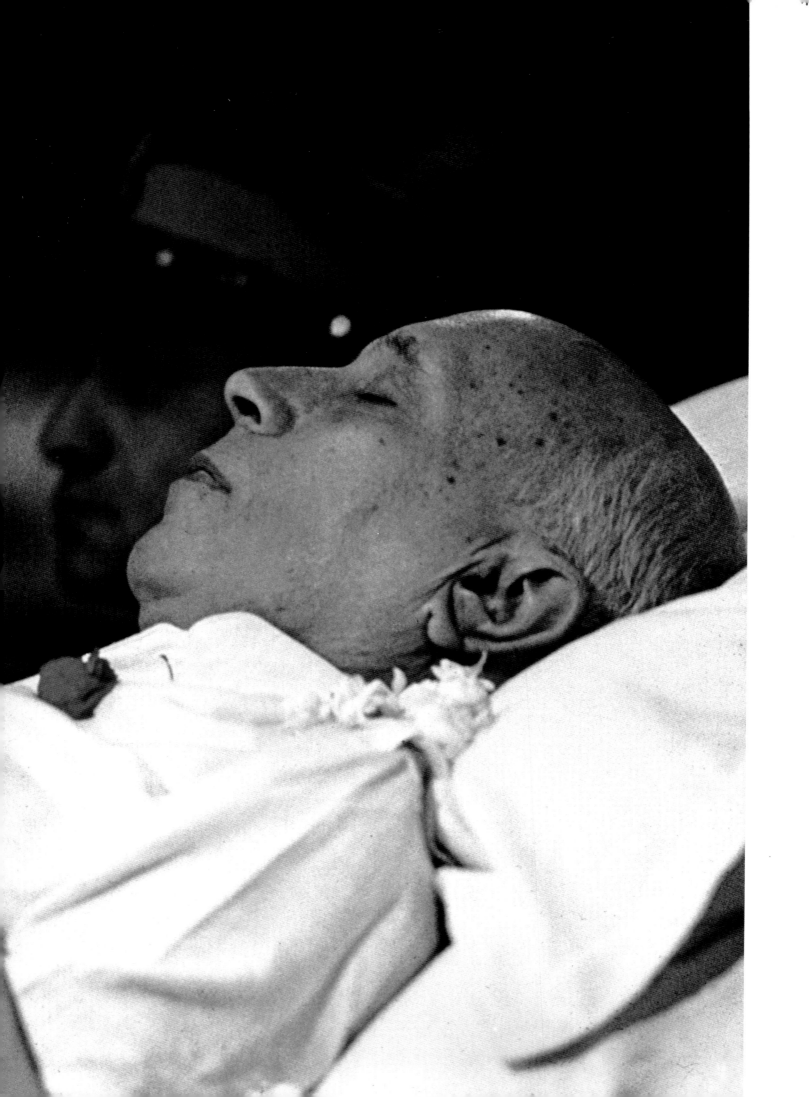

◁◁ India. Allahabad, Kumbh Mela Festival, 1960

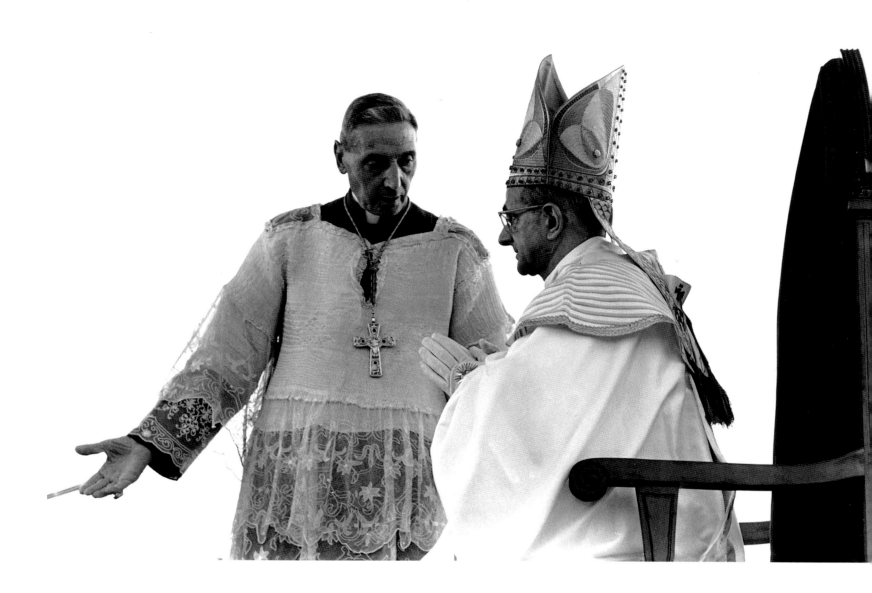

India. Nehru's funeral bier, 1964

India. Pope Paul VI in Bombay, 30 November 1964

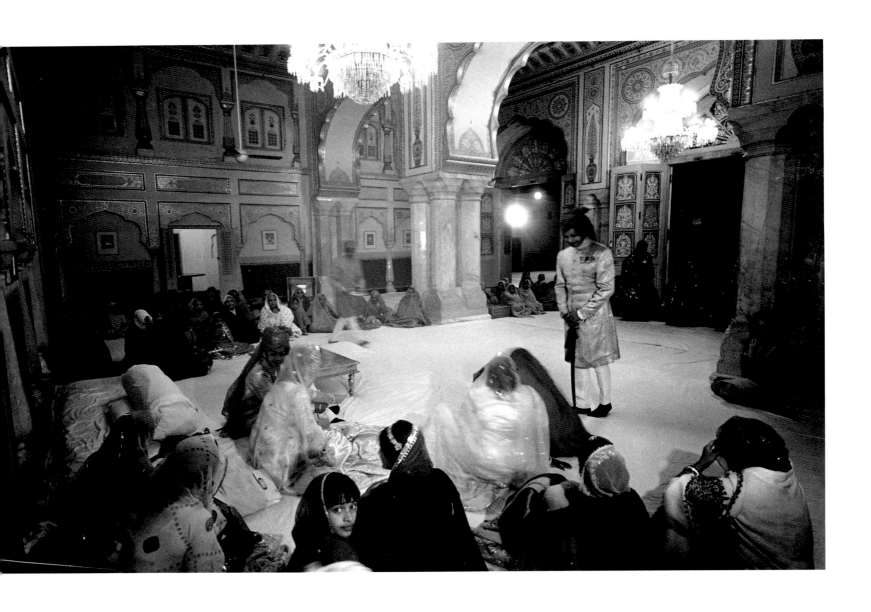

India. The Maharani of Jaipur gives a birthday reception for the Maharaja's son in the women's quarters of the city palace, Jaipur, 1964

Sikkim. His Highness the 16th Gyalwa Karmapa, 1965

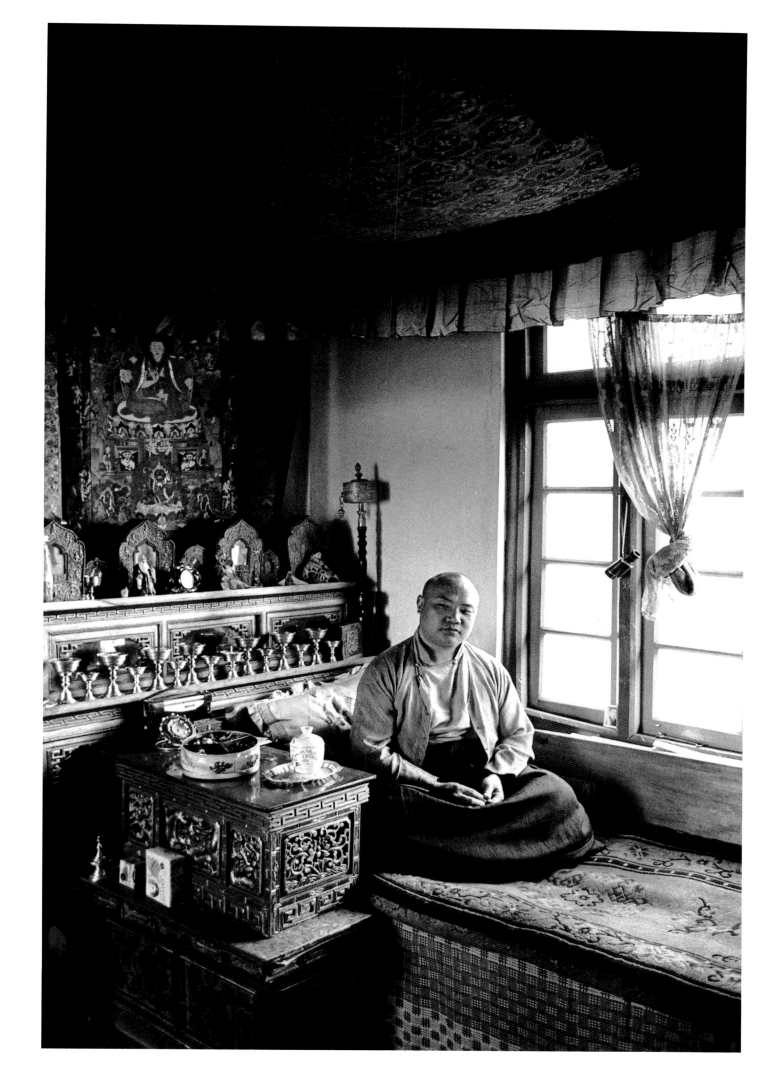

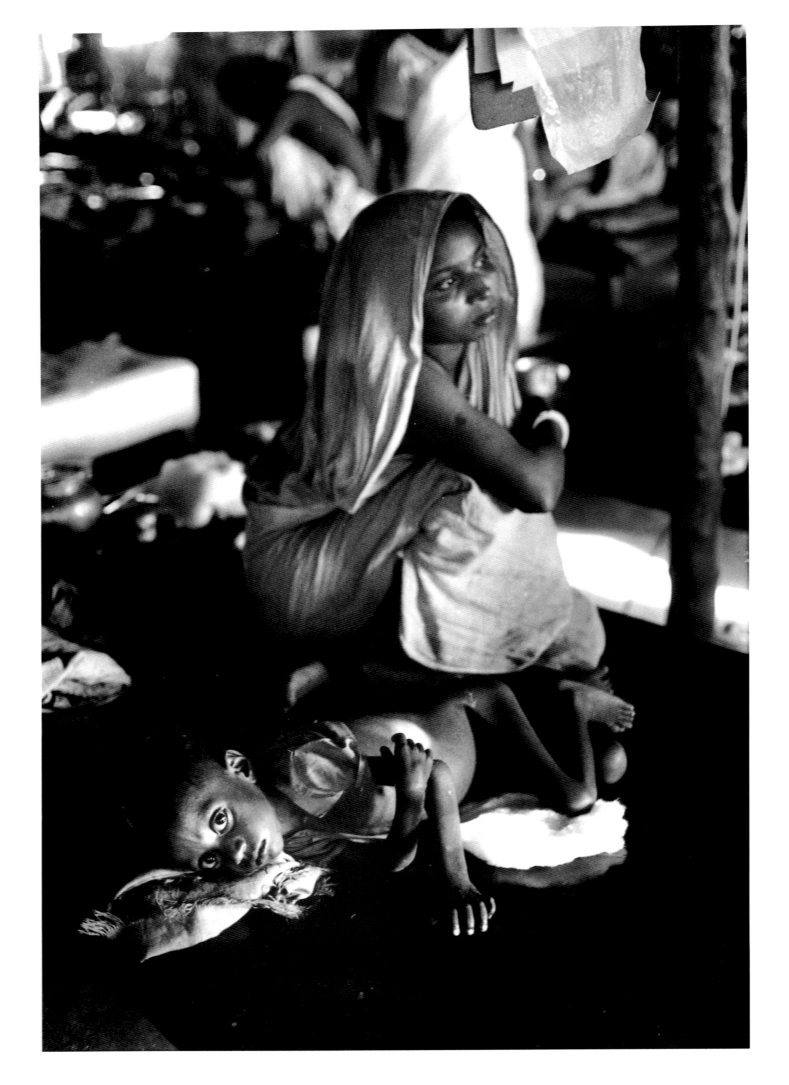

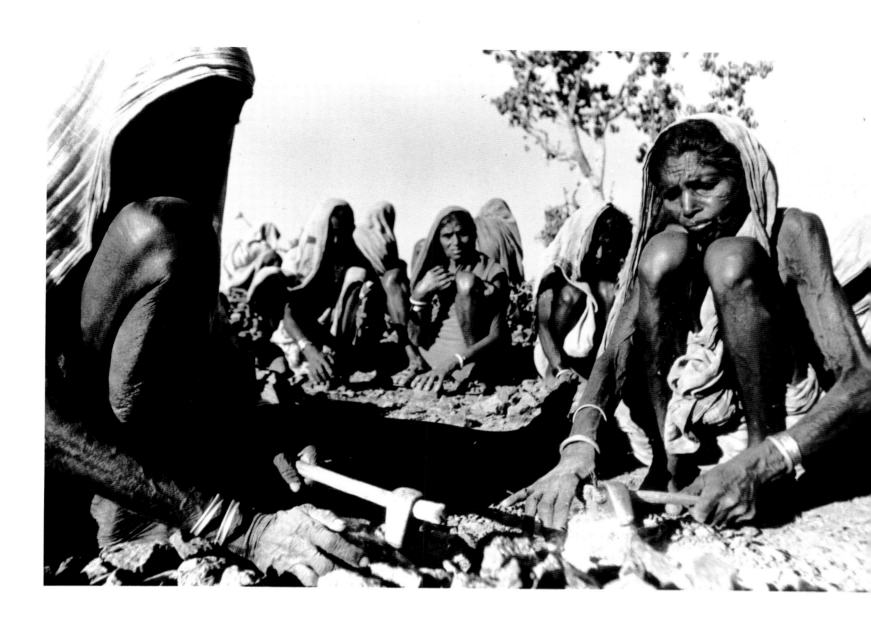

East Pakistan. Refugee camp, woman and child, 1971

India. Drought and famine, women breaking rocks, 1966

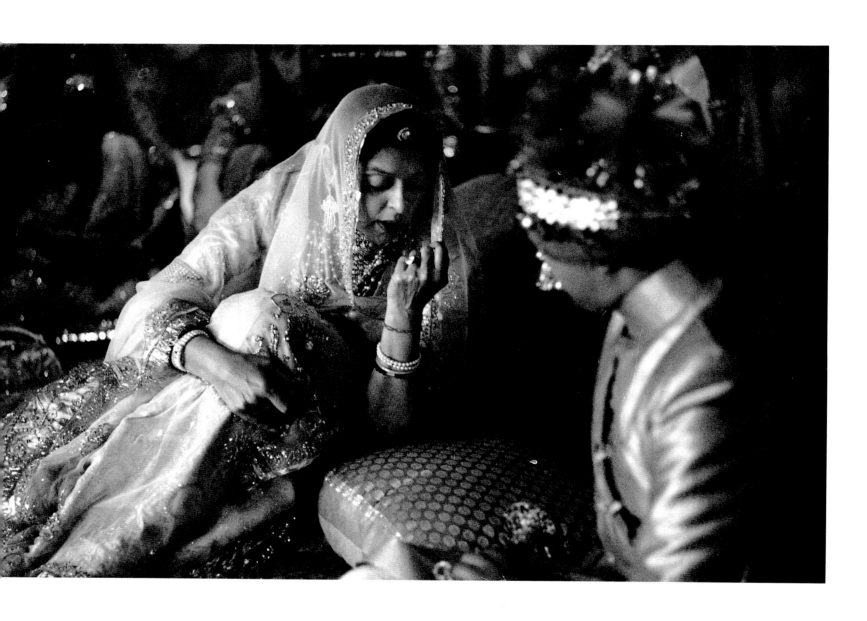

Maharani Gayatri Devi of Jaipur before wedding of "Bubbles", Maharaja of Jaipur's son, 1966

Chotay Lal and family, 1966

India. Maharaja Sawai Singh of Jaipur leading escort of Maharajas. Wedding of "Bubbles", Maharaja of Jaipur's son, 1966

India. Prime Minister Shastri performing task of spinning, on the platform on which Gandhi was cremated, 1965

Delhi. Sadhus' demonstration against cow slaughter, 1966  ▷

Delhi. Anti-riot police, 1966  ▷▷

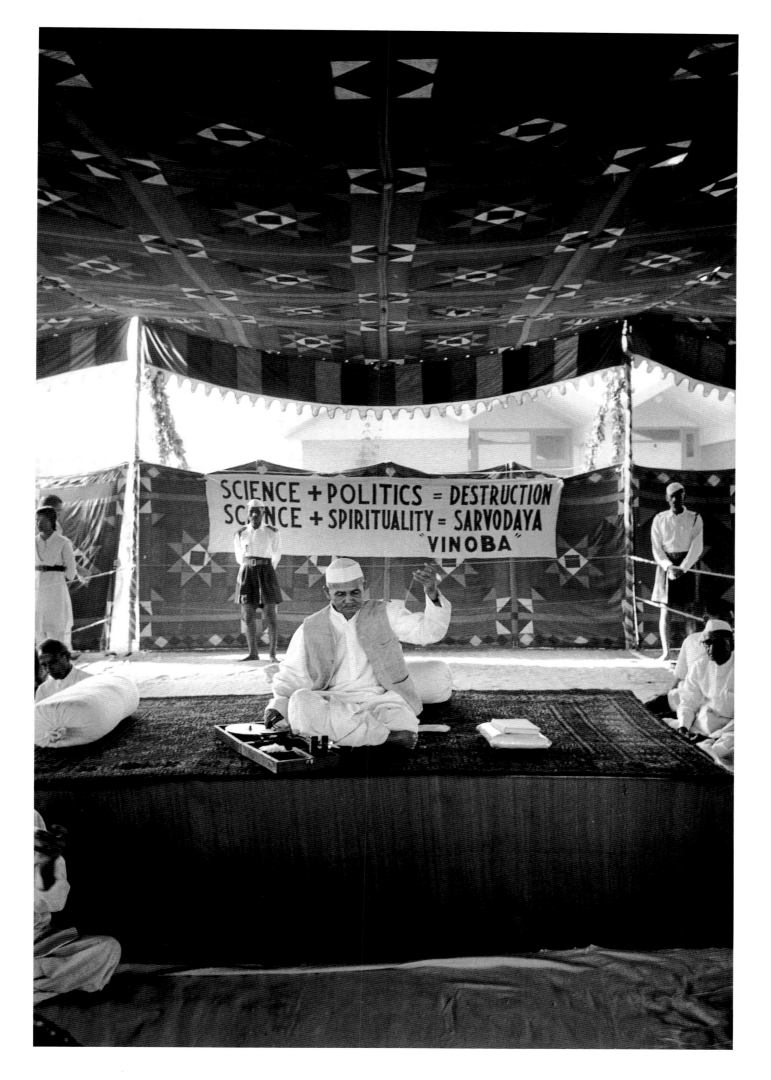

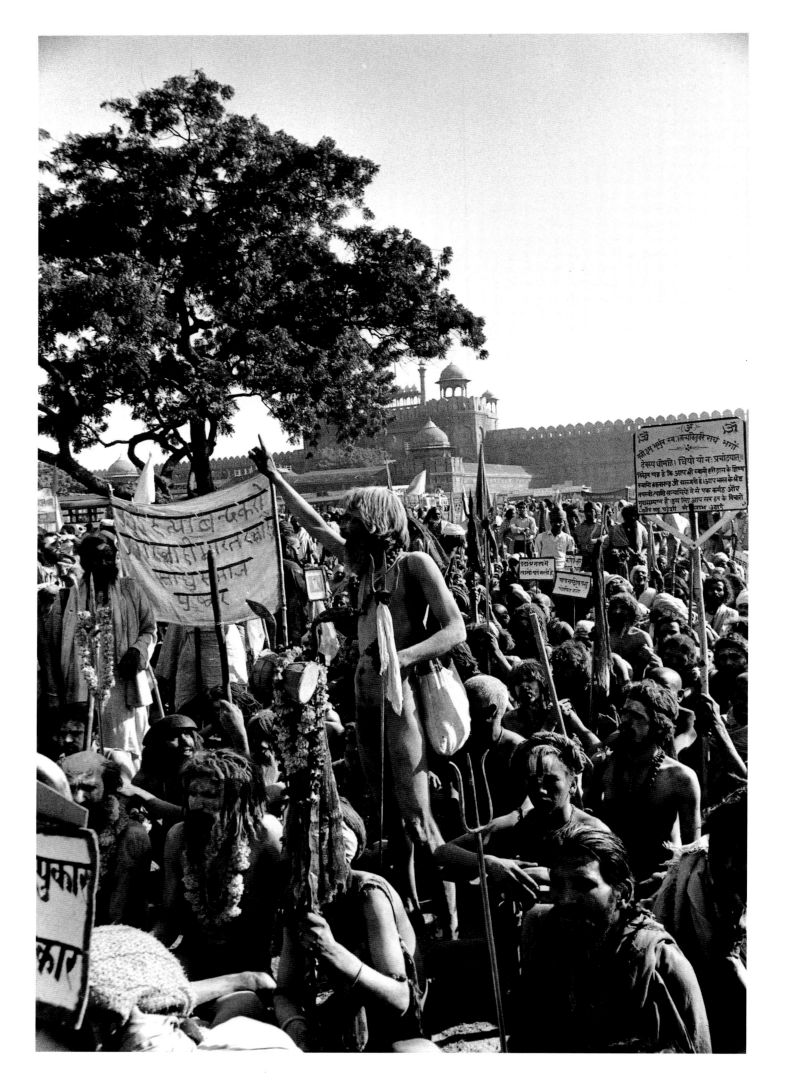

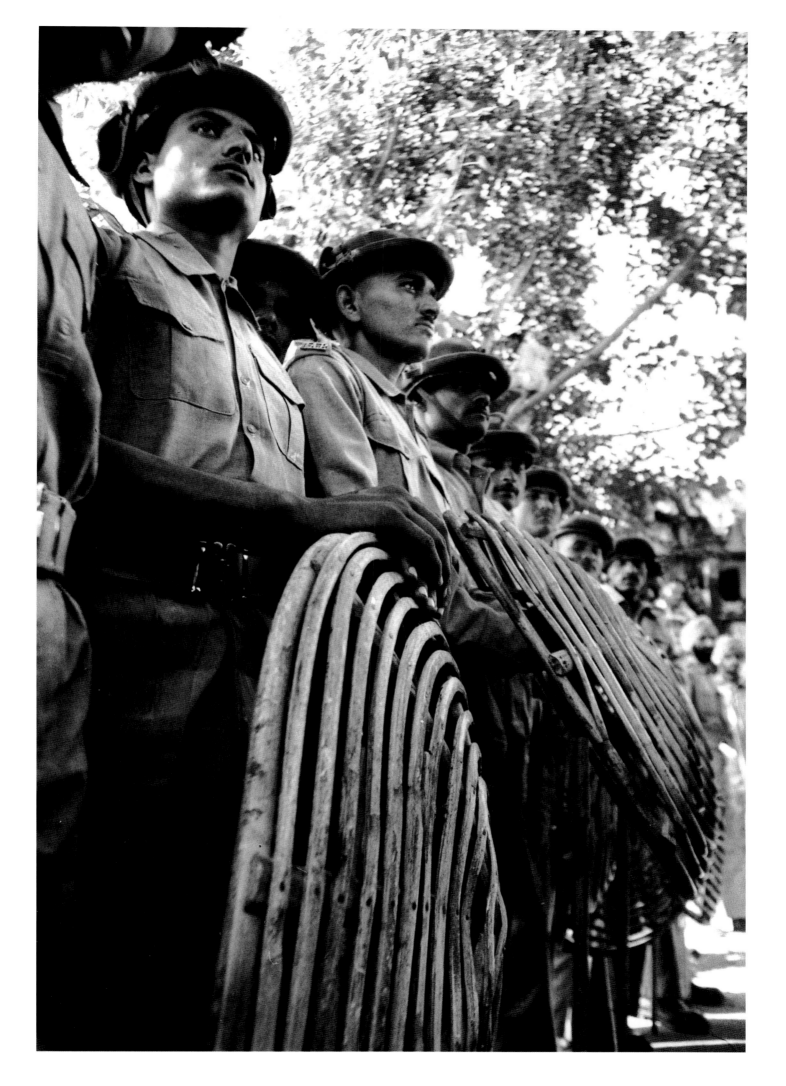

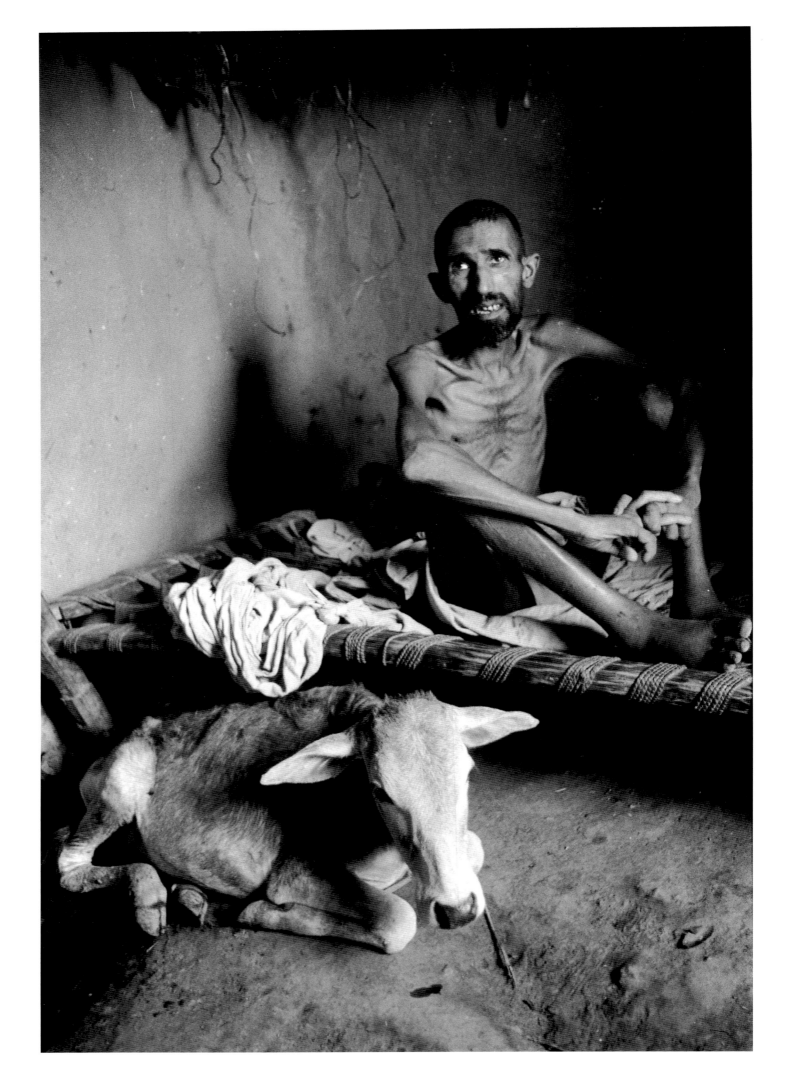

India. Bihar famine, 45-year-old man dying of hunger, 1967

East Pakistan. Exhausted mother and child, 1971

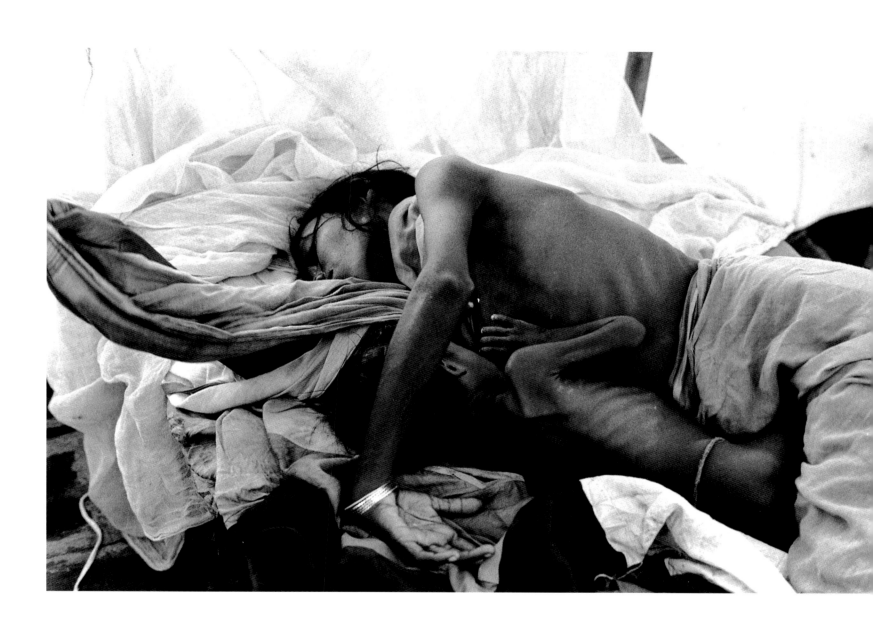

Ladakh. Tibetan children with writing slates, 1969 ▷

Ladakh. Raja and Rani of Stok on their palace roof, 1969 ▷▷

India. Indira Gandhi campaigning, 1971 ▷▷▷

India. Wedding couple with wedding threads, 1963 ▷▷▷▷

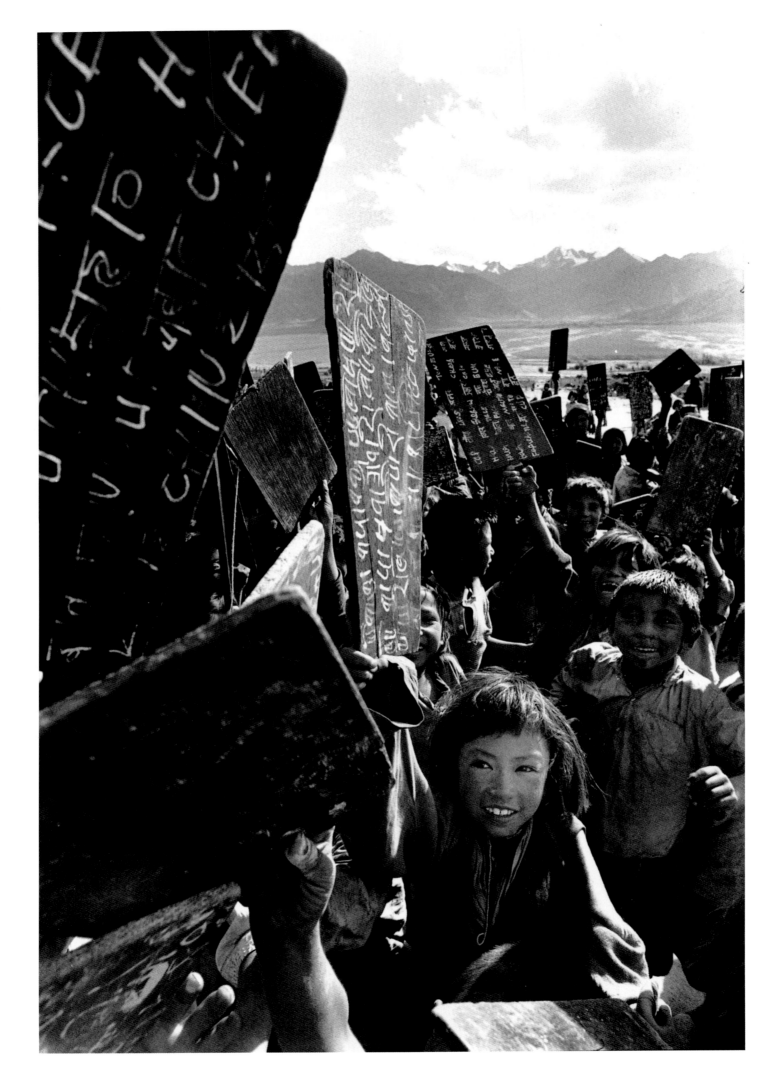

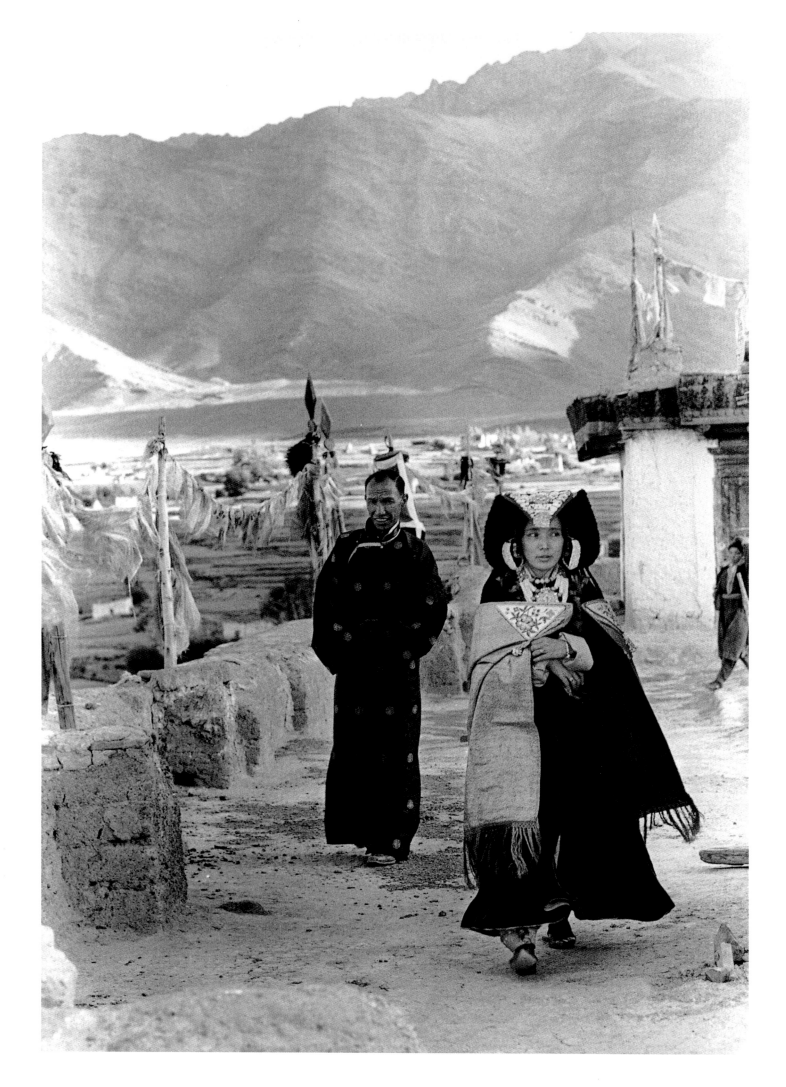

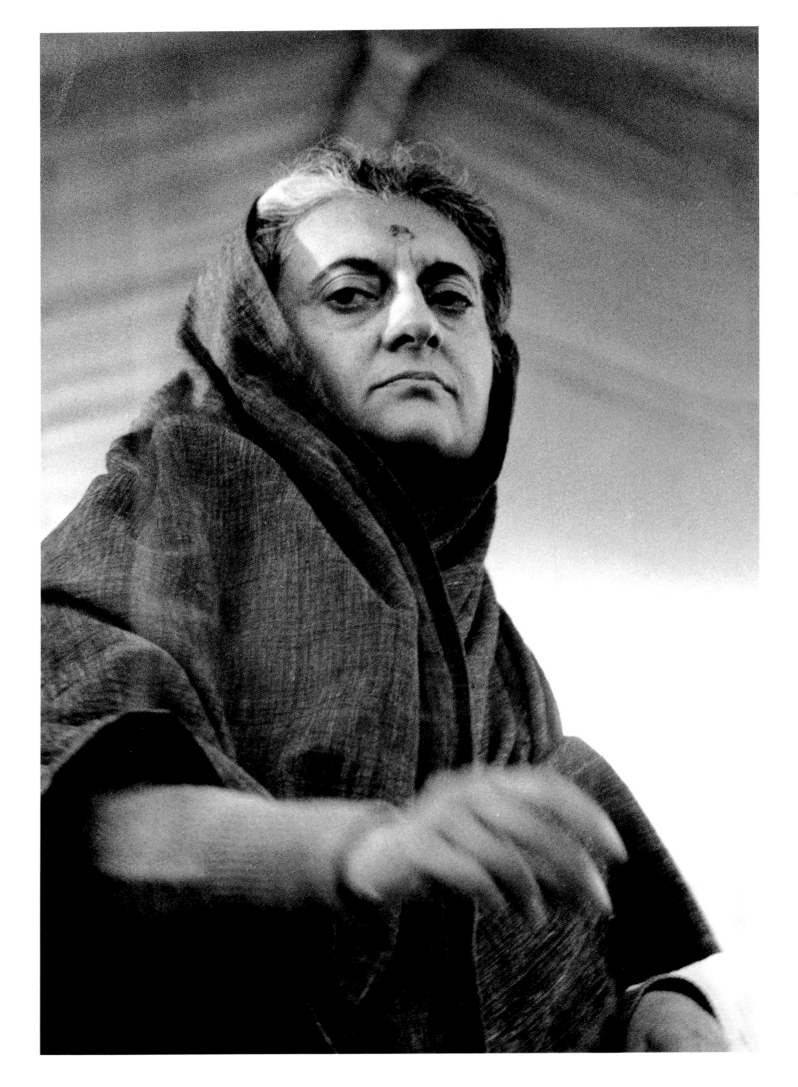

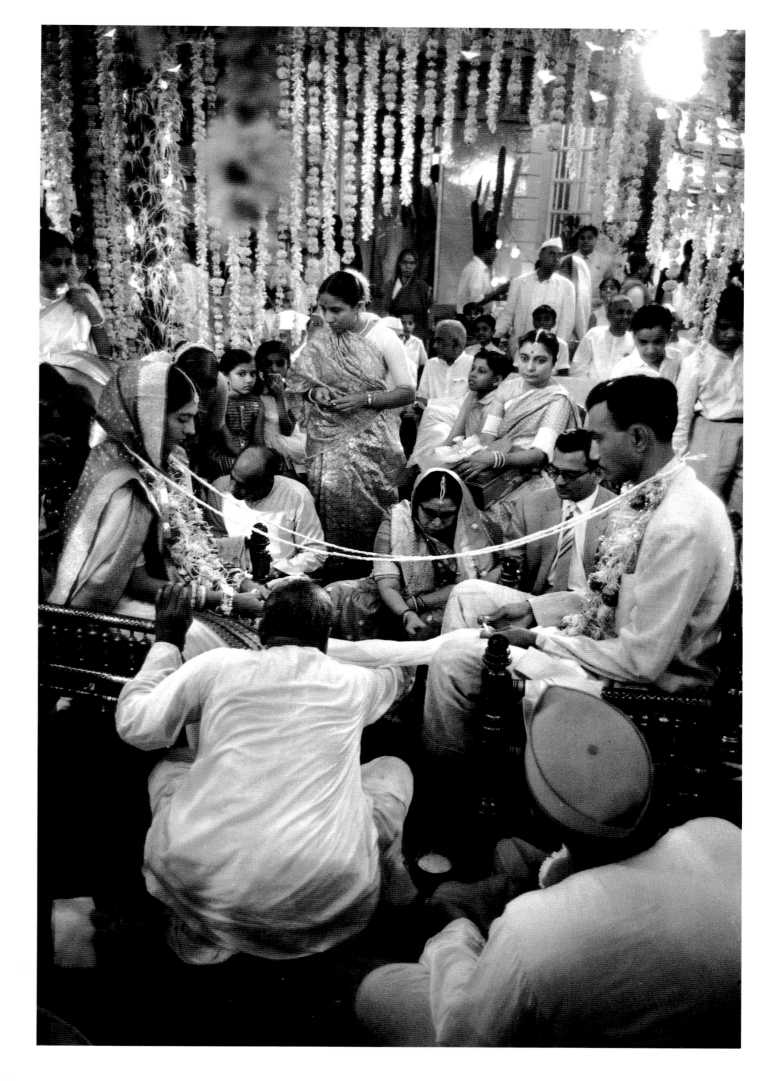

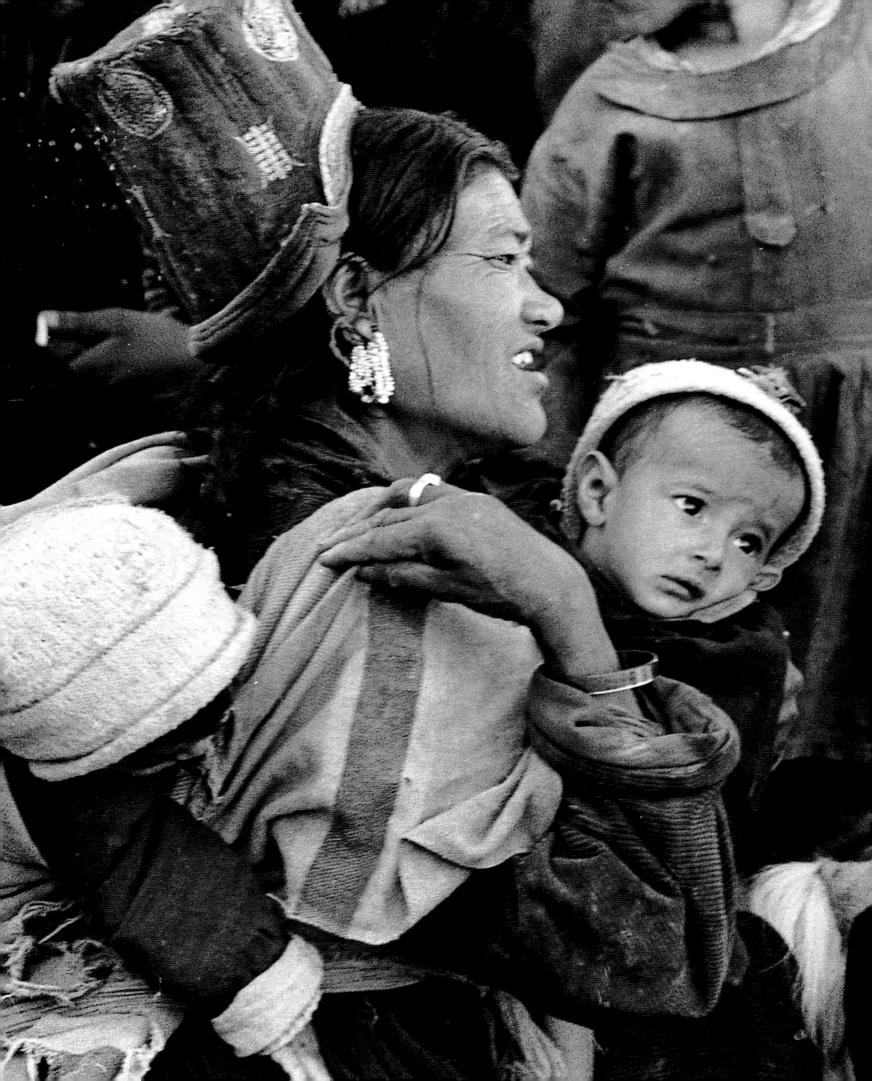

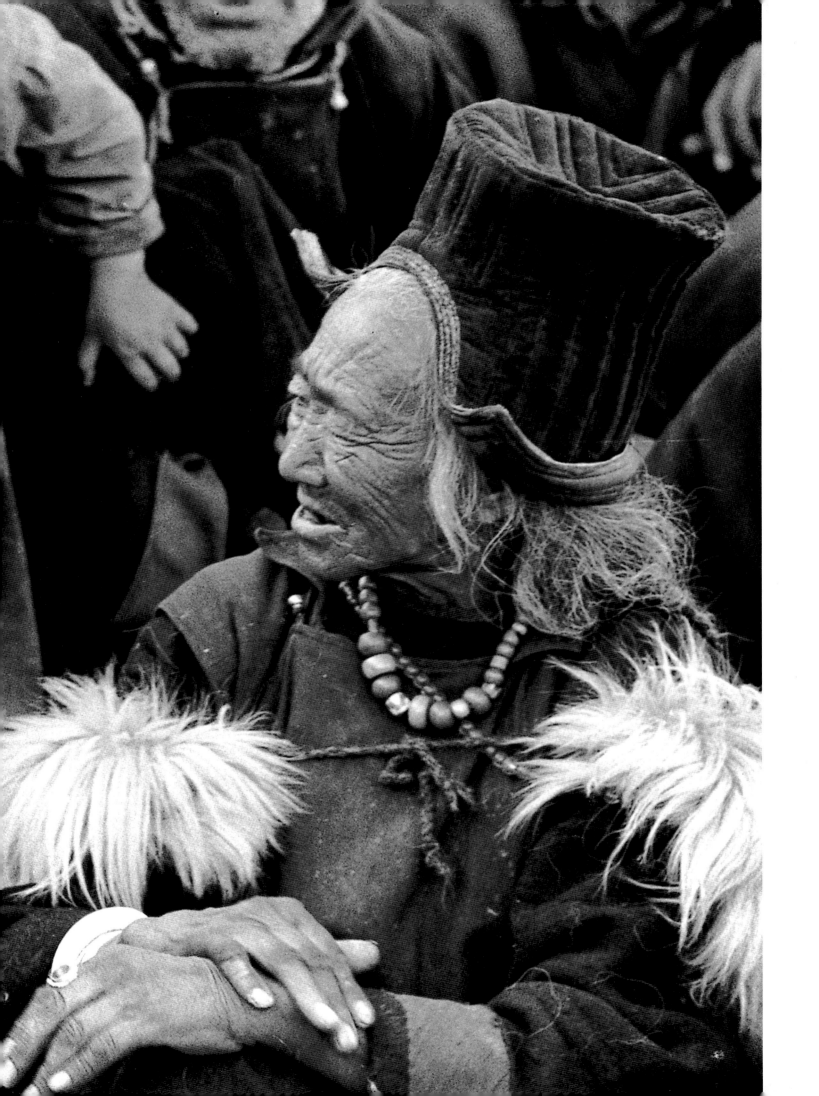

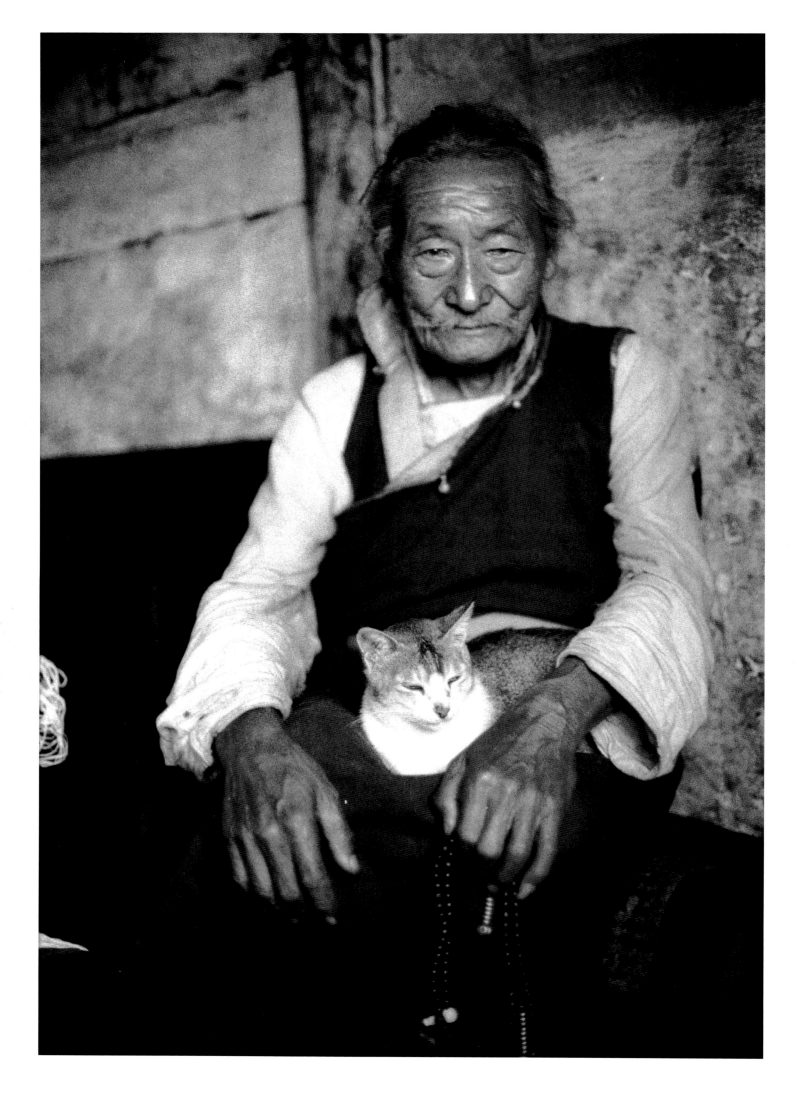

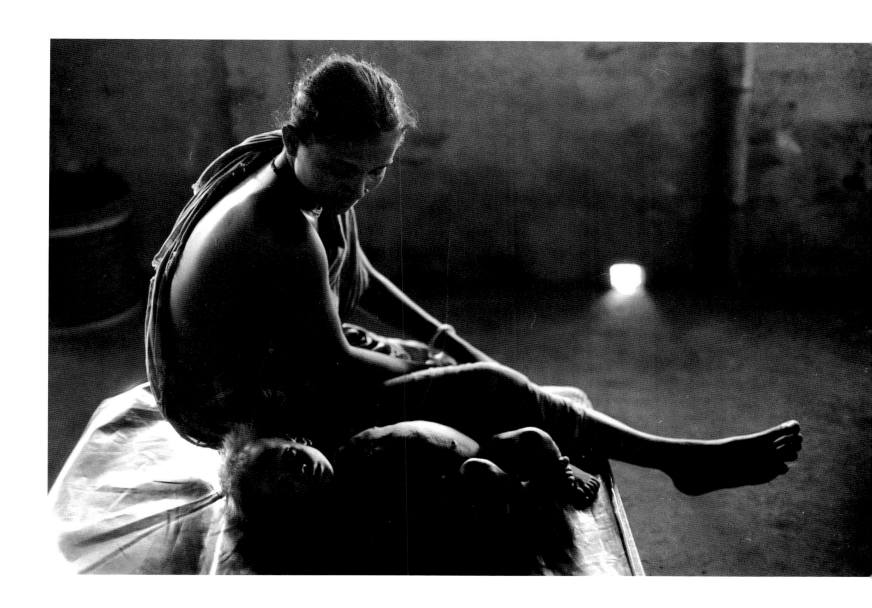

◁◁ Ladakh. Women at a polo match, 1969

Sikkim. The Lingdok Gomchen, 1972

East Pakistan. Haringata camp, woman and child, 1971

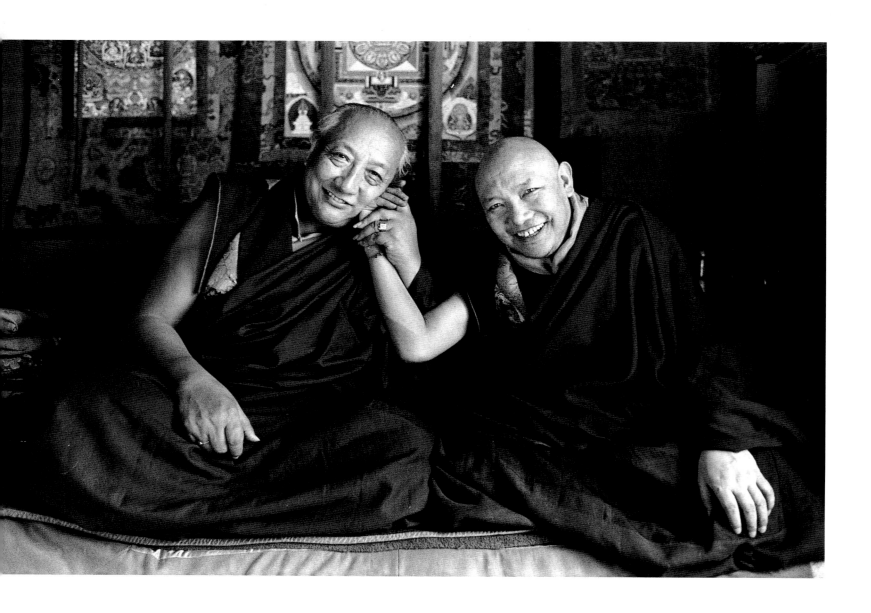

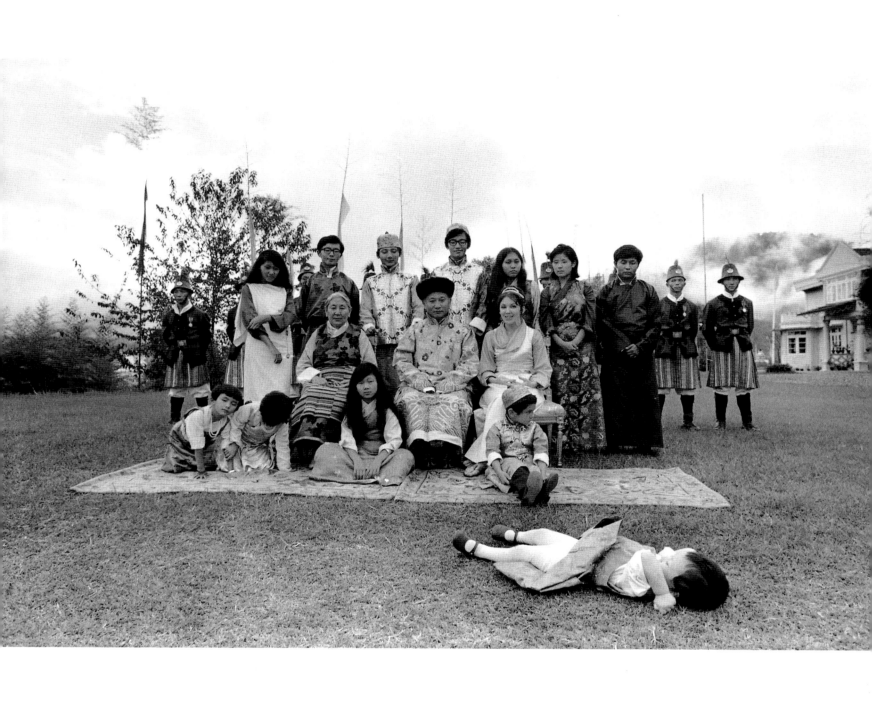

Nepal. His Holiness Dilgo Khyentse Rinpoche with Trulshik Rinpoche, 1977

Sikkim. Chogyal Palden Thondup Namgyal and family, 1969

Sikkim. Venerable Khanpo Thupten and pupil, 1972

India. Mother Teresa, 1972

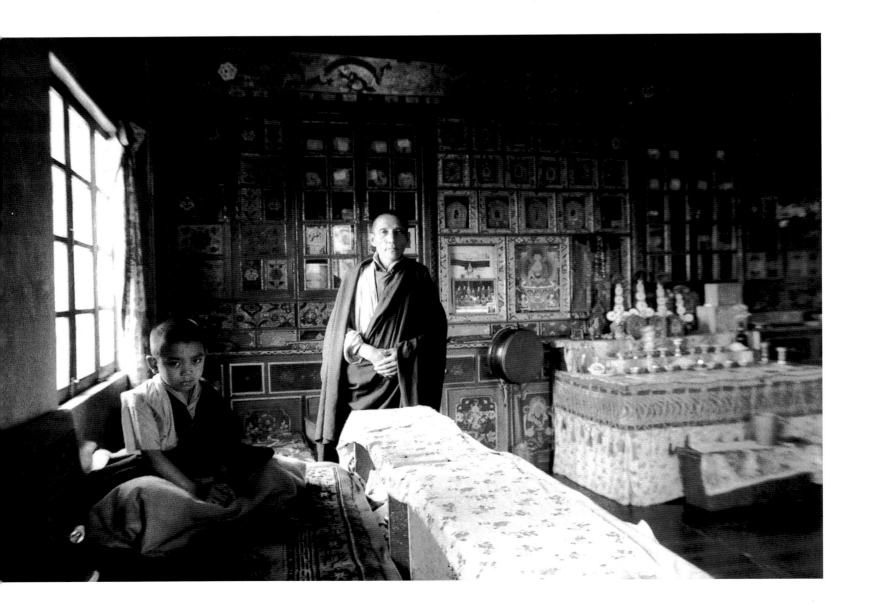

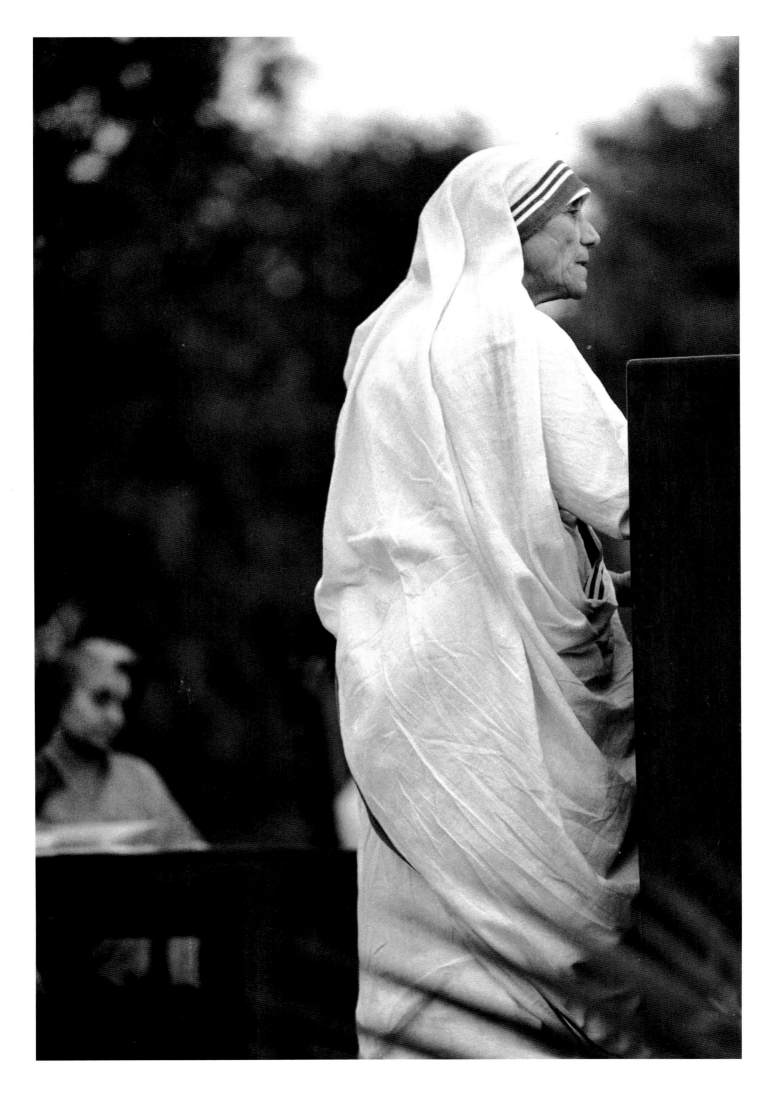

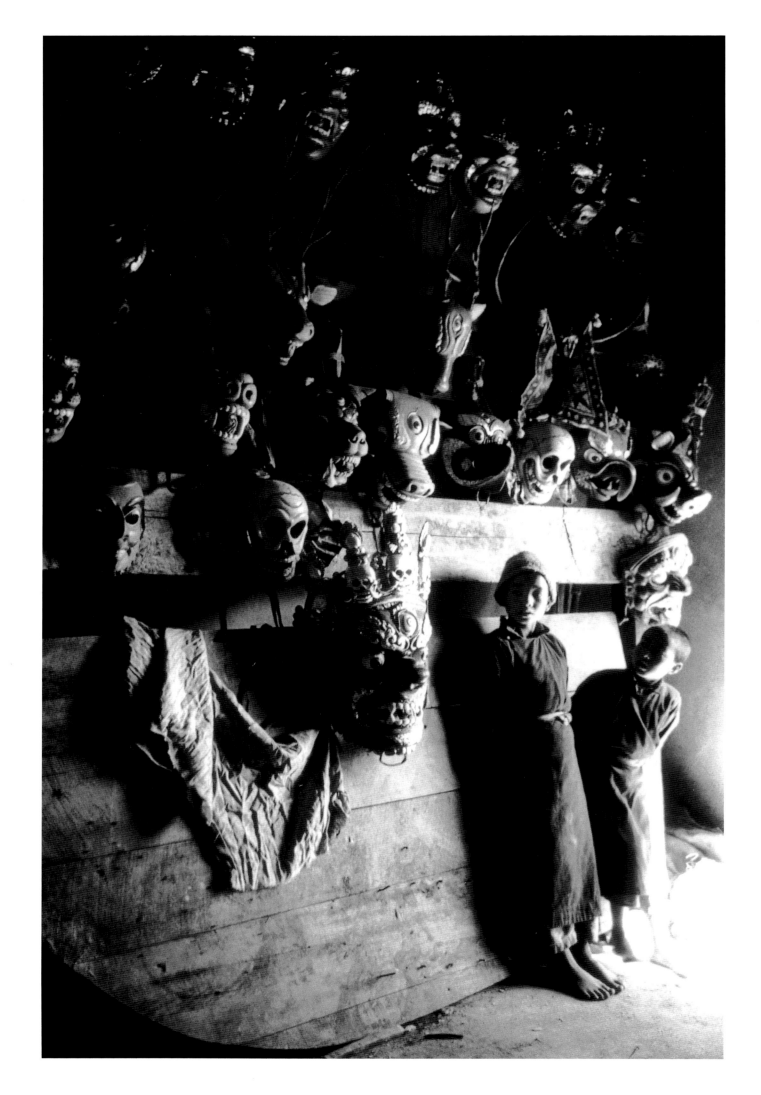

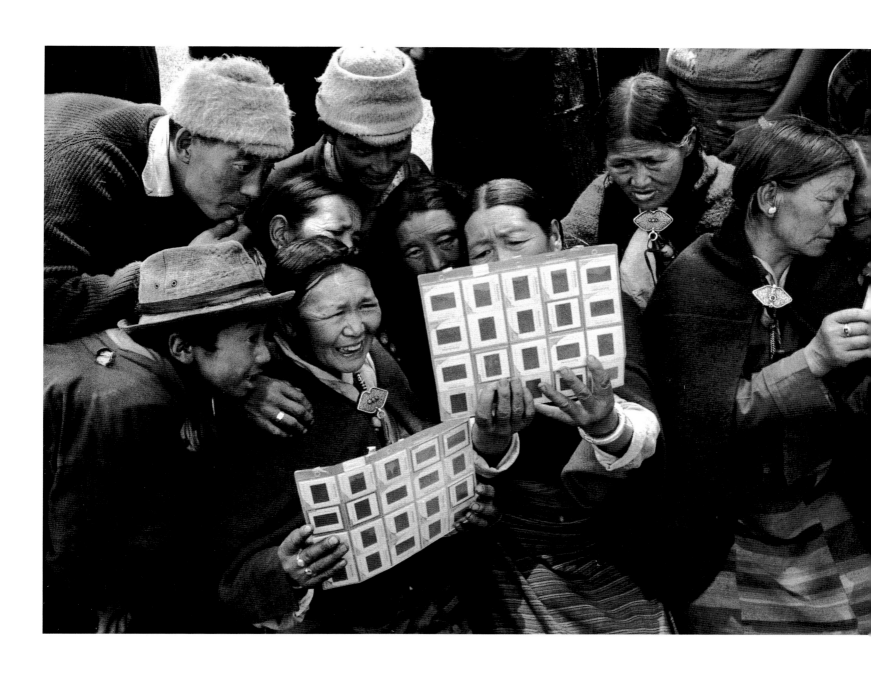

Sikkim. Mask room at Pemayangtse monastery, 1967

Sikkim villagers looking at slides of themselves, 1971

Photo: © Lise Sarfati Collection

# Lise Sarfati

Lise Sarfati is French and was born on April 12, 1958 in Oran, Algeria. She took a master's degree in Russian at the Sorbonne in Paris.

### Exhibitions
1995  Naarden Photo Festival, Holland
1995  Visa pour l'image. Perpignan, France
1996  Pauvres de nous. Hôtel de Ville, Paris
1996  Prix Niépce, Centre national de
la photographie, Paris
1996–1997  Musée Nicéphore Niépce,
Châlon-sur-Saône, France
1997  Galerie photographique, Montpellier
1997  Tarbes, France
1997  Cahors, France

### Awards
1992  Panorama Européen Kodak de la jeune
photographie professionelle, Arles, France
1993  Prix Yann Geoffroy, Milan, Italy
1995  First prize for documentary photography,
Ernst Haas Award, Maine, USA
1995  Visa d'Or Kodak du Jeune Reporter,
Perpignan, France
1996  First prize for documentary photography,
Ernst Haas Award, Maine, USA
1996  Prize from the International Center
of Photography (ICP), New York
1996  Prix Niépce, Paris

### Publications
1998  *Les révolutions invisibles*
(Calmann Levy, Paris)

### Collections
Fonds national d'art contemporain, Paris
Musée Nicéphore Niépce, Châlon-sur-Saône, France
Fondation NSMVI (Banque Neufile
Schlumberger) Paris
Mairie de Montpellier
The Boston Consulting Group, Paris
Bouwfonds Kunststichting, Holland

Ioulia, 20, St. Petersburg, 1999

Eight women

At home, in the dining room, in the bedroom
they pose to be photographed
sometimes a woman is sitting on a chair or a sofa and looks at me
another time a woman undresses
the women move around the room awkwardly
they don't know how to bring out their desire

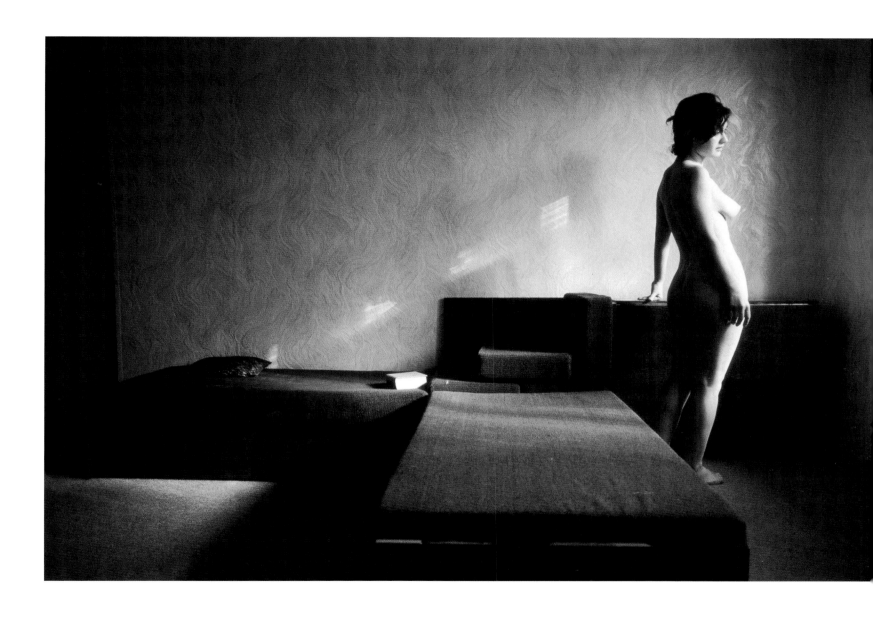

they bump into the objects that surround them
mirror, piano, sofa, cigarette, stool, door, bed
the women are physical
the rupture; a man who changes himself into a woman
he overflows with femininity
I was attracted by Magnum in the way that opposites attract
Magnum is an agency where the majority are men
male photographers work in a way which is totally opposed to mine
they are strategical and defined and sometimes warriorlike
one can also find men
who are real women
and those are the ones that I like

*L.S.*

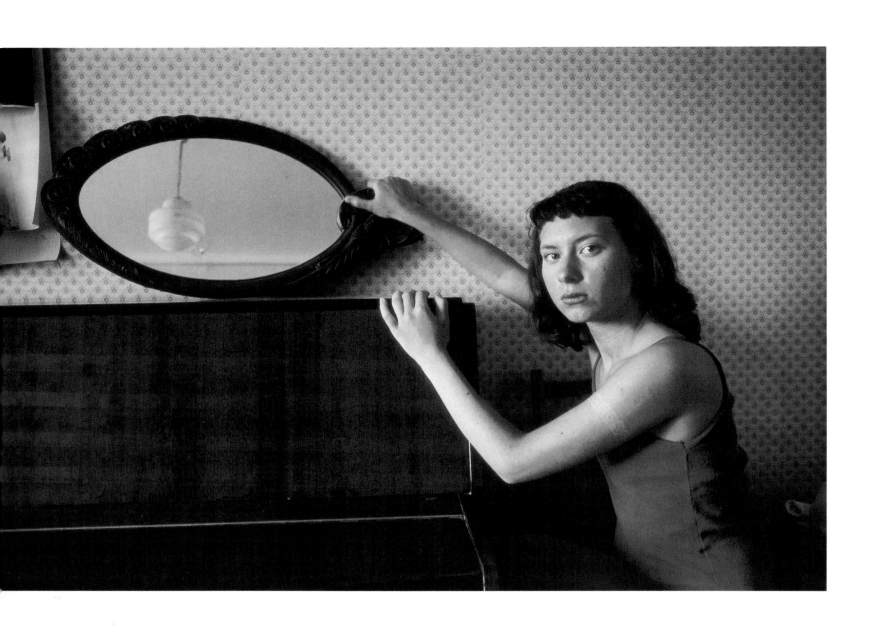

Lolita, 28, St. Petersburg, 1999

Ioulia, 21, St. Petersburg, 1999

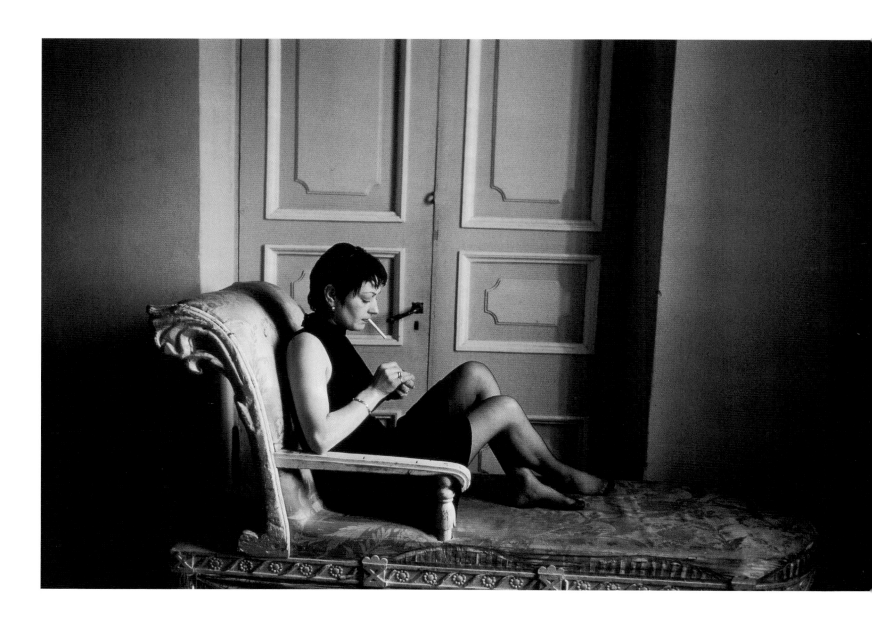

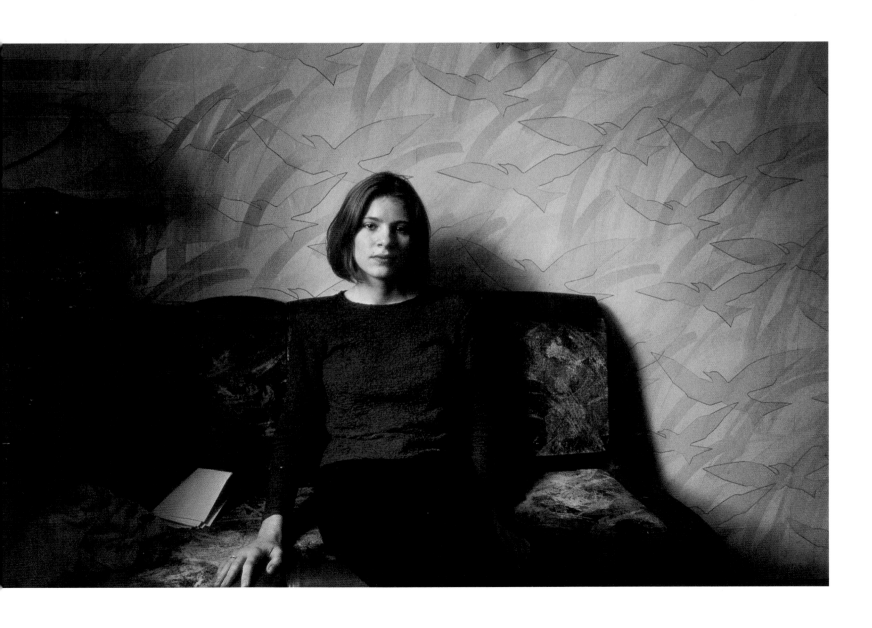

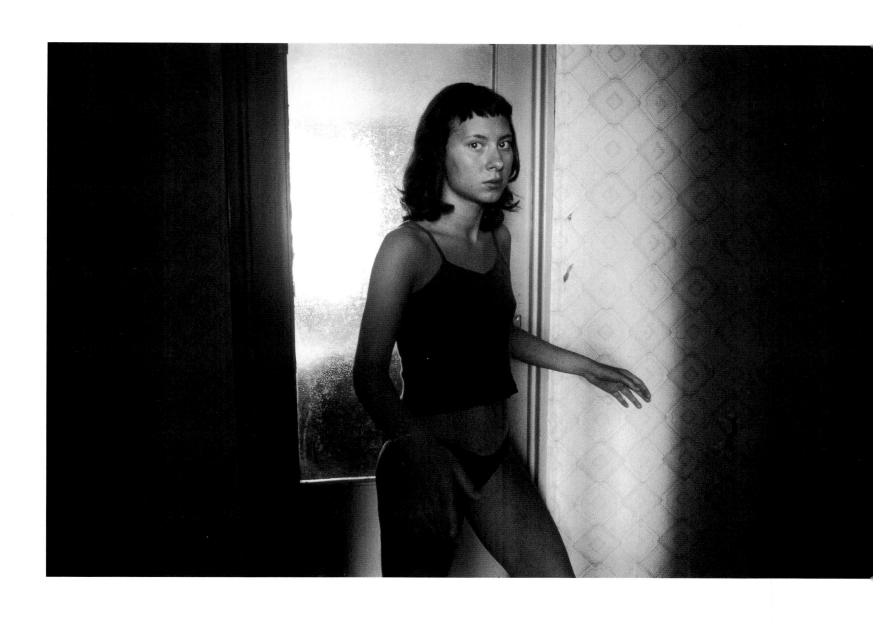

Ioulia, 20, St. Petersburg, 1999

Lolita, 28, St. Petersburg, 1999

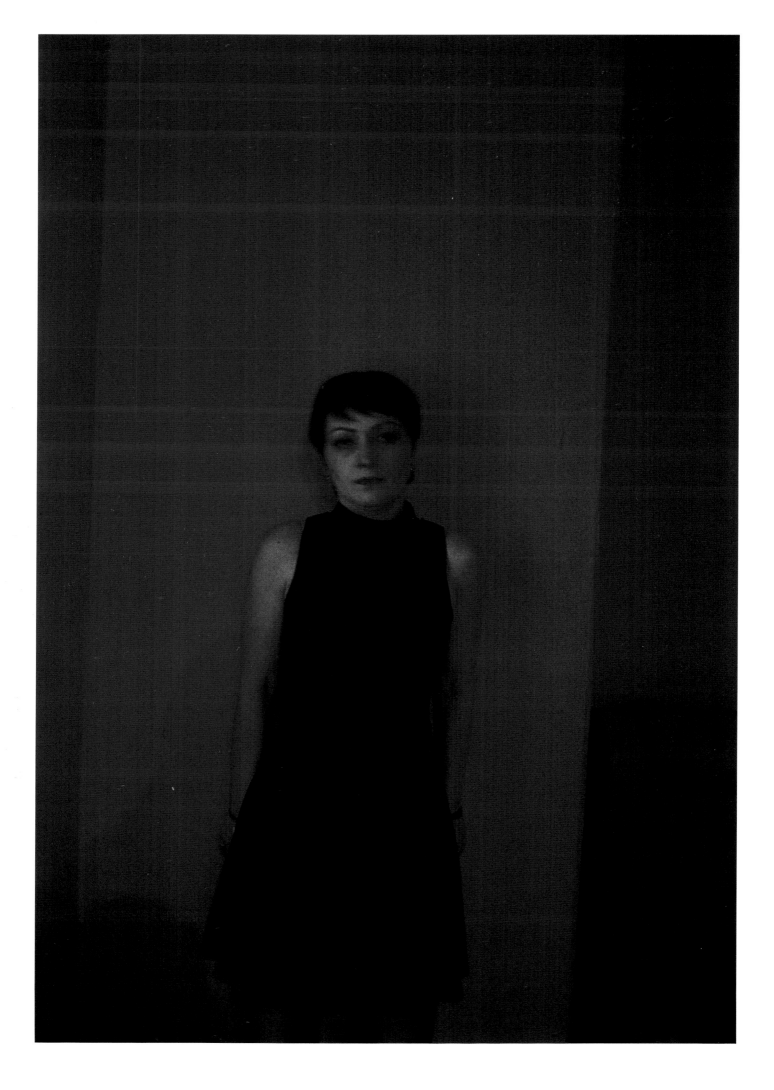

Christina, 21, St. Petersburg, 1999

Ania, 23, Moscow, 1999

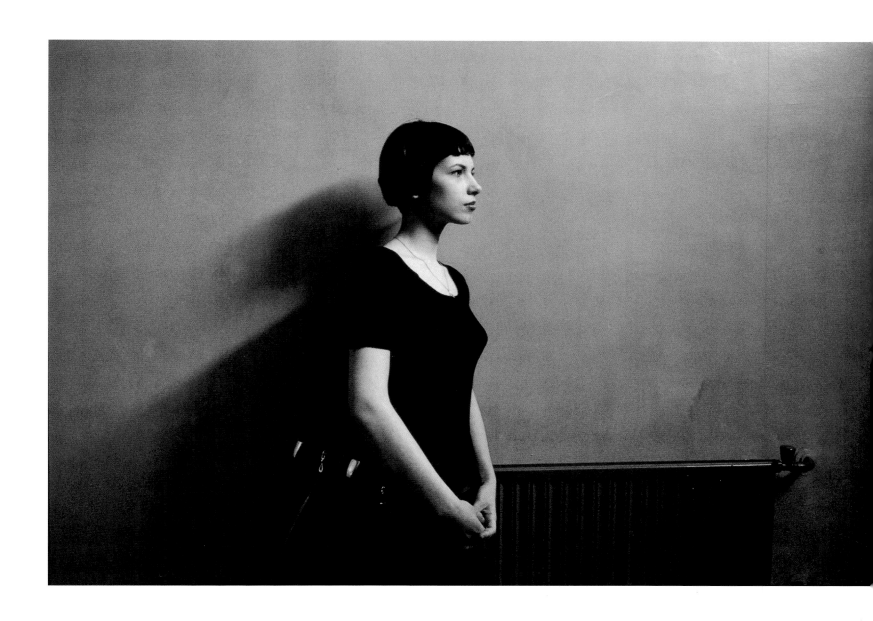

Alexandra, 24, Moscow, 1992

# MAGNA BRAVA

This book addresses the work of the five Magnum women photographers: Eve Arnold, Martine Franck, Susan Meiselas, Inge Morath, and Marilyn Silverstone. They have chosen the photographs to give an idea of their work, each concentrating on a broad stretch, while touching on the impact of the single image and the wider idea of the photo-essay, with its conjoined or narrative pictures. In an intelligent sense, it contains an idea of five working lives. By following the visual argument we can begin to see the heart and the passion behind the work—what matters to the photographers. It is that passion that expresses the person of the photographer. In Inge Morath's words: "Photography is essentially a personal matter, a search for inner truth."

This is perhaps most obvious in Marilyn Silverstone's work, taken in India, Pakistan, and Tibet, because her life has changed radically from West to East, from public clamor to religious retreat. For nearly twenty years she worked as an expert photographer of news events from the dramatic high points of political and social life, such as the Dalai Lama's flight from Tibet, to the disasters of violence, famine or disease. Eventually she was repulsed by her own skill—"You get

**Magna Brava**

168

Marilyn Silverstone: Poland.
Ceremony, Tomb of the Unknown Soldier. 1957.

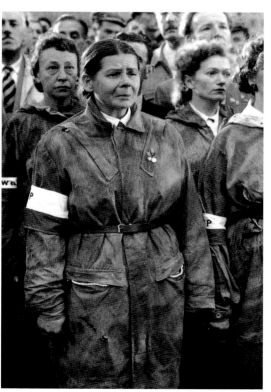

to taking pictures of people like pieces of meat"—and by the sense that she could be defined as a photographer rather than a person, as an observer not a participant in society.

The photographs of her approach to religion do not offer the sense of retreat that we might expect. It is rather an advance into emotional maturity. Her admiration and the warmth of the response in such pictures as the group of His Holiness Dilgo Khyentse Rinpoche and Trulshik Rinpoche, who ordained her as a Buddhist nun, offers the sense of her personal development in visual form. The pictures of religious life build on the knowledgeable strength of her earlier work, through calmness and pleasure.

196

They offer a severe contrast to Susan Meiselas's photographs taken in Central America—the civil wars of Nicaragua and El Salvador, and the desperate attempts of illegal emigrants to cross the border into the United States. The distinction between this and the other bodies of work lies in the nature of the subject—its overwhelming desperation. Here, instead of seeing through the photographer and achieving a sense of her personality and presence as a necessary component of the work, we are offered a direct and undiluted empathy with the subject, with no intrusive or subjective sense of the intermediary. We are presented with the urgent need to respond to insane killing. Burt Glinn advised her, looking at her pictures, that she was getting too close; it comes as no surprise that she received the Robert Capa Gold Medal for exceptional courage and enterprise. Her picture of the first day of the fighting in Nicaragua, with the masked fighter leaping across the street, puts her in a mirror position to the woman looking out from the doorway. Neither of them is well placed for survival. It is a deadly, domestic view of violence.

114

Susan Meiselas' Central American work belongs in a broad political arena, dealing with absolutes. It is forensic and there is even a sense of academic or scientific collection behind the deep, unpardonable distress it pictures. While she came to know her subjects, it is their situation not their individuality that is the immediate concern.

Eve Arnold's *In China* project was a long-pursued dream. She was one of the first westerners allowed in to the country when America and China established diplomatic relations in 1979. Throughout the months of travel in China (she covered 40,000 miles in six

months) she had the awkward status of the escorted and honored guest, the mannered and socially self-conscious position of a celebrity rather than a working observer. Under such circumstances it would be difficult to take photographs with any degree of naturalism, and yet this is the achievement. Photographing a communist country, she ironically created a celebration of personality and of individual beauty. These encounters with strangers in a multiplicity of cultures are eminently personal. Their role in society is clear, and this is a communist idea; the grace and intelligence they have brought to that role is an echo of Eve's own western individuality. Here we find liking and mutual respect.

Martine Franck's photographs of Tory Island, a celebration of a contained and individualistic society, were designed to achieve political influence. The intention is to depict a society which, while fragile, is organically

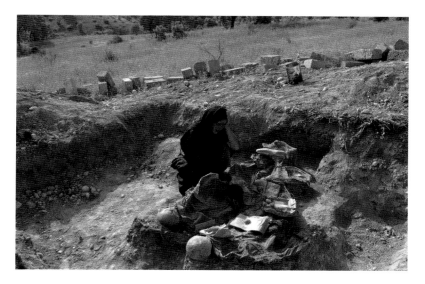

Susan Meiselas: Woman next to grave of her exhumed brothers, Koreme, June 1992.

Martine Franck: Bombay, 1980.

successful. The centralized politicians of Ireland had seen the islanders' life as impractical and proposed that they be re-housed on the mainland. Here, there were two outsiders involved, Derek Hill, the painter, who encouraged a school of painters on the island, and his friend, Martine Franck. She undertook the work for the French organization, Les Petits Frères des Pauvres, which had initiated a photographic project on exclusion in Europe. The photographs humanized the

political question and expressed admiration for island life. The outsider's role in this is elementary: she is deemed not simply to be objective but more authoritative; she has a lever to shift opinion. Martine Franck's photographs offer an effective sense of a community that is worth preserving. The impact of a sustained photographic association is an interesting one; it is a dialogue. People will come to see themselves through the outsider's opinion. The intervention of both artists has enhanced or clarified the self-esteem of the islanders and added conviction to their arguments.

Inge Morath's New York is a self-conscious city. Its theatrical architecture is a backdrop, which gives romantic grandeur even to the tiny, laboring figures of window washers. Like all great cities, it offers a constructed culture, but perhaps more than others, it has taken in such an extraordinary mix of races that its signalling surface has both a blatancy and a need—a man may bring his albino boa constrictor to the Food Fair, while navel piercing and graffiti are personal art forms displayed with public pride. Inge Morath's photographs invite us to examine and enjoy this self-conscious eccentricity as a key to a city in which acceptance is not so much gained as cracked open.

138

160

161 / 155

Her more personal photographs, of the painters, writers, or film-makers who are her friends, balance this public intimacy with a certain gracious distance. She deliberately learns about a culture or an artist before approaching photography, needing to know their language and expression. It becomes, in the sense of her extended education, her own portrait as well as theirs.

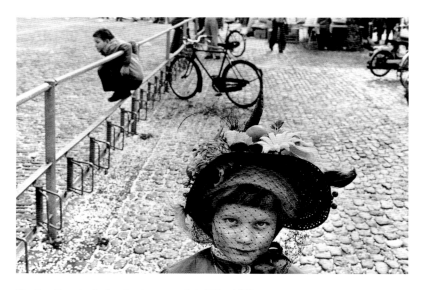

Martine Franck: Switzerland, carneval de Bâle, 1977.

We are offered an intimacy dependent on a similar courtesy in us: the more we know of the art, the more the pictures will communicate.

### An independent art

The purpose of the Magnum alliance is the independence of the photographers. In an increasingly organized world which is often influenced by commercial piracy, such independence is of growing importance. Moreover, the independence is not just from commercial lures and imperatives, but arguably from more insidious proposals, such as narrow definitions set up by politics or art. The photographers have, essentially, defined their own work, and the photographs in this book are all their personal choice. Photography is often addressed as an "independent" art, in a sense that relates to its difference from other arts. But it is independent here in another sense. Documentary photographers—these particular documentary photographers—are independent in a pronounced and heroic fashion. In Inge Morath's words: "I have needed my freedom. Once or twice I simply did not do a reportage. I went there and said, 'I don't see it'."

The dictionary definition of the word used for one of the heroic myths of our time, the maverick, or travelling cowboy, is an unbranded cow. In our context this seems pleasingly appropriate. It is significant that, when Eve Arnold tried film-making, she was not wholly seduced by the experience. After making a film in a Dubai harem in 1971, she was offered an extended contract. Although tempted, she decided against it:

"I love the idea that I can go off with a single camera and a few rolls of film unencumbered and find instant response to a mood, a need."

The proportion of women among the Magnum photographers is still very small. After fifty years, the fifty members include only five women. None of the five thinks of herself as a "woman photographer" in any exclusive or necessary sense. There are, however, two ways in which their being women may be looked at profitably: one is whether there may be a difference in their position in society, and the other is in the response of their subjects.

Born in 1947 Magnum came out of World War II and still carries that association. Photojournalism is commonly most dramatic in its dealings with combat. In the general view of war, the female role is non-aggressive. Women are not expected to be combatants. Men can become a part of the action in a way that remains more difficult for women. This may have the concomitant advantage that women in a "man's world" may be undefined, without precise status or place: not being entertained in the officers' mess may offer a freedom to wander.

The one condition common to all five women is that of concentration, absorption within the subject. Women are conventionally expected to be flexible, responding

Inge Morath: Lottery vendor having a siesta, Madrid, 1955.

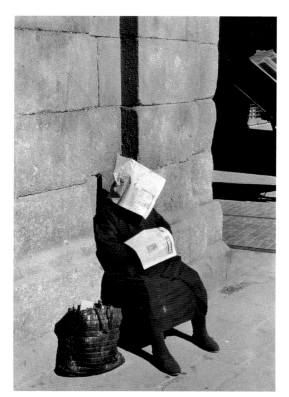

to immediate claims on their time. Opposing that expectation is still in itself a kind of aggression. It involves the sacrifice or disposal of other options. While this is obvious, it perhaps needs stating because the western world has adopted a falsely optimistic assumption that choice is unnecessary, and that one possibility may simply be added to another. All five photographers have not just spent time but devoted time to major projects and that time is a critical element in the comprehension of the work.

They have common ground. They are unrooted and international in approach, impressive and undaunted travellers. They share the skill and understanding of

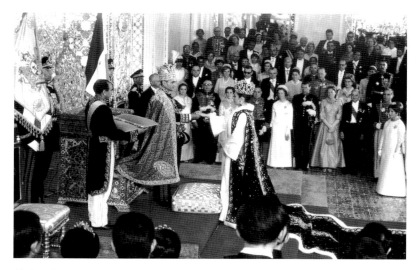

Marilyn Silverstone: Iran. Shah and Empress during their coronation, 1967.

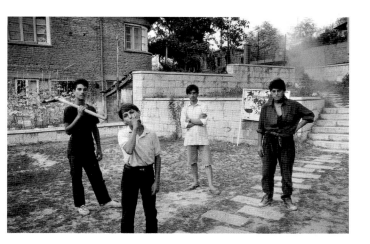

Inge Morath: Four teenagers, Nikopol, Bulgaria, 1994.

communication—Inge Morath's skill in languages (German, French, English, Romanian, Russian, and Mandarin), Eve Arnold's social sympathy, Susan Meiselas' education in anthropology—which enable the outsider to make the critically necessary contact and achieve a welcome. But there is no perceptible formula in their lives, which would make the path easier to follow.

Their subject matter shares an expression of interest in women and in looking at the world from their viewpoint. Women in the company of men are apt to be self-conscious, acting up to a male idea of women. Eve Arnold's photographs of Marilyn Monroe are a key to the visual understanding of this potential difference. Most of the photographs of her taken by men have a gloss of sexuality. She and Eve were both aware of her ability to turn this persona on, as an almost mechanistic trick. It is Eve's personal charm that

gives us the relaxed individual, and the subtler person of Marilyn Monroe. But it was based on the readiness in women not just to enjoy and admire each other's attractions but to admit how they were achieved. Inge Morath's beauty class and Eve Arnold's photographs of Joan Crawford stripping down and making up, cheerfully and in Joan Crawford's case, determinedly, reveal the fabrication.

It is perhaps unnecessary to propose a "woman's view" of war, except to say that the male/female roles do not correspond to the dualities of active/passive or strong/weak. Marilyn Silverstone's grieving women

Inge Morath: Dancing bedouins, south of Baghdad, 1956.

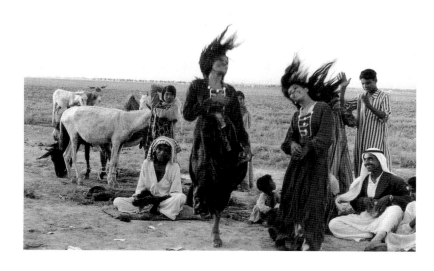

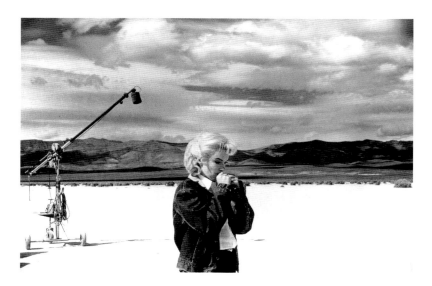

Eve Arnold: Marilyn Monroe in the Nevada Desert, going over her lines for a difficult scene she is about to play with Clark Gable in the film "The Misfits", 1960.

## Documentary photography

The unity of impulse behind the practice of the Magnum photographers may be expressed simply as photojournalism or documentary photography, two overlapping terms. The word photojournalism emphasises the relation between the word and the picture, the way the two together may make a clear and pinpointed attack in circumstances of hostility, or offer the heart of a situation. Together they may offer understanding. Photographing people is an inherently ambiguous business.

The idea of documentary photography is comprehensive and impressive. It is pre-eminently a sociable art, an expression of humanity. It naturally divides into two fields: the anti-social (dramatic and newsworthy, generally focussed on disasters and dislocation), and the social. Social documentary, as a term, has tended to refer to the examination of social injustice, but should include the coherent and admiring view of society, where the photographer becomes a sympathetic player.

Documentary photographers have traditionally been outsiders. In recent years this has been looked on with some suspicion as an invasion, as cultural imperialism. There is a political preference nowadays for the photographs of the insider, the person who belongs to a group and will know more of its working. There is an opposite, "artistic" preference for the disengaged observer. Both challenge the practice illustrated here.

But documentary photography thrives. This is partly for the very simple reason that photography, like any other art form, continues to be a professional business and the professionals hold the key to consistent success: concentrated knowledge and understanding. Knowing and seeing are not the exclusive province of the insider. The insider may disregard or even not know the familiar (from the details of domestic life to the appalling facts of civil violence) because life is to be lived, not watched. The outsider has potentially a privileged position granted on a temporary basis, allowing both actual and emotional access that might be denied to a next-door neighbor. The outsider is also, necessarily eccentric, and the formal rules may well be relaxed around that individual. The idea of women being treated as honorary men in Middle Eastern countries is familiar. Curiously, the same idea applies to men as honorary women. Eve Arnold tells a story that when she set up an all-woman team to film inside a harem, she was obliged to use a man as the lighting

178    in Warsaw or her famine-driven mother are suffering, but this is not a passive act; it requires phenomenal inner strength. In the conventional demand for differences between the sexes, men are expected to conceal weakness, women to conceal strength. Even in Susan Meiselas's Nicaraguan and El Salvador guerrilla warfare, the destructive action is visibly male, but the war is to be read both in the distress of the women and in their contained anger, for example, the women standing, not reacting to the brutal revenge on the

111    captured guerrilla, dragged through the streets. This may be partly exhaustion but it is also potentially the concealment learnt from the text, which explains what cannot be seen in the pictures, that the women, driven by the killing of children, would seek out the materials for making bombs and bring it home as the shopping.

220    In an earlier work, on carnival strippers, Susan Meiselas' intensity in exploring the women's lives was designed, in her words, to evoke both horror and honor. She was concerned to know what, behind the continuous sexual posturing, they were thinking and feeling. Their own words, published with the photographs, balanced the photographer's opinion, by expressing their own sense of empowerment in the act of striptease. This work offers a dialogue between photographer and subject in which the result is a debate not a judgment.

engineer and expected he would only be allowed in the empty room beforehand. But he was allowed to stay: "What we were to learn is that to an Arab, if you are not an Arab, then you are not a man...."

The outsider may also be the opposite: a one-woman army, who can collect the enemy's ammunition and make it a weapon against violence, injustice or sickness. This is heroism and carries the moral burdens of heroism: the need for clear-cut ethics, something close to a certainty of truth or right, the necessity to reject pictures that would titillate or sell as sensation.

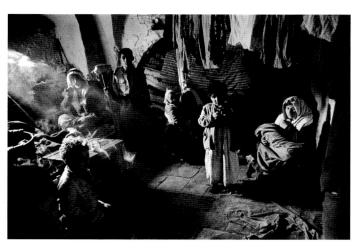

Inge Morath: Old Jerusalem. Family of Palestinian refugees, 1960.

There is a proposal that advanced technology has undermined the integrity of documentary photography. It may change the working manner of the photographer, as small hand-held cameras have enabled faster and less obtrusive work, but digital manipulation is not new. Photographs were altered from the very beginnings of the art, cut and retouched, painted, and re-framed. The obvious anxiety of manipulation is the covert falsifying of truth. But this has been done as much by human intervention, the photographer's omission, or the editorial decision. The tidying up of history is a sinister impulse—and absence from the record may be as sinister as a manipulated presence.

The area where technology is currently a danger lies in our belief in the image as, in some poignant manner, a rendering of truth or actuality. This is not simply a moral problem. Manipulation may encourage the commonplace, tidy up not just the improprieties but eccentricity. "Straight photography" in the hands of an

expert observer is a natural parent of Surrealism. Inge Morath's New York photograph of the llama in the car  163  has more impact if we are confident that it was there in life. Take away that probability and our charmed amazement at the genuine loopiness of life goes with it. An eye for the eccentric in daily life is essential in finding and making history. Fashion or habit may persuade us that a sight is normal; the humorous attention of Inge Morath can show us the true weirdness of the beehive hairdo as an historical aberration. Then, it  145  seemed reasonable and almost unworthy of comment.

The current argument for the "death" of documentary photography or photojournalism presupposes that its specific character can be overtaken by advancing technology. Events can be recorded with greater efficiency, or "coverage", by the video or by television. But this is a simplistic idea and relates to simplistic recording. The technology will change what we are offered and even the manner we may see—television has trained us to see a still image in one second and regard serious attention to that image as accomplished in three. It may be that still photography is now where painting stood in the mid nineteenth century, being offered the choice of suffering or benefitting from a technological challenge. Technology can be subverted by the intelligent intention.

Documentary photography has had a reputation for transparency; the idea that, from the surface presented, we can judge a situation. However, it may be that the contrary role, however it is defined—philosophy,

Marilyn Silverstone: South Vietnam. Mai (20) works in a bar in Saigon, 1966.

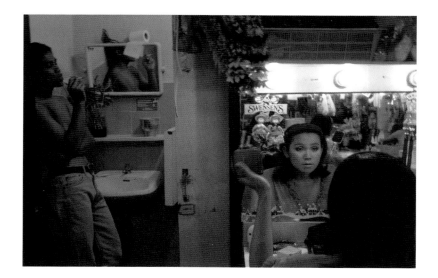

Susan Meiselas: Ladyboys, Bangkok, Thailand, 1994.

216

obscurity, confusion, ambiguity,—the difficulties in understanding—will increase its role in the art. The still image is better thought of as stilled and may well be enigmatic, like the picture of the girl in the street by Martine Franck. The photographer can construct or catch a halt in the complex machinery of life, so that we may achieve that apparent impossibility of examining the fractured second.

211

The work of Lise Sarfati, newly accepted as an associate in the Magnum agency, seems to fall into this philosophical vein, offering an ambiguous complexity, where the disconnecting statement of her words presents a brisk snapshot. The women offer themselves for a portrait in terms of their own surface; a man joins them by adopting their clothes. We are in Russia—Leningrad has turned to St. Petersburg—the principles have turned circle from communism to capitalism. There is a sense of dislocation. Lise Sarfati contrasts herself with the men of Magnum, stands back from their briskness of attack and offers her subjects respect and attention. The intensity of the color invites an intensity of regard. She is reaffirming the contemplative value of photography.

## Moments in history

The practice of these photographers is lavish in its use of film; they have archives of hundreds of thousands of negatives. The element of personal choice is critical. The photographer knows not just which is the visibly good picture in any group but which is the accurate reflection of the experience and, more mysteriously from

the viewer's point of view, which pictures may have grown in importance with time.

Capturing life and pinning down the present is a difficulty. Life is immensely complicated in its emotional and historical movement. Action can be frozen and can be caught, by a camera on motordrive, in minute fractions of a second, and in bulk. What is caught may simply be meaningless, a trawl in uncharted water. But the single image is expected to carry a burden of meaning, a weight of responsibility, as an encapsulation of history and society. This is rarely possible. Much of the work of the photographers discussed here has involved a sustained examination of people and society. One of the pleasures in revisiting such photographic work, beyond the original finished project (the photo-essay in a journal or the book) is that it can be rearranged. People and society do not travel in a linear direction; they move around and change their relationships. A body of photographic work offers the same opportunity. It is indeed one of the legitimate pleasures of a travelling exhibition to reorganize the pictures and watch a renewal or redefinition of meaning. This may be a game, but it is an appropriately human one.

Inge Morath: Toreador Antonio Ordonez dressing for *corrida*, 1954.

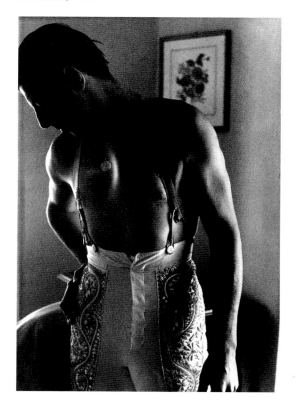

Susan Meiselas's work may be used for the enquiry. Her work has that urgency of the photodocumentary of war. The more urgent, in the human or political sense, the photographs, the more precise they need to be in their impact. Her work in Central America, in Nicaragua and El Salvador, and her subsequent work on the border crossings offer illumination to an extraordinarily difficult subject. However, the repulsive violence of the individual pictures offers us unfocussed distress. Only by knowing what happened before and after, why and to whom, can we understand and find the right anger. Photographs need a history. In the case of the dreadful picture of the two boys covered in

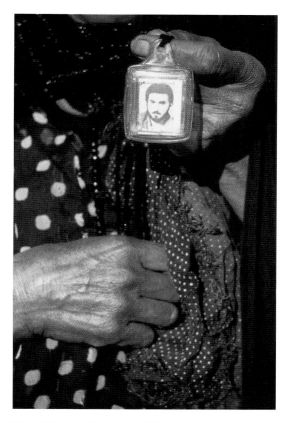

Susan Meiselas: Cemetery of Sulaimania, Iraq.
Mother holding memorial to her dead son, 1992.

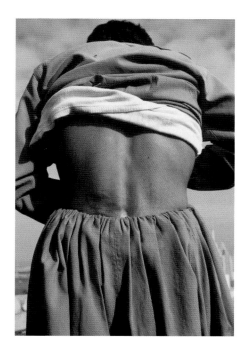

Susan Meiselas: Erbil, Kurdistan. Tamur Abdul, 15,
the only survivor of mass execution, December 1991.

blood, the knowledge given by the text gives it some of that necessary history: "Children rescued from a house destroyed by 1,000-pound bomb dropped in Managua. They died shortly after."

The pictures themselves build up into history and intermesh. The inherent confusion and darkness of the border crossings photographs are explained and illuminated by the earlier photographs of the "war zones". The human disaster of the Nicaragua and El Salvador pictures explains this extraordinary act: the willingness to cross a national border, to render

oneself an illegal person, living in the United States without any relation to the country's social contract, vulnerable to crime, and to become a non-person, dehumanized by military capture.

Photography is not an art uniquely tied to its own time. Contrary to popular myth, the camera did not invent the world. Historical connections may be legitimately made and give strength to the work. The power of photography to make personal history—to attach us privately to the past through our family photographs—is an extraordinary proposition. Political history is apt to be cold. Touches of life and resemblance may persuade us of the actuality of history. Here, political urgency has taken Susan Meiselas' work into historical territory. Her initial photographic project on the Kurds was forensic: to prove the truth of Saddam Hussein's 1988 Anfal campaign to annihilate the Kurdish race. It was a chilling project. As Susan Meiselas comments: "I was coming in at the end of the story...photographing the present while understanding so little of the past." Photography was revealed in her researches as a subversive idea. The opponents of the Kurds would consider even a family portrait as subversive if it could be interpreted as an expression of Kurdish identity and nationalist ambition. It became a revolutionary gesture, an extraordinary reversal of anthropological

117

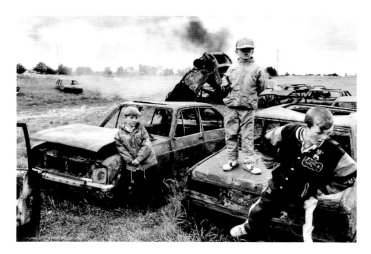

Martine Franck: Darndale, outskirts of Dublin. Graveyard for cars, 1993.

one, which carries echoes of Paul Strand's admiration of village life. The near comparison is Strand's Hebridean pictures, taken in the 1950s, of a similar small-scale coherent island community on the Atlantic coast. Strand's work in turn is related to the very first essay in social documentary photography: the photographs taken in the 1840s by David Octavius Hill and Robert Adamson, titled *The Fishermen and Women of the Firth of Forth*. They also celebrated village life as an alternative model to the sweeping urban and mechanical revolutions of the early nineteenth century.

Part of the historical sense of the Tory Island photographs—their resemblance to Paul Strand's Hebrides—lies in their quietness. They are mild and sometimes even sentimental in character. But this is a reflection of

anxieties about imperial arrogance, for Susan Meiselas to search the archives of the West and bring the images back, to re-make from the incoherent fragments of photographic reminiscence the historical presence which has been so damaged. It has become a remarkable collaborative exercise in historical retrieval, which was published as a book and continues on an Internet website.

Martine Franck's photographs of Tory Island are historical in a different way. Her view is a generous and admiring

Martine Franck: Hadrian's Wall, Northumberland, England, 1977.

Martine Franck: England, Newcastle-upon-Tyne, 1977.

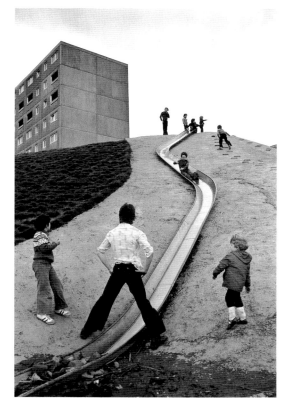

a social and constructive life; this is how it works. Tory Island is a non-industrial society; children play with dolls or boats rather than computers.

Martine Franck's photographs share this "old-fashioned" character with Eve Arnold's photographs of China. The cultural and historical reference seen here is not simply photographic. For example, certain of the interior photographs, the woman doctor or the woman preparing herbal medicine for impotency have the integral poise and dignity of Vermeer's studies, a delicately expressed beauty in their color, light, and simplicity. They look curiously out of time, partly because they connect with western history; the colors are not uniform chemical paints, the light is not strip-lighting.

33

37

It would be easy, in both cases, to see the attraction with a cynical eye; to see the close relation to the land, the very lack of machinery, as unsophisticated. Eve Arnold found her host pointing to signs of industrial pollution with pride, as evidence of progress. But the beauty, the color, the rosy cheeks of the accountant,

36

Eve Arnold: Accountant, 1979.

the self-sufficiency of such communities are an efficient satire on the values of our modern, western society. If we see in these images the quaint or the impractical, what have we gained?

**The role of the photographer**

In her China photographs, Eve Arnold was notably concerned with nature. The organization of the pictures is natural and offers an elegance made by the sitters and an environment that is their own. The very familiarity of the color and subtle touches of light and shadow, especially in pictures such as the woman accountant or the doctor, or the mother and child in the shop, is a familiarity of nature. This was achieved, in part, by a comparative lack of obtrusiveness; she did not take a tripod, she did not use lights or flash. In the latter case, there was an advantage. Hard, modern, even light may speed up the capture of the subject and increase the accuracy of our information but it

52

would have wrecked the extraordinary subtlety of that interior light. Part of the impact of these pictures and a significant part of their magical distinction, depends on her readiness to take the exposure at the necessary—not the demanded—speed, and add the risk of a picture that was too dark or spoiled by movement. It is, in the emotional sense, the light that makes the picture.

These photographs also explain, by reversal, Inge Morath's remark: "What I found especially difficult was when the clients said they only wanted color while there was no real color there." Eve Arnold found real color, singing with light, and it is critical to the photographs.

Similar decisions are necessary even with the most agonizing photographs. How to express, not just what is—in some efficient physical fashion—but how it is. Surprisingly, Susan Meiselas's work can be analyzed uncontentiously for its color, use of light, and format. Looking at the distinction between the Central American work and the border crossings, it can be said that the first is in color, fully illuminated, and in standard format. The second is black and white, arbitrarily or badly lit, and presented in a panoramic format. This is a difference in language, which is necessary to understanding. For the later work, she had to align herself with the official side, but she also wished to

Eve Arnold: Inner Mongolia, general store, 1979.

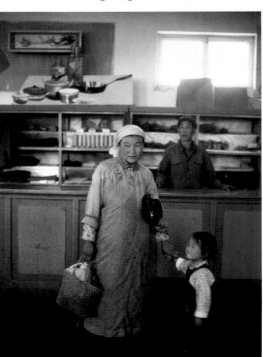

express the obscurity and confusion of the immigrants' experience, their attempts to break into another country in the darkness. The wide landscape is the habitat or the stage of the action. The people are lost and found, hidden and discovered by the simple oppositions of dark and light. The inhuman power of authority is expressed in blinding headlights and the disconnected hand coming from behind with the gun. The shadows of the people in the bus, the shadows of the night and its true confusion are accurate as experience. The pictures could not have been taken in the light of day. Their intensity lies in the panoramic settings, the angled position, and the monochrome.

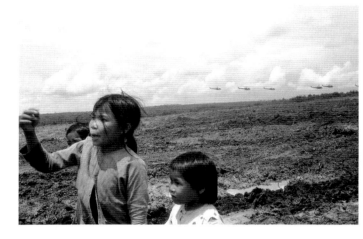

Marilyn Silverstone: South Vietnam.
Three children watching US helicopters, 1966.

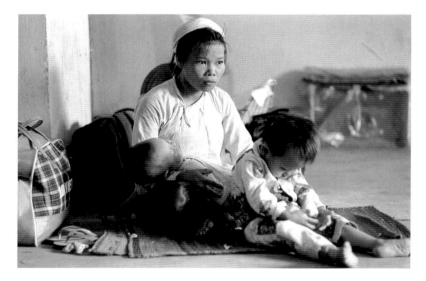

Marilyn Silverstone: South Vietnam. Widow with children, Danang airport, 1966.

They must stand for a negative of humanity. There is no dignity, no beauty. Such photography is justified by the need to shock strangers into action.

It is, however, possible to present victims as beautiful, as people with whom we can establish a healthy sympathy. Marilyn Silverstone's picture of the East Pakistan refugees offers the beauty of the dispossessed, for example, the mother and the child, sidelit to follow the lines of their classically unclothed forms, with just the little square of light coming through the back wall to anchor the composition. It is a beautiful and a touching picture: the universal image of the Madonna and child. It asks for our tenderness. In taking such a picture, the photographer may be distanced or analytical, because the victims are too absorbed to be troubled. In other

The idea of a studied aesthetic of violence, famine, or disease is clearly anathema. There remains an aesthetic consideration, if only because calculation and effect are linked. The study of inhumanity has an important role in the arts. Paintings of the Crucifixion are pictures of human brutality, justified by their meaning and intention. They may have a formality in construction, a knowledge of handling and color that gives them a transcendent beauty. The photographer, like the painter, needs to be precisely clear of his or her motive in making such pictures because the act offends the principle of human dignity. The risk, in Marilyn Silverstone's words, is of treating people "like pieces of meat."

Pictures of disaster are generally designed to shock and distress. Victims are degraded, denied personality.

Marilyn Silverstone: USSR. Children of Kashkelen State Farm, 1958.

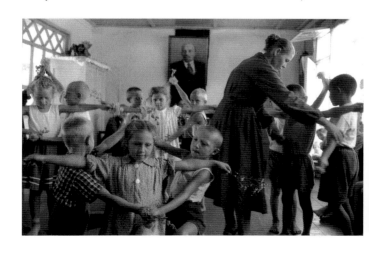

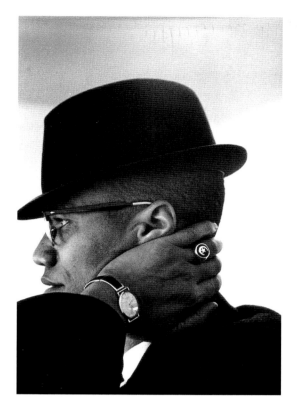

Eve Arnold: Portrait of Malcolm X in Chicago, 1961.

circumstances, a particular skill is required in not interrupting the flow of events.

One of the most extraordinary talents of the documentary photographer is an ability to disappear. A colleague of Marilyn Silverstone describes her working in India: "Tall and blonde as she is, she never attracted more than momentary curiosity; she was never mobbed or plagued by people staring at her cameras. Her concentration on the event at hand was like a force emanating from her, turning people back to their own affairs. On a festival day I lugged her extra cameras and lenses, wading behind her, knee deep into the Arabian Sea, surrounded by thousands of dancing, chanting Indians…. As Marilyn photographed them, the people looked not at her, but at me." This is an extremely interesting phenomenon, because it allies the withdrawn, introspective impulse of the arts with the recording of society. It presumably works on the same principle of the basic idea of teamwork—the idea that people are working alongside each other, even when, as in this case, the subjects are working to a different end. There is, perhaps, even a calming aspect to the abstraction generated by work, which removes that sense of the hunter and hunted endemic to photography.

It is obvious, though often ignored, that a photographer is personally present in the society he or she records.

Whatever impact she may have, she is solidly, physically, present. In photographs of violence, this presence takes on the burden of complicity and, in certain acid cases, responsibility for encouraging that violence. This is simply an exaggerated version of the broad problem of documentary photography that the photographer's actions and intentions are crucial. Where we are expected to assess the subjects of the photograph, we need also to be able to judge the photographer as a witness.

The impact of the photographer is only sometimes seen in the response of the subject. Eve Arnold's photographs of Malcolm X include one extraordinary case. Under the aegis of Malcolm X she was admitted to a rally linking Black Power and the Nazi Party of America. Why was Eve Arnold there? She was "patronized" by Malcolm X—licensed to trespass—a white Jewish woman with none of the credentials necessary to endear her to the company. In her photograph of the Nazi leader, his taut physical control—the dog on the chain of a dubious self-command—is concentrated in race hatred, offered to the person of the photographer and through her to the world. This is a terrible picture and the alliance is not a comfortable memory for Black Power. It is not surprising that the organizers of a recent, respectful exhibition on Malcolm X requested Eve's other photographs but wanted to leave this one out. Eve, correctly, insisted that this important historical fact should be visually expressed, not suppressed.

225

Eve Arnold: George Lincoln Rockwell (center), head of the American Nazi Party, at a Black Muslim meeting, Washington D.C., 1960.

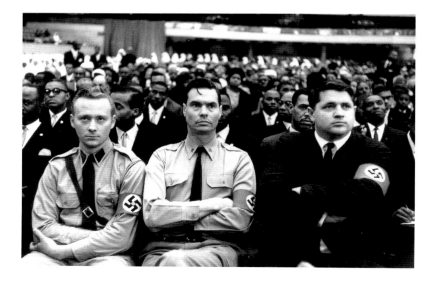

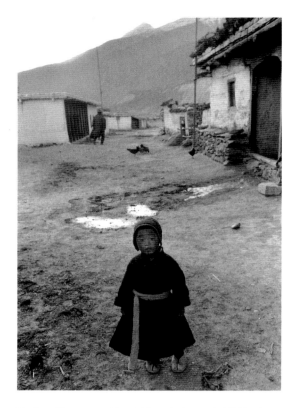

Marilyn Silverstone: Nepal. Warmly dressed child in the street at Jomosom.

In the organic, the correctly social documentary series, taken in balanced society, the photographer is a participant. The sustained photo-essay under these circumstances needs an interrelation between subjects and photographer, in which the two parties move towards each other, each attempting to understand the other's self and intention. The photography responds to the organic nature of communication: agreement and contradiction. The subjects need to have trust in the photographer. The photographer needs to respond to the criticism of the subjects. More precisely, in the point illustrated by Marilyn Silverstone's picture taken in Tibet of the group examining a set of slides, communication may be established by the sharing of pictures.

201

An engaging example of critical response to the photographer is Marilyn Silverstone's Nepalese child, politely puzzled, but dumpily confident. With her feet neatly parallel, stance balanced by her descending belt and a slight bell-like list of curiosity, she is herself a camera on a tripod.

226

The essential difference between the social documentary or portrait photograph and other areas of photography is that it requires respect. A brief, cynical relationship may be set up, as a satire or social comment, but the approach still needs connection if it is to work. The photographer needs, in some manner, to live the life he or she is photographing, to be touched, in order to pass on the sense of life. Most people, faced by a camera, become self-conscious, not so much about being photographed as about the resulting photograph. If willing to be photographed, they start to act themselves, to try to achieve that impossible act of behaving naturally under observation. It becomes a social and practical obligation for the photographers to restore or conjure up that nature.

Social documentary is a fascinating form of creativity because, pre-eminently, it needs that close connection and co-operation to work. However absorbed and introspective the photographer's concerns, the subjects will have allowed or invited him or her into their society, as an observer and interpreter, but also as an acting partner. Martine Frank says of Tory Island that, in the four years she has been involved, she has witnessed "a renewal of vitality and incredible hope." She has been more than a witness, she has had an active role.

**The portrait and the mask**

Inge Morath has found some of her best models among artists, not just because they are her friends, but because they are interested in the process and are able to think of the act rather than the result; to think with the working photographer. When Saul Steinberg agreed to pose for a photograph, he appeared wearing a mask. She took that photograph and initiated

Martine Franck: Henri Cartier-Bresson with the Dalai Lama, Dordogne, 1991.

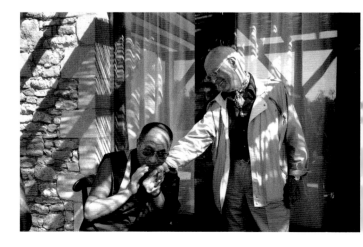

a whole joint project of masked portraits. She talks of Steinberg as "a one-man civilization." Her alliance with him in the project expresses formally the Surrealism of self-invention. It would be natural, looking at them first, to think of them as a record of Steinberg's work: his expression, through a simple and satirical line, of types or emotions. The engaging contrast, between the two-dimensional mask and the three-dimensional person wearing the mask, leads us to ignore the obvious fact that the photographs, like the masks, lie on a flat surface. The photograph is Surrealist, with the additional twist that we generally believe in its reality.

We have an affection for the mask. It is a simpler and less ambiguous manner of communication than the human face, with its compound response to the world. In "The sad phonecall", we sympathise readily with the piece of paper. This, in fact, is part of the attraction of a beautiful face, that it has both the simplicity and perfection of the mask; it is a satisfying surface. Inge Morath uses the idea of the mask in a different manner, with the two portraits of beautiful women, Rebecca Miller and Gloria Vanderbilt. Here their beauty is masked and confused by the reflecting shop window that makes Rebecca Miller a mannequin, and the screen door that makes the photograph of Gloria Vanderbilt into a screen-print reproduction.

133

139 / 162

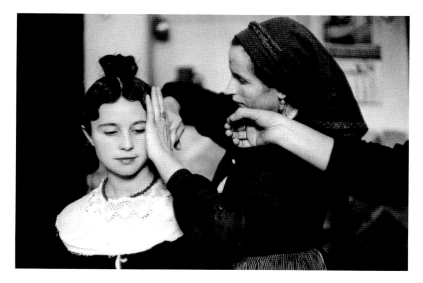

Inge Morath: Bridesmaid hairdo, 1955.

Eve Arnold: Joan Crawford, 1959.

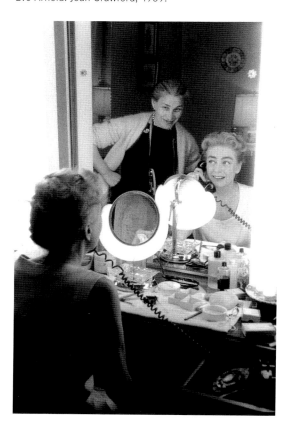

The mask of make-up has been, for nearly a century, the province of women, who have accepted standards of facial beauty in which they may train (as in Inge Morath's telling photograph of the beauty class) to look exactly like the next woman. Joan Crawford's extraordinary performance for Eve Arnold's camera, in which she wished her public to realize how much work went into her beauty, includes a truly remarkable picture showing the peeling off of a facial mask. Here the mask removes the personality of imperfection and leaves a second mask below the one torn off—surely an act of theatrical Surrealism.

Equally Surrealist is the photograph by Susan Meiselas of the Central American woman, one of the civilian fighters in the insurrection, wearing an Indian mask to conceal her identity. Here the role of the mask is painfully double-edged. It symbolizes a secret war where the enemy cannot see the face of his enemy, where there are no formal, mitigating rules.

99

The idea of the mask is inherent in self-consciousness and the human urge for privacy. The essay on the individual is one of the principal triumphs of photo-journalism; the "day in the life," the intimate entry to the private life of others, is a fascinating exercise. It requires an approach of commensurate intimacy, an empathetic relationship between the photographer and subject, if it is not to be a view through the keyhole. Eve Arnold's working relationship with Marilyn Monroe is an exemplar of this relation, as is her relation with Isabella Rossellini. It may be that such an association

228

227

with famous or public figures is more difficult nowadays, with the increased sophistication of public life. The number of experts surrounding a public figure, suggesting, demanding, dictating, or only decorating the set of their lives, makes the photographer's role more difficult. The celebrity likes the mask and the public-relations machine helps to hold it aloft between the photographer and subject. The resulting photography may be absurd. Magazines such as *Hello!* show life under a layer of carefully applied social varnish where no humanity glints through.

The human face cannot be satisfactorily described—a picture worked up from verbal description remains a Frankenstein's monster with the pieces stuck together and the person nowhere. Less obviously, it takes similar skill to make a photographic portrait that is recognizable. The portrait photographer needs to have an idea of how someone should, normally, characteristically or engagingly, look and then evoke it. Portrait photography is always, in that sense, constructed. Particularly in a one-to-one relationship, the portraitist has the problem of doing several things at once: analyzing and finding the right appearance, talking or arranging

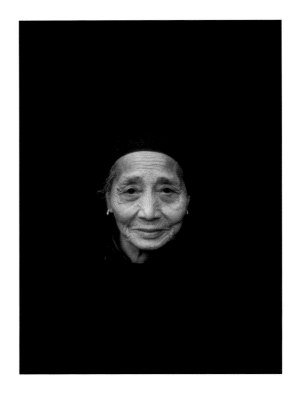

Eve Arnold: Retired worker, 1979.

Eve Arnold: New England. Isabella Rossellini reading her lines, 1985.

the sitter into that physical and mental position and, while maintaining the dialogue, taking the picture at the right moment. Inge Morath's New York photographs are the photographs of an insider: this is her home and her own cultural environment. Her portraits have that personal knowledge that gives us entry to intellectual life.

Part of the explanation for the ambiguity of Eve Arnold's photograph of the retired worker lies in the lack of knowledge between the two women. They did not meet. The subject has drawn back and Eve photographed her with the dark, floating surround to her face that apparently offers us a human mask. This was a photograph, taken on impulse, in admiration of the woman's beauty: "She withdrew into the shadows, so that only the ancient face with seams like the pleats on a Fortuny dress, shone forth. We looked at each other through the lens and then after a beat I clicked the shutter." It offers a nice irony, a pleasing codicil to the story *The Picture of Dorian Gray*, that twenty years after the two women looked at each other in the span of a heartbeat, people are asking if the photograph is Eve herself.

49

## Beyond the photograph

Martine Franck talks of the rare miraculous photographs. They offer a balance and conjunction, a self-justifying logic and a beauty. The "decisive moment" or the "punctum" are not grand historical turning points. They balance on a delicate pivot, emotional, personal, and even obscure in its fascination. Such terms describe pictures that stay in the mind and haunt our intelligence.

229 Inge Morath's picture of Mrs Evelyn Nash, taken in London in 1953, is one such. This is a classic example of a picture perfect in composition and expression, with the formal stillness of the two principal figures framed by the car and balanced against the disparate backdrops of the avenue, inhabited by tiny retreating figures and columns with the closer passers-by. The picture is a variant—by coincidence?—of the llama in 163 Times Square. Mrs Nash's feather and the llama's ear signal so clearly in the same language: the lady is an equally rare sighting. The picture is invested with a humor and generosity which takes it beyond any political thought about wealth and status, which a description might give us, and gives it a curiously satisfactory completeness. Like the llama, it does not need a history.

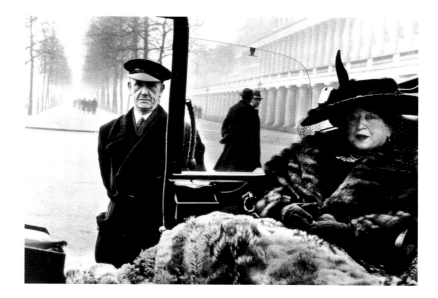

Inge Morath: Buckingham Palace Road, 1953.

Mrs Nash, her car, her chauffeur, and her landscape make a photograph. The innocent, friendly mockery of Martine Franck's old woman in the hospice at Ivry-sur- 229 Seine, making the ring of the lens with her hand, offers us a discussion of the art. This is a picture of great depth, offering us that potential confusion and dislocation of old age, when innocence and knowing wit sit together in one mind. It is also a photograph about the magical character of photography. The woman has turned her hand and eye into a camera to look at the photographer and see what she sees. On the table stands a carafe of water, adding a still elegance to the composition and offering us two more capturing lenses. Two pieces of curved glass placed opposite and containing liquid hold an image. The round glass of the flask has the visible scene held upside down, the straight-sided empty glass holds the photographer's shadow laterally reversed. They are incoherent, little lurking echoes of reality. This is indeed a rare picture, one that will stay in the mind and grow. It is one of the occasional miracles, that all six photographers pursue, that make the art of photography.

Martine Franck: Old people's home, Ivry-sur-Seine, 1975.

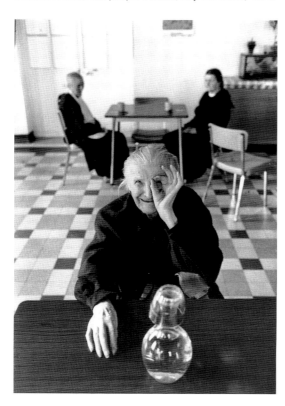

# MAGNA BRAVA

Biographies

# Eve Arnold

Eve Arnold was born in Philadelphia, Pennsylvania of immigrant Russian parents. She began photographing while working at a photo-finishing plant in New York City in 1946, then studied photography (for 6 weeks) with Alexey Brodovitch at New York City's New School for Social Research in 1948.
Eve Arnold first became associated with Magnum Photos in 1951, becoming a full member in 1955. She was based in America during the 1950s.
In 1962 she came to England to put her son to school at Bedales and except for a six year hiatus (she worked in China and America to prepare a book on each of these countries) Eve Arnold has since then been based in Britain.

## Exhibitions
Brooklyn Museum, Arnold's first major solo exhibition of her China work.

There have been innumerable exhibitions, both in Britain and abroad, principally: In Britain at the National Portrait Gallery London, and In Retrospect at the Barbican, the National Portrait Gallery, Edinburgh, the National Gallery of Photography, Dublin, the Ikon Gallery, Birmingham, the National Museum of Film, Photography and Television, Bradford. (The exhibition is currently travelling on a three-venue tour of Australia.)

## Awards
1980  National Book Award for her book *In China*.
1980  Lifetime Achievement Award from the Society of Magazine Photographers.
1995  Fellow of the Royal Photographic Society.
1995  Elected "Master Photographer", awarded by New York's International Center of Photography.
1996  Kraszna-Krausz Book Award for *In Retrospect*.
1997  Honorary Degree of Doctor of Science, University of St Andrews, Scotland.
1997  Honorary Degree of Doctor of Letters, Staffordshire University.
1997  Doctor of Humanities, Richmond, the American International University of London.

## Publications
1976  *The Unretouched Woman* (Alfred A. Knopf, New York; Jonathan Cape, London)
1978  *Flashback! The 1950's* (Alfred A. Knopf, New York)
1980  *In China* (Alfred A. Knopf, New York; Hutchinson, London; Kiepenheuer und Witsch, Germany; Shogakukan, Tokyo; *En Chine* Nathan, Paris, 1981)
1983  *In America* (Alfred A. Knopf, New York; Secker & Warburg, London.)
1987  *Marilyn Monroe, An Appreciation* (Alfred A. Knopf, New York and internationally.)
1987  *Marilyn for Ever* (Albin Michel, France; Mondadori, Spain; Italian Edition *Omaggio a Marilyn* Arnoldo Mondadori, Milan)
1988  *Private View: Michail Baryshnikov's American Ballet Theatre* (Bantam Books, New York)
1989  *All in a Day's Work* (Bantam Books, New York; Hamish Hamilton, London)
1991  *The Great British* (Alfred A. Knopf, New York)
1996  *Eve Arnold: in Britain* (Christopher Sinclair Stevenson, London)
1996  *In Retrospect* (Alfred A. Knopf, New York; Christopher Sinclair Stevenson, London)

## Martine Franck

Martine Franck was born in Antwerp. She was educated in England and the United States. She studied at the University of Madrid and finally at the École du Louvre in Paris. Martine Franck began photographing in 1963 in China, Japan, and India. In 1964 she worked in the photo-laboratory of Time/Life in Paris, after which she worked as an independent for Life, Fortune, Sports Illustrated, the New York Times, and Vogue. She has been a photographer with the co-operative Théâtre du Soleil since 1965. In 1970/71 she was a member of the agency Vu, and in 1972 one of the founders of the agency Viva in Paris. In 1980 she became an associate of Magnum Photos, and a full member in 1983. She may be best known for her pictures of the elderly, published in 1980 in *Le Temps de Vieillir* and in 1988 in *De Temps en Temps*, her portraits of professors at the Collège de France, and her interest in humanitarian projects.

### Exhibitions

1971  Le Théâtre du Soleil. Galerie Rencontre, Paris

1974  Paroisse de Saint-Pierre de Chaillot. Centre Galliéra, Paris

1977  Le Quartier Beaubourg. Centre Georges Pompidou, Paris

1978  Carlton Gallery, New York

1979  Side Gallery, Newcastle-upon-Tyne, England Photogalerie Portfolio, Lausanne, Switzerland

1981  Le Temps de Vieillir. Musée Nicéphore Niépce, Chalon-sur-Saône

1981  La Jeunesse à 20 ans. Centre Georges Pompidou, Paris. B.P.I.

1982  Galerie Municipale du Château d'Eau, Toulouse

1982  Handicaps sans Frontières. FNAC Forum, Paris; Metz; Toulouse; Nice; Mulhouse

1983  Des Femmes et la création. Maison de la Culture du Havre

1984  Des Femmes et la création. R.A.T.P. Station Saint Augustin, Paris

1984  Théâtre du Soleil. Shakespeare, Los Angeles

1985  Vingt Contemporains vus par Martine Franck. Centre Georges Pompidou, Espace Photo, Paris

1986  Centre d'Art Contemporain, Forcalquier

1987  Centro Culturale Pier Paolo Pasolini, Agrigento, Sicily

1988  65 Portraits. Maison de la Culture, Amiens

1988  Le Théâtre du Soleil. Centre Culturel Français, Berlin

1988  C'était 68. With Raymond Depardon, FNAC Forum des Halles, Paris

1989  De Temps en Temps. Centre National de la Photographie, Paris

1991  Des Métiers et des Femmes. (Exhibition commissioned by the Ministry for Women. FNAC, Défense, 1993.)

1991  130 Photographies. Taipeï Fine Arts Museum, Taiwan

1992  Museo d'Arte Contemporaneo, Santiago, Chile 130 Photographies. French Institute, Buenos Aires

1994  Le Collège de France. FNAC, Paris

1997  Paris Photo. Eric Franck Fine Arts, Paris

1998  D'Un jour l'autre. Maison Européenne de la Photographie, Paris

1998  Tory Island. The Gallery of Photography, Dublin

1988  Henri Cartier Bresson Fotografato da Martine Franck. Galleria Carla Sozzani, Milan; French Cultural Centre, Rome; FNAC, Paris

1999  D'Un jour l'autre. Maggazzini del Sale, Venice

### Publications

1970  *Etienne-Martin*. Text by Michel Ragon (La Connaissance, Brussels)

1971  *Sculpture by Cardénas*. Text by José Pierre (La Connaissance, Brussels)

1971  *Le Théâtre du Soleil: 1789* (Théâtre Ouvert/Stock, Paris)

1976  *Le Théâtre du Soleil: 1793* (Théâtre Ouvert/Stock, Paris)

1976  *Martine Franck*. Preface by Ariane Mnouchkine (Contrejour, Paris)

1978  *Les Lubérons*. Text by Yves Berger (Chêne, Paris)

1980  *Martine Franck: Le temps de vieillir*. Collection Journal d'un Voyage. Introduction by Robert Doisneau (Editions Denoël-Fillipachi)

1982  *Martine Franck*. Texts by Vera Feyder and Attila Colombo. I Grandi Fotografi Series (Gruppo Editoriale Fabbri, Milan)

1983  *Martine Franck: Des Femmes et la Création (photographies)*. Introduction by Vera Feyder. (Maison de la Culture du Havre, Le Havre)

1986  *Le BIP en toute liberté*. (Editions du Centre Pompidou/BIP, Paris)

1987  *Martine Franck*. Introduction by Giuliana Scimé. (Centro Culturale Editoriale Pier Paolo Pasolini, Agrigento, Italy)

1988  *De Temps en temps*. Preface by Claude Roy.

Postface by Michel Christolhomme. (Les Petits Frères des Pauvres, Paris)

1988 *Portraits*. Text by Yves Bonnefoy. (Editions Trois Cailloux, Amiens, France)

1994 *Le Collège de France*. (Imprimerie Nationale, Paris)

1995 *The Man who Planted Trees*. Text by Jean Giono (Limited Editions Club, New York)

1998 *From One Day to the Next*. Introduction by John Berger. (Thames & Hudson, London; Aperture, USA; Le Seuil, Paris; Schirmer Mosel, Munich)

1998 *Martine Franck: Tory Island*. (Wolfhound Press, Dublin, Ireland; French and German Edition, Benteli, Zurich)

1998 *Henri Cartier Bresson photographié par Martine Franck*. Text by Ferdinando Scianna. (French and Italian editions, Franco Sciardelli, Milan)

## Films

1970 *Music at Aspen*. Dir. Martine Franck.

1970 *What has happened to the American Indians?* Dir. Martine Franck.

1991 *Contre l'oubli: Lettre à Mamadou Mauritania*

1996 *Ariane & Co. Théâtre du Soleil*. Filmed stills by Martine Franck with Robert Delpire for Arte.

## Susan Meiselas

Susan Meiselas was born in Baltimore, Maryland on June 21, 1948. She graduated from Sarah Lawrence College in 1970 and obtained her Master of Education at Harvard University, School of Education in 1971. From 1972 to 1974 she worked as a photographic consultant at the Community Resources Institute developing curricula using visual materials for teachers in New York City public schools. During 1974 to 1975 she taught photography and animation film for rural communities as Artist in Residence for the South Carolina Arts Commission and Mississippi Arts Commission. In 1975 she was a Faculty Member in the Center for Understanding Media at the New School for Social Research in New York. Since 1976 Susan Meiselas has been a freelance photographer with Magnum Photos, New York.

## Exhibitions

*One Woman*

1977 AM Sachs Gallery, New York

1991 FNAC Gallery, Paris

1992 Side Gallery, Newcastle-upon-Tyne, England

1982 Camerawork, London

1984 Museum Folkwang, Essen, Germany

1990 Art Institute of Chicago, Chicago

1994 Hasselblad Center, Goteborg, Sweden

1998 Leica Gallery, New York

## Awards

1979 Robert Capa Gold Medal, Overseas Press Club

1982 Leica Award of Excellence

1982 Photojournalist of the Year, ASMP

1984 National Endowment for the Arts Fellowship

1985 Engelhard Award, Institute of Contemporary Art

1987 Lyndhurst Foundation

1992 MacArthur Fellowship

1994 Missouri Honor Medal, Missouri School of Journalism

1994 Maria Moors Cabot Prize, Columbia Journalism School

1994 Hasselblad Foundation Prize

1995 Rockefeller Foundation, Multi-Media Fellowship

1997 News and Documentary Emmy Award, Electronic Cameraperson

1999 Rockefeller Foundation, Multi-Media Fellowship

## Films

1985  *Living at Risk.* Co-directed & co-produced with
A. Guzzetti & R. P. Rogers, distributed by New Yorker
Films.

1991  *Pictures from a Revolution.* Co-directed & co-
produced with A. Guzzetti & R. P. Rogers, distributed
by Kino International.

*Voyages.* Directed by M. Karlin, writing and photography
by Meiselas produced for Channel 4 England.

## Publications

1975  *Learn to See.* Edited by Susan Meiselas.
(Polaroid Foundation, Cambridge, Mass.)

1976  *Carnival Strippers.* Written by Susan Meiselas.
(Farrar, Straus & Giroux, New York; *Strip-tease forain,*
Chêne, Paris, 1977)

1981  *Nicaragua.* Written by Susan Meiselas.
(Pantheon Books, New York)

1983  *El Salvador: Work of 30 Photographers.*
Text by Anne Forché. Edited by Susan Meiselas
(Writers and Readers, New York)

1990  *Chile from Within.* Edited by Susan Meiselas.
(W. W. Norton, New York)

1997  *Kurdistan: In the Shadow of History.* Written
by Susan Meiselas. (Random House, New York)

## Collections

Hasselblad Foundation, Goteborg, Sweden

Museum Folkwang, Essen, Germany

Birmingham Museum of Art, Alabama

The Art Institute of Chicago, Illinois

Museum for Photographic Arts, San Diego, Ca.

George Eastman House, Rochester, New York

The Fogg Art Museum, Harvard University,
Cambridge, Mass.

Baltimore Museum of Art, Maryland

Haverford College, Pennsylvania

## Inge Morath

Inge Morath was born in 1923 in Graz, Austria, and
studied in Germany and France. She worked as a
translator and writer in Europe, and became assistant
to Henri Cartier-Bresson after joining the photographic
co-operative Magnum on the invitation of Robert
Capa in 1953. From 1954 she worked independently
as a member of Magnum Photos in Paris. Her extensive
travels and her special interest in the arts found
expression in photographic essays published by a
number of leading magazines, e.g. Life, Paris Match,
Holiday Magazine, Saturday Evening Post, Vogue,
Picture Post, Illustrated Magazine, etc. as well as
in a growing number of books.

As a portraitist of personalities in politics and
the arts, she has photographed a great number
of famous contemporaries. Inge Morath has also
published documentation about a number of movies
as well as the stage productions of plays by her
husband, Arthur Miller, among them the now
famous staging of *Death of a Salesman* in Beijing.

## Exhibitions

1988  Retrospective. Union of Photojournalists in
Moscow; Sala de Exposiciónes del Canal de Isabel II
Museum, Madrid; El Monte Gallery, Sevilla: Öster-
reichische Fotogalerie im Rupertinum, Salzburg

1989  Portraits. Burden Gallery, Aperture Foundation,
New York; Norwich Cathedral, England; American
Cultural Center, Brussels

1991  Portraits. Kolbe Museum, Berlin;
Rupertinum, Salzburg

1992  Retrospective. Neue Galerie der Stadt Linz,
Austria

1993  Retrospective. America House, Berlin;
Hradcin Gallery, Prague

1993  Retrospective. America House, Frankfurt/Main,
Germany; Hardenburg Gallery, Velbert, Germany;
Smith Gallery and Museum, Stirling, Scotland;
Royal Photographic Society, Bath, England

1994  Spain in the Fifties. Spanish Institute, New York

1995  Spain in the Fifties. Museo de Arte
Contemporáneo, Madrid; Museo de Navarra,
Pamplona. Show traveling in Spain now.

1996  The Danube. Neues Schauspielhaus, Berlin;
Leica Gallery, New York

1996  Retrospective. Galleria Fotogramma, Milan

1996  Women to Women. Takashimaya Gallery, Tokyo

1997  Photographs 1950s to 1990s: From the Journals

of Inge Morath. Tokyo Museum of Photography

1997 The Danube. Magyar Fotográfiai Múzeum, Krecsemét; Esztergom Museum, Hungary

1997 Retrospective. Kunsthal, Rotterdam, Holland

1997 Retrospective. Galerie Falguière-Esther Woerdehoff, Paris

1997 Fiesta in Pamplona. Galería Municipal, Pamplona, Spain

1998 Celebrating 75 Years. Leica Gallery, New York

1998 New Prints. Port Washington Library, New York

1998 Retrospective. Edinburgh Festival, Scotland

1998 Retrospective. Museum of Photography in Charleroi, Belgium

1998 Retrospective. Municipal Gallery, Pamplona, Spain

1999 Retrospective, Camino de Santiago. Gallery of the University of Santiago de Compostela

1999 Spain in the Fifties. Museo del Cabilde, Montevideo, Uruguay

1999 Retrospective. Kunsthalle, Wien

## Awards

1983 State of Michigan Senate Resolution No. 295: Tribute to Inge Morath in recognition of her outstanding accomplishment as a photographer and chronicler of human life

1984 Dr. Honoris Causa Fine Arts. University of Hartford, Connecticut

1992 Great Austrian State Prize for Photography

1999 Gold Medal. National Arts Club, New York

## Publications

1955 Guerre à la Tristesse. Text by Dominique Aubier. Photography by Inge Morath and others. (Collection Neuf, Paris; Fiesta in Pamplona, Photography Magazine, London 1956; Fiesta in Pamplona, Universe Books, New York, 1956.)

1956 Venice Observed. Text by Mary McCarthy. Photography by Inge Morath and others. (Reynal & Co, New York; Venise, Connue et Inconnue, Editions de L'Œil, Lausanne)

1958 De la Perse a L'Iran. Text by Edouard Sablier. (Robert Delpire, Paris; From Persia to Iran, Viking Press, New York, 1980; Persien, Manesse Verlag, Zurich, 1960; Also reissued in paperback: Paris: Nouvel Observateur, 1980.)

1958 Bringing Forth the Children: A Journey to the Forgotten People of Europe and the Middle East. Text by Yul Brynner. Photographs by Inge Morath and Yul Brynner. (McGraw-Hill, New York.)

1961 Tunisie. Text by Claude Roy and Paul Sebag, Photographs by Inge Morath, Andre Martin and Marc Riboud. (Delpire, Paris; Tunisia Orion Press, New York.)

1967 Steinberg Le Masque. Drawings by Saul Steinberg. Photographs by Inge Morath. (Maeght, Editeur, Paris.)

1969 In Russia. Photographs by Inge Morath. Text by Arthur Miller. (A Studio Book, Viking Press, New York; I Russland, Grohndal & Sons, Oslo, 1970; En Russie, Bucher Verlag, Lucerne, 1974.)

1973 East West Exercises. Text by Ruth Bluestone. Photographs by Inge Morath. (Simon Walker and Co., New York.)

1974 Inge Morath: An Exhibition of her Photographs. Ann Arbor: The University of Michigan Theater Programs

1974 Three Works by the Open Theater. Photographs by Mary Ellen Mark, Inge Morath, Max Waldman. Inge Morath: "Nightwalk Portfolio." Text by Karen Malpede. (Drama Book Specialists, New York.)

1975 Grosse Photographen unserer Zeit: Inge Morath. Text by Olga Carlisle. Bibliothek der Photographie series, edited by Romeo Martinez. (Bucher Verlag, Lucerne. Also Published in French.)

1976 Meine Schwester - das Leben. Poems by Boris Pasternak. Photographs by Inge Morath. Edited by and with text by Olga Andreyev Carlisle. (Reich Verlag, Lucerne; My Sister Life, Harcourt, Brace, Jovanovich, a Helen and Kurt Wolf book, New York.)

1977 In the Country. Photographs by Inge Morath. Text by Arthur Miller. (Viking Press, New York; Country Life, Reich Verlag, Lucerne.)

1979 Inge Morath: Photographs of China. Introduction by Robert M. Murdoch. (Grand Rapids Art Museum, Grand Rapids.)

1979 Chinese Encounters. Photographs by Inge Morath. Text by Arthur Miller. Farrar, Straus & Giroux; Penguin Books, England; In China Reich Verlag, Lucerne.)

1984 Salesman in Beijing. Photographs by Inge Morath. Text by Arthur Miller. (Viking Press, New York; Methuen, London; also published in paperback by Penguin, London.)

1986 Portraits. Photographs and afterword by Inge Morath. Introduction by Arthur Miller. (Aperture, New York.)

1988 Inge Morath: Saul Steinbergs Masken und Andere Fotobilder. Introduction by Otto Breicha. (Rupertinum Museum, Salzburg, Austria.)

1988 Fotografias, Retratos de Hombres y Paisajes. Text by Arthur Miller, Begona Medina, Lola Garrido Armendáriz. Photographs by Inge Morath. (Sala de

Exposiciónes del Canal de Isabel II / Consejeria de Cultura, Madrid.)

1991 *Russian Journal*. Photographs by Inge Morath. Introduction by Yevgeny Yevtuschenko. Essays by Olga Andreyev Carlisle and Andrei Voznesesnky. (Aperture, New York; Sinclair Stevenson, London; *Russisches Tagebuch*, Christian Brandstaetter Verlag, Vienna.)

1992 *Inge Morath: Fotografien 1952–1992*. Kurt Kaindl, Editor. Text by Kurt Kaindl and Magrit Zuckriegl. Photographs and text by Inge Morath. (Kurt Kaindl Edition Fotohof/Otto Mueller Verlag, Salzburg. In German and English.)

1993 *Inge Morath*. Text by Anna Fárova. Prazsky Hrad, Editor. Photographs by Inge Morath. (Prague, Prosinec, Leden)

1994 *Inge Morath: España, Años 50 (Spain in the Fifties)*. Photographs and text by Inge Morath. Edited with a foreword by Lola Garrido Armendariz. (Lola Garrido Armendariz – Arte con Texto, Madrid. In Spanish and English.)

1995 *Donau*. Photographs and afterword by Inge Morath. Text by Karl Markus Gauss. (Kurt Kaindl Edition Fotohof: Otto Mueller Verlag, Salzburg. In German and English.)

1995 *Inge Morath und die Sociéte Imaginaire*. (Batuz Foundation, Altzella.)

1996 *Women to Women*. Photographs by Eve Arnold and Inge Morath (Magnum Photos, Tokyo.)

1996 *Inge Morath: Sociéte Imaginaire*. (Kuratorium Schloss Ettersberg, Weimar.)

1997 *Inge Morath San Fermín*. Texts by Arthur Miller, Ramón Irigoyen. Photographs and text by Inge Morath. (IGA, Pamplona.)

1997 *Photographs 1950s to 1990s: From the Journals of Inge Morath*. (Tokyo Metropolitan Foundation for History and Culture/ Tokyo Museum of Photography, Tokyo.)

1998 *Camino de Santiago*. Text by Manuel Rivas. Photographs by Inge Morath. Editor Lola Garrido Armendariz. (Universidad de Santiago de Compostela.)

1999 *Inge Morath: Portraits*. Edited by Kurt Kaindl. Photographs by Inge Morath. (Edition Fotohof im Otto Mueller Verlag.)

## Marilyn Silverstone

Marilyn Silverstone was born in London on March 9, 1929 to parents who were both immigrants from Eastern Europe. She graduated in 1950 from Wellesley College (Wellesley, Massachusetts, USA) and later worked as an Associate Editor for Art News, Industrial Design, and Interiors. She also served as associate producer and historical researcher for an Academy Award winning series of films on painters. In 1955, she began to work as a freelance photographer and from 1959 to 1973 lived in New Delhi, India. It was in 1964 that she became an Associate Member of Magnum Photos and in 1967 a Full Member.
She traveled widely in Asia, Europe, Africa, Central America, and the Soviet Union. During her years in India, she worked for major publications (Paris Match, Cosmopolitan, New York Times, London Sunday Times, Look). Her coverages included daily life and customs in India, Sikkim and Bhutan, the Kerala uprisings, the arrival of the Dalai Lama in India, the marriage of Hope Cooke to the Maharaja of Sikkim, the funeral of Nehru, the Iranian Royal Family and their Coronation. Marilyn Silverstone became an ordained Buddhist nun in 1973. In 1978 she became a contributing photographer at Magnum. She now lives at the Shechen Tennyi Dargyling Monastery in Nepal and was fully ordained in Hong Kong in 1987. She is currently researching the vanishing customs of Rajasthan and the Himalayan kingdoms.

### Awards
1971 London Film Festival Award for *Kashmir in Winter*

### Film
1971 *Kashmir in Winter*. Made from Marilyn Silverstone's photographs.

### Publications
1962 *Bala: Child of India*. Story by Marilyn Silverstone and Luree Miller (Methuen & Co., London)
1964 *Gukhas Ghosts: The Story of a Boy in Nepal*. (Methuen & Co., London)
1985 *Ocean of Life: Visions of India & Himalayan Kingdoms*. Preface by Haven O'More. Afterword by the Ven. Khanpo Thupten (Aperture, A Sader Book, New York)